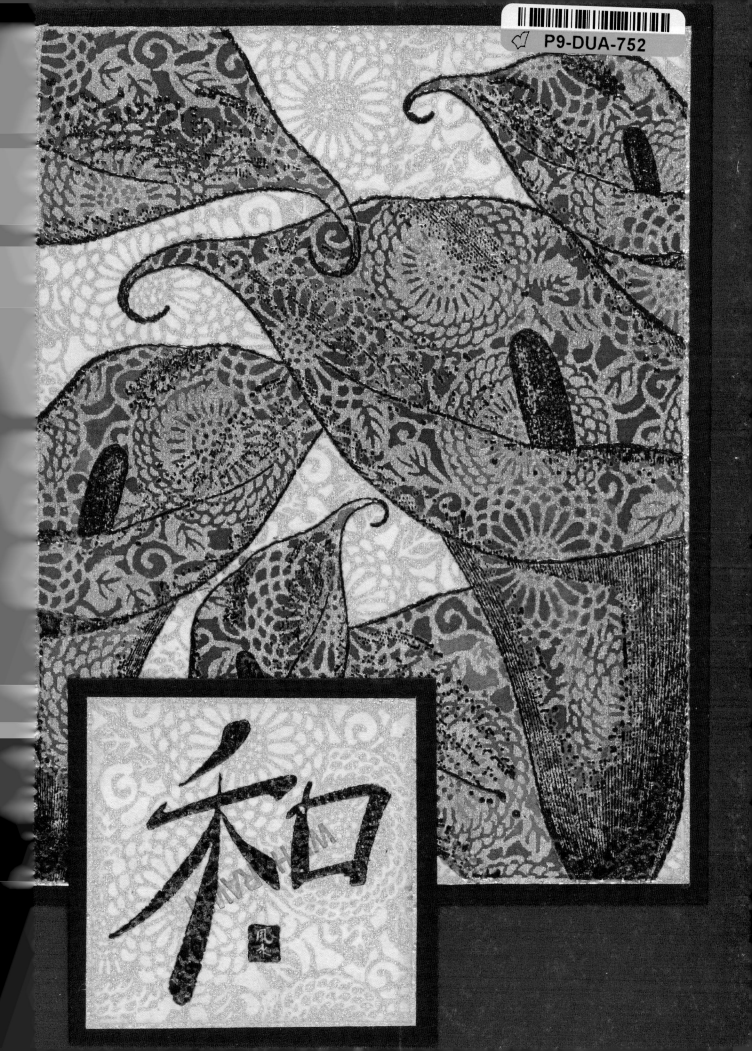

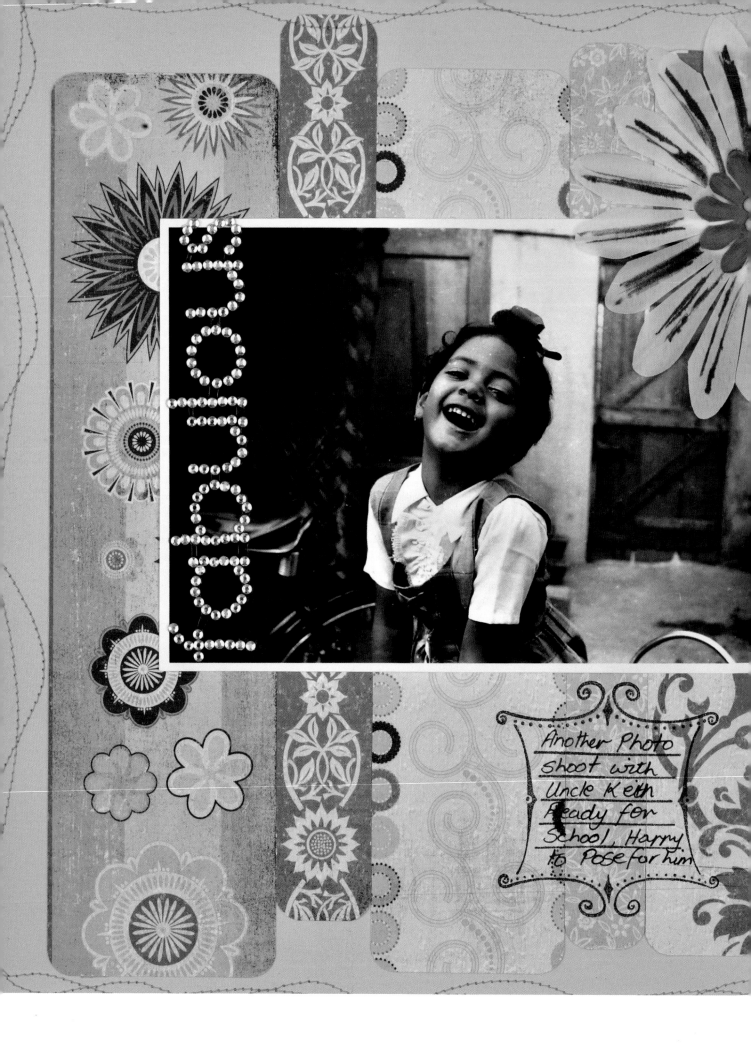

gorgeous

Another Photo
shoot with
Uncle Keith
Ready for
School, Harry
to Pose for him

Welcome to the World of Asian-style Scrapbooking!

So, you picked up this book off the shelf. Maybe it was the cover artwork that grabbed your attention; maybe it was the title. Now you sit here reading this and you want a definition. You are probably thinking to yourself, "What is Asian style and what is Asian-style scrapbooking?" Mixed-media artists and fine artists have long looked to the

East for inspiration, using rubber stamps of Japanese geishas and Chinese text to create exotic art and cards. Stampers and paper crafters have also long used Asian ephemera and handmade papers to create art that is unique. Numerous magazines and Web sites devoted to the art form exist and offer inspiration. Origami is a well-known and respected art form, and calligraphy and Chinese brush painting are both recognized by the public at large. Yet not many people have recognized the style of Asian scrapbooking.

So, let's change that, shall we? Scrapbooking with an Asian style is about taking inspiration from the East for your layouts. You might look at color combinations found in tropical Southeast Asia, for example, and work those colors into your projects. Scrapbooking with an Asian style might simply mean taking a closer look at some of the scrapbook products that you already use—or are found in your local scrapbooking store—that have been strongly inspired by Asian culture and highlighting on those elements. Perhaps Asian-style scrapbooking is about taking those Asian text rubber stamps off the shelf and using them to create a title or perhaps a bit of journaling. Asian-style scrapbooking could be about using different media for your artwork, incorporating origami or handmade papers from Thailand to create an exotic and unique project. Asian-style scrapbooking could entail incorporating some Chinese calligraphy or a piece of batik fabric in your layout or project in a style you otherwise would not have considered.

Asian style is simply looking to other parts of the world for inspiration—stepping outside of the common sources and reaching for the exotic. To start, I will introduce you to composition, from the Asian perspective, and show you how it can be used in your projects. Throughout this book I will show you color combinations that are related to parts of Asia and dive into combinations that may be a bit wild and crazy! I will show you motifs and elements that are either inspired by Asian culture or directly derived from Asian life. Asia has long been known for its papers and paper-crafting skills, and we will look at different types of papers sourced from Asia as well as learn some paper craft techniques you may not have seen before. Finally, we will explore Asia through its words and characters, learn meanings of specific characters and use them in layouts and projects. When all is said and done, I will share some helpful Web sites and resources with you for finding the materials used in this book.

So, now that you know what Asian-style scrapbooking is all about, let's go make some projects!

Hong Bao
by Claudia Lim
The Hong Bao is a traditional Chinese method of gift giving. During celebrations, weddings and birthdays, hong bao, translated as "red envelopes," are filled with money and given to the honored persona. In keeping with its Asian theme, Claudia's layout features patterned paper with an Asian flair and a traditional Chinese color scheme. *Supply Credits* Cardstock: Bazzill; Patterned paper: American Crafts, SEI; Lettering: Heidi Swapp; Photo anchor: 7gypsies; Buttons: Foof-a-La; Sticker letterings and arrow: EK Success

HONG BAO
Red Packets

What I love most about these Hong Baos is

the beautiful work of art that's on them.

So the next time you receive a Hong Bao,

don't just peep into the content,

take time to appreciate the work of art that's printed on it.

vin & tang

michael

singing

dancing

music

dolls

jewellery

into hairstyles and make-up

loves to shop for clothes

owns countless shoes

loves books, reading, writing and art

quiet and creative

likes to try new things

perfectionist attitude

love

relaxed attitude

dislikes change

physically active & noisy

loves maths & science

owns 3 pairs of shoes

dislikes shopping for clothes

not into fashion or hairstyles

computer/PS2 games

basketball

football

tennis

cricket

cars

being me

alyssa

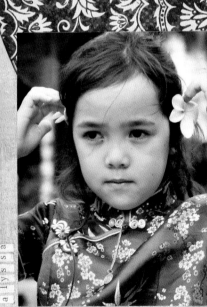

Compositional Yin and Yang
Using Symmetry and Asymmetry in Your Projects

Yin and Yang by Lynita Chin
Yin and yang represent dark and light, or negative and positive—the ultimate balance. Lynita created this layout to highlight the differences between her two children and simultaneously represent the concept of harmony and balance in traditional Asian culture.
Supply Credits Cardstock: Bazzill; Patterned paper: BasicGrey; Acrylic alphabet: Heidi Grace; Chipboard coasters: Urban Lily; Tiny alphabet stickers: Making Memories

Mulege by Kristy Harris
Using the layout and organization of a tatami room as its inspiration, this layout gives a lesson in both asymmetry and symmetry. (Tatami mats are traditional Japanese flooring made from woven straw.) Traditional Japanese homes have a specific room filled with these mats, always in specific configurations and often in groups of three. Each page, when viewed individually, is asymmetrically composed. Yet when combined as a two-page spread, the photographs balance one another symmetrically as they are the same weight and size. In effect, they are mirror images of one another, which creates a symmetrically, balanced layout when viewed as a whole.
Supply Credits Cardstock: Bazzill; Patterned paper: Urban Lily; Rub-ons: Urban Lily; Chipboard embellishments: Scenic Route; Journaling spot: Jenni Bowlin Studio; Chipboard letters: Junkitz; Acrylic paint: Making Memories

Balance from the Chinese perspective can best be described by the principle of yin and yang. Every positive has a negative, every dark spot has light and hard is countered by soft. The Chinese believe deeply in a sense of balance, which is manifested in the concept of something being two-sided or paired. Examples of the Chinese sense of balance can be seen in the use of the "Double Happiness" characters—such as the mandarin duck pairs used as a wedding decoration, the dragon and the phoenix that balance each other and of course the simple yin and yang symbol. Chinese balance is the equal treatment of the dual sides of nature. Symmetrical balance is attained in projects where two (or more) objects having equal weight are used together. It's easy to achieve symmetry with pairs, an even number of columns and mirrored images. For example, two-page layouts can be symmetrically balanced if the page designs are mirror images of each other.

The Japanese, however, tend to think of design asymmetrically. Asymmetry is the practice of setting off one large image by several smaller ones. Japanese artists believe that asymmetry represents life and that the flowing energy of a subject is expressed in its asymmetry. Design rules in Japanese arts such as ikebana hold that a symmetrically balanced layout is stagnant and represents stillness or death. Japanese asymmetrical balance, or more correctly imbalance, can be done with colors, shapes and position.

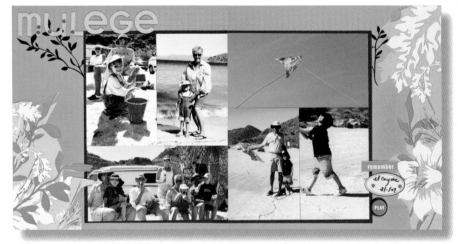

Source It!

Asian architecture can be a great source of inspiration for your projects, especially when making compositional choices in your layouts. A search through your local library will yield a number of inspirational books that are filed with images of homes, buildings and plans for Asian design.

congratulations

Coloring Your Projects with Asia's Inspiring Spectrum

Using different colors symbolic of different Asian cultures, these projects highlight the beautiful colors of Asia. Projects are by Wendy Steward, Brenda Marks, Heather Taylor and Odile Germaneau.

From China's Yellow River to the Pink City of Rajasthan

People identify Asia with certain colors. Rich vermillion reds, imperial yellow and that specific "Chinese blue" evoke images of a majestic China. While images of modern Japan include the vivid neon lights of Tokyo, the colors of Japan are more traditionally connected to muted earth tones. Thailand, the Philippines and Bali are tropical Southeast Asian locales that are visions of tangerine, mango and lime. When thinking of India, vibrant colors of jeweled saris and exotic Bollywood movie sets come to mind and affect the way we imagine that country. Colors also have specific meanings in Asian cultures; for example, imperial yellow was once reserved only for China's royal family, and the Japanese believe that the color green symbolizes rebirth and a connection with the natural world. The color black, throughout Asia, is commonly viewed as a noncolor or connected with evil spirits.

Throughout this chapter we will discuss color theory, in practical terms, using the colors of Asia as our guide. The use of color is the most basic of all of the tools we have in our scrapbooking toolbox; and I hope to give you some new tricks, expand your color horizon and have you thinking in combinations you might have otherwise not considered. *Note:* On occasion, I refer to a color wheel. If you don't already own a color wheel, I strongly suggest you invest in one as color wheels aren't expensive and are an invaluable resource. They are readily available at most scrapbooking stores and almost all craft/fine art stores.

Looking through the Kaleidoscope
Understanding Asian Colors

We see and interact with colors on a daily basis. Colors can change the mood and feel of the projects that we work on. Many people, and certainly most crafty people, have visceral reactions to certain colors and may think of colors in connection with specific locations. Asia is a big bright mix of colors. For me, the Near East represents the color of spices such as cinnamon, turmeric and sage. The bright colors of purple, fuchsia and peacock blue trimmed in gold remind me of Indian saris. The colors marigold yellow and grass green represent the Balinese offering baskets that are placed on the streets every morning; and the wild colors of red, green, orange, pink and gold can be seen on a Taiwanese street performer during a Taoist festival. All of these colors are separately Asia to me, but yet they combine into a wonderful kaleidoscope quilt of memories. It is these memories that often guide me when I am preparing to do a layout.

A quick introduction to what we are going to cover in this chapter can be done by looking at the two projects on page 13. In these layouts I used colors to highlight the emotion and the memory of the place that I wanted to capture. Both layouts feature pictures from the JW Marriott resort in Phuket Thailand, but by changing the color scheme the resulting projects feel very different. For me, when I think of Thailand, I immediately think of the aquamarine sea, the warm white sand and the bright blue sky. The first layout, called *JW Marriott*, highlights the water features of the hotel and the view of the seemingly endless horizon as seen from the hotel lobby. The colors used in the layout, blue and yellow, draw your attention to the water features in my pictures. Now, contrast this with the second layout using greens and bright pinks

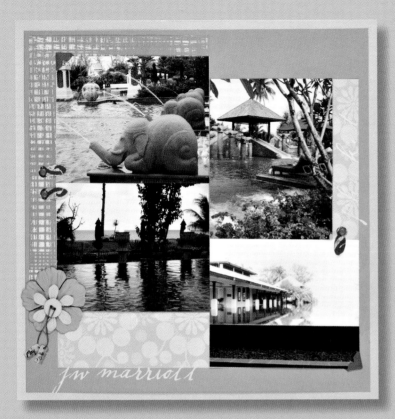

JW Marriott by Kristy Harris

Cool colors of blue highlight the water features found in this resort hotel in Phuket Thailand, while highlights of bright warm colors such as yellow and red make this layout feel tropically inspired.

Supply Credits Cardstock: Die Cuts With A View, WorldWin; Patterned paper: Rusty Pickle, Autumn Leaves, Mod; Brads: Making Memories; Flowers: Prima; Rub-ons: American Crafts/ Trademarks; Photo corners: Heidi Swapp; Tags, photo turns: Rusty Pickle; Other: Button, thread

Favorite Vacation by Kristy Harris

Using bright colors of coral and lime green, grounded with splashes of brown and black, give a definite tropical feel to this layout about the grounds of the JW Marriott Hotel in Phuket Thailand.

Supply Credits Cardstock: DCWV; Patterned paper: Luxe Designs; Rub-ons: Luxe Designs; Chipboard paisley: Fancy Pants Designs; Chipboard flowers: American Crafts; Acrylic paint: Ranger (paint dauber); Other: Ink

Source It!

While I am blessed, by living in Asia, to have a daily source of inspiration, it is possible to get introduced to Asian colors no matter where you live by taking a virtual field trip to Asia. For example, great sources of inspiration can be found in any Chinatown or other Asian community in cities throughout the United States and Europe. Watching Asian movies is a great way to take a field trip to Asia. Watching *Raise the Red Lantern, Lost In Translation, Monsoon Wedding, Crouching Tiger/ Hidden Dragon* and the comedy *Kung Fu Hustle* will fill your creative well with amazing Asian colors and images.

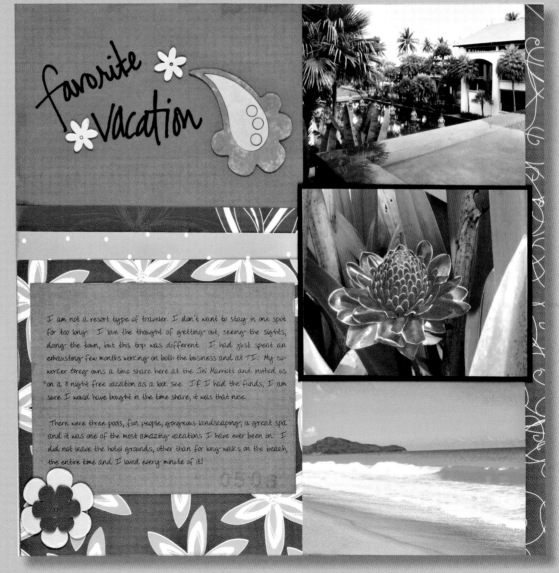

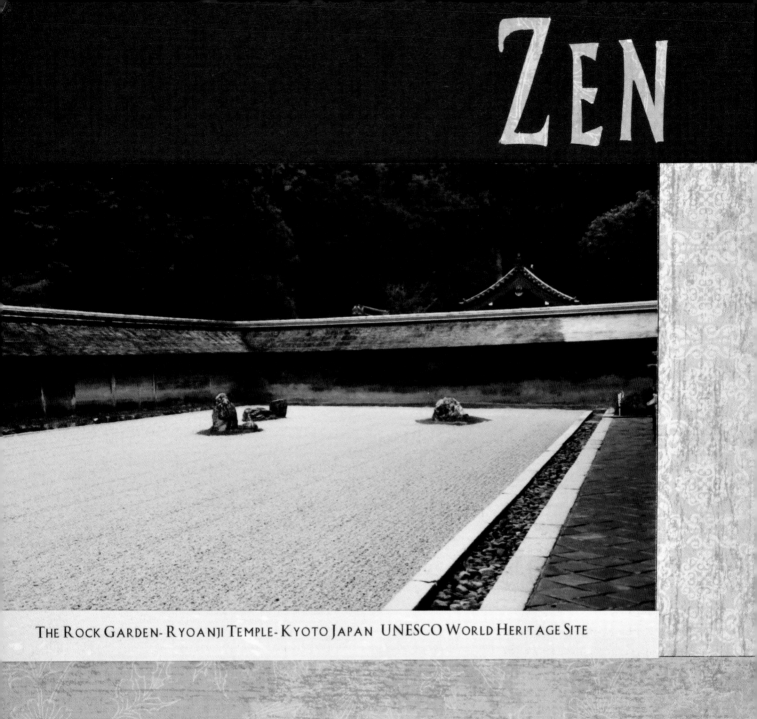

ZEN

THE ROCK GARDEN- RYOANJI TEMPLE- KYOTO JAPAN UNESCO WORLD HERITAGE SITE

Zen by Kristy Harris

This layout is an example of using two values of the same hue to make a monochromatic layout. The green cardstock and lighter shade of green-patterned paper complement the natural shades of green found in the picture. A simple title completes this layout, which focuses on the picture of a Zen garden.

Supply Credits Cardstock: WorldWin; Patterned paper: K&Company; Font: Times New Roman

to give the layout a more energetic and warm feel. The picture of the coral pink flower framed in black has become the focal point, the picture which highlights the rest of the project. The color of the flower was further highlighted by using cardstock and patterned paper in the same vivid pink.

I hope that as you read this chapter and view the layouts you will better understand how color and their cultural connotations can add an interesting new dimension to your scrapbook projects.

Zen Aesthetics
The Beauty of Japanese Simplicity

Japan is a paradox. While it is one of the most modern societies in the world, the Japanese culture is also one of the most traditional. Tokyo represents the modern with the bright, crazy colors of the Kawaii style, the pervasive use of pastels in Hello Kitty style and the Goth look associated with the animae-inspired Harajuku kids. All provide wonderful inspiration for layouts, but I've focused on muted colors, especially earth tones, and the monochromatic palettes found in the Zen aesthetic. Proponents of Zen interior design believe that natural objects should be showcased and that the use of bright colors and bold design are inappropriate. To create the Zen aesthetic in scrapbook design, a layout should use monochrome palettes or earth tones, the patterned paper should be simple and not overly ornate and the embellishments should be minimal, which will result in the photographs taking center stage.

To really understand monochrome palettes, perhaps a bit of color theory would be valuable. I hear "color theory" all the time, but how about a real easy-to-understand explanation? A color is actually called a "hue," and each hue can be changed by altering its value, or its intensity. A hue's value is adjusted by making it lighter by adding white (thereafter called a "tint") or darker by adding black (called a "shade"). It might help you to think of a tint in relation to gray on a gray scale. Starting at the center and moving toward the left side of the scale, by adding a bit of black at each step, gray becomes darker—moving from gray

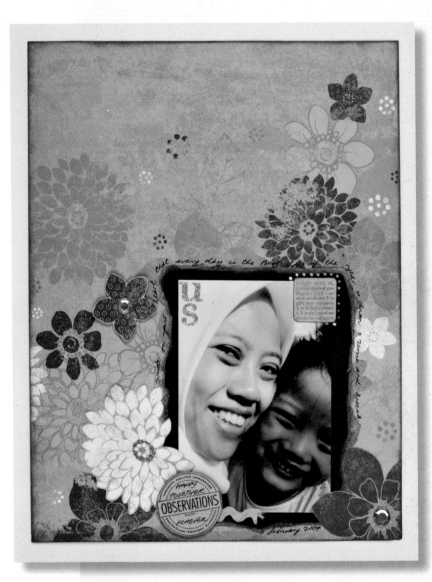

Us by Edleen Maryam

Using a collection of patterned paper by one manufacturer makes paper matching easy. Edleen's layout in the earth tones of greens, browns and blues is highlighted by a splash of white. Though the paper is patterned with multiple flowers, the busy paper doesn't overwhelm the picture because the color scheme is muted and limited. I really like Edleen's Zen approach to paper cutting here. By cutting around the flower, she slipped the photograph in behind the flower, adding depth without adding multiple embellishments.
Supply Credits Cardstock: Bazzill; Patterned paper: My Mind's Eye; Stamp: 7gypsies; Other: Brads, gems

toward steel, on to charcoal, until finally you've reached a full black. Starting again at the center, if you move toward the right of the scale adding a bit of white each step of the way, you will be moving from gray toward true white. If you replace gray with a color, each subsequent lightening of the original color is called a "tint."

It is also possible to create different tones of color by adding gray to change the intensity. Therefore, a monochromatic color scheme is one that uses all of the same colors, in varied tints and shades. In other words, a layout using a specific hue of green, with additional accents of varied tints or shades of the same hue, would be considered monochromatic. Later in the chapter we will discuss other color combinations in traditional color theory.

The example projects use monochromatic combinations or combinations that feature earth-toned colors. For those who love to play with color, the good news is that Zen layouts need not be void of a second color. Recall that while true monochromatic projects are shades and tints of the same color, Zen proponents will permit themselves to use a splash of an accent color to bring about a specific emotion or to highlight a design detail. This can be accomplished in your scrapbook projects as well.

Japanese Browns
by Heather Taylor
Simple without excess embellishment and using two tones of the same hue, this card is the perfect example of a monochromatic Zen-inspired card. *Supply Credits* Cardstock: Bazzill; Stamps: Stone House Stamps (word), Art Neko (mon); Inks: VersaMark, VersaCraft Black; Ribbon: Nostalgiques

TIP In the Zen aesthetic, the use of a small embellishment in a complementary color adds excitement to an otherwise monochromatic palette and brings attention to a specific design detail.

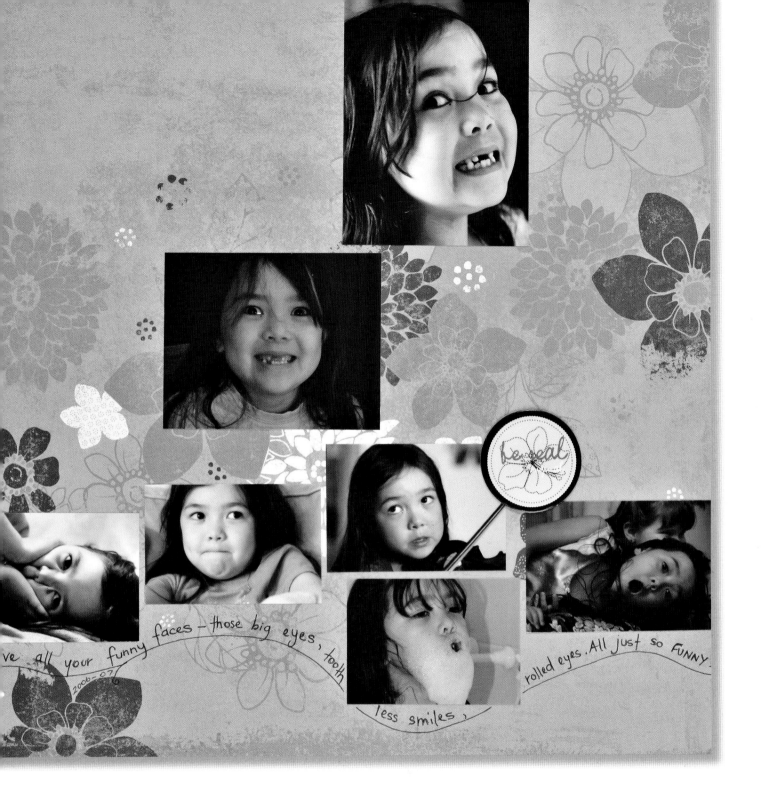

Be Real by Lynita Chin

Lynita took inspiration from the Japanese art of ikebana for this layout. Ikebana floral arrangements follow the same rules as Lynita did in this project. First, the largest item should be in the back of the design, in this case the largest being the tallest photographs, and the smallest (shortest) are placed in front. The project contains an odd number of photographs (seven photographs). The smaller photographs (flowers) are arranged in a wide shallow bowl on the bottom or in front. The design should be minimalist (no title, and minimal embellishments), and finally the design should be asymmetrically balanced.

Supply Credits Patterned paper: My Mind's Eye, Chipboard coaster: Urban Lily

Raise the Red Lantern!
The Bright and Bold Colors of China

Nearly ten years ago, my mother and I were traveling in a small town in a fairly remote part of China. We were probably the only Westerners in the town during that time of year, and it was getting to be dinnertime. We found only one open restaurant, which was at our hotel, and they were hosting a wedding banquet. While we ate our dinner, off to the side of the festivities, we watched the bride go through a number of changes of clothes. The last change was from a white dress to a bright red one. To be honest, we were shocked. We wondered, "What on earth is she wearing?" Here we were, two women from Oregon, in a foreign land; and while not unworldly, we just could not wrap our brains around a red wedding dress. Later, when I returned to Beijing to continue with my Chinese language class, I asked my teachers about the dress.

It was then I learned that red is a traditional color for weddings and other festivals in China as a symbol of celebration, luck and prosperity. I now look at the use of color in a different way after that wedding; and when I bring out a bright red paper for use in my Chinese layouts, I feel as if I am bringing in good luck!

Chinese culture has strong associations with certain colors. In the art and practice of feng shui, colors are given specific meanings and are linked to the four main directions (North, South, East and West) and five elements (Earth, Wood, Metal, Fire and Water). The goal of feng shui is obtain a balance of the elements in order to have a balanced Chi, or life force. Red means luck, celebration and prosperity and is linked to the element of fire. The Chinese word for *yellow* is a homonym for the word *royal*, and the use of the color was limited to the royal family. In feng shui, yellow is associated with the Earth element, symbolizing growth. Blue and green, which are considered to be the same color in feng shui, are connected to the Wood element and mean harmony and longevity. White, attached to the Metal element, is the opposite of red and is worn as a color of mourning (the exact opposite of Western culture!). The Water element is connected to black and has negative associations and is assumed to mean evil.

TRADITIONAL CHINESE COLORS
When giving your projects a Chinese flair, the following colors can be used as a guide:

Imperial Yellow
Bright Red (firecracker red)
Rust
Green
Blues: Chinese Blue, Indigo, Peacock Blue

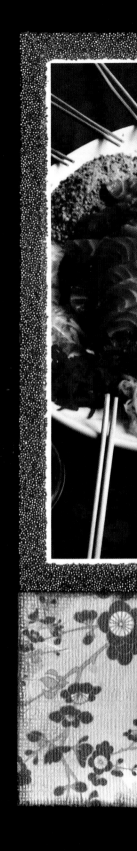

by Sharon Chan
The patterned paper by Die Cuts With A View features a Chinoiserie-inspired motif using branches and flowers. When combined with Chinese colors and detailed Chinese-type flowers, this layout has a distinct ethnic flair.
Supply Credits Cardstock: Bazzill; Patterned paper: Die Cuts With A View (small floral), American Crafts (large flowers), Autumn Leaves (scalloped edge); Other: Chipboard letters, microbeads, glossy accent

"Lo Hei" — tossing yusheng — is a CNY custom for families and friends to gather around the table and, on cue, proceeding to toss the shredded ingredients into the air with chopsticks while saying auspicious wishes out loud to mark the start of a prosperous new year.

And of course we had our own family tossing event at Auntie Mary's House on the First day of the New Year. Everybody came and we had a ball tossing the salad and wishing everybody good wealth, Health and happiness and of course it helped that the lo-hei was super duper yummy

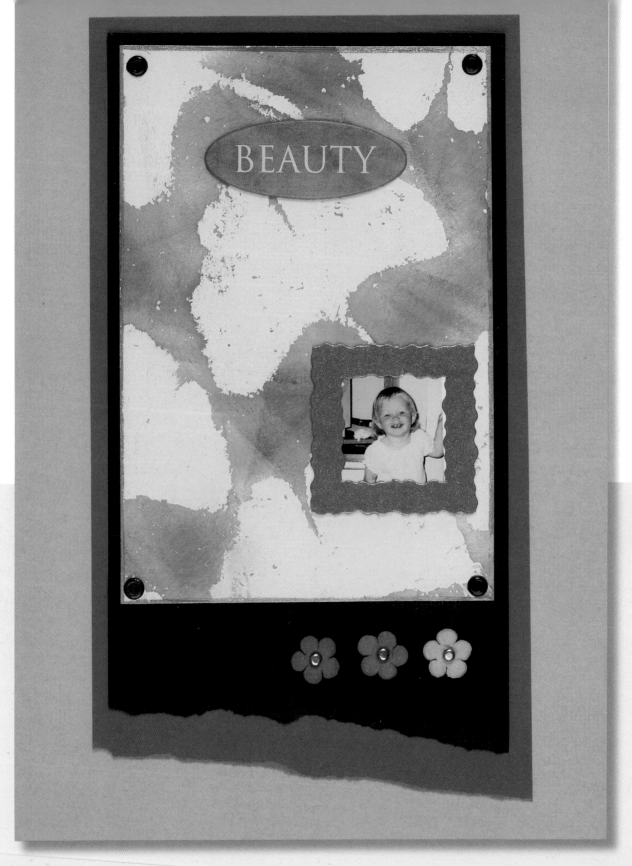

Beauty by Ann Pennington

The picture of Ann's grandchild's smile is complemented by the bright, vivid and happy color of yellow, the color traditionally reserved for the Chinese emperor. This unique project features a reverse batik technique.

Supply Credits Mulberry paper, high-gloss photo paper, white scrap paper, cardstock; Die Cuts With A View ("Beauty" sticker); Stamp Attack (gingko stamp); clear embossing powder; embossing pad: VersaMark; Inks: Posh Impressions (Citrus, Beach Ball Yellow, Orange, Popsicle Orange); Other: Paper flowers, brads, eyelets

Intense by Lynita Chin

Inspired by the traditional Chinese colors of yellow and blue, and combining them with black-and-white photographs, this layout has a definite "Chinoiserie" feel to it. The use of this complementary color scheme of yellow and blue (colors that complement each other are opposite each another on the color wheel). Complementary colors always work well together and are an easy way to create a coordinated layout with the use of colors.

Supply Credits Cardstock: Bazzill; Patterned paper: BasicGrey; Rice paper: Alphabet stickers: American Crafts; Flower: Prima; Inks: archival ink (sepia); Other: Brad, charm, ribbon, small tag

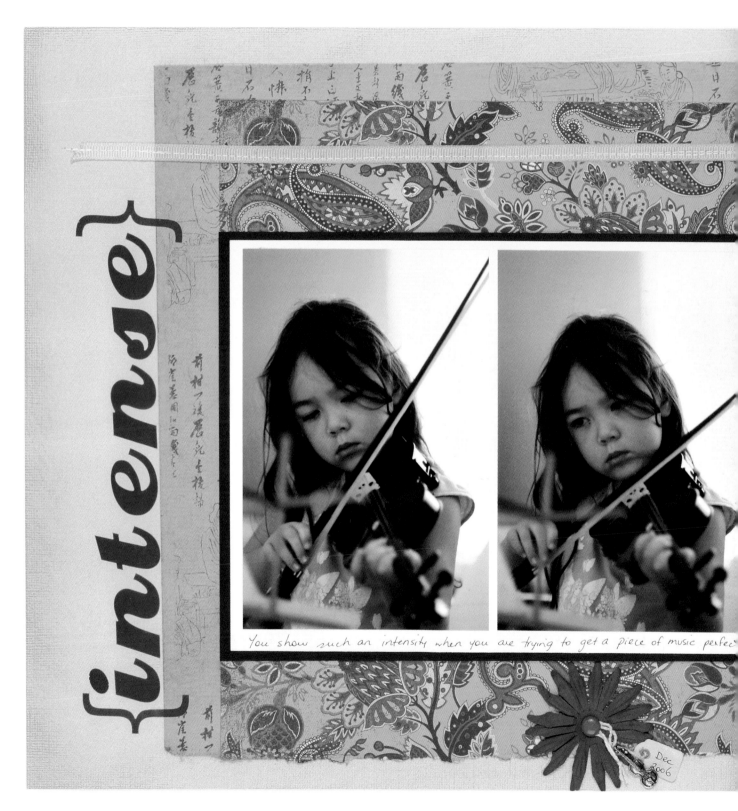

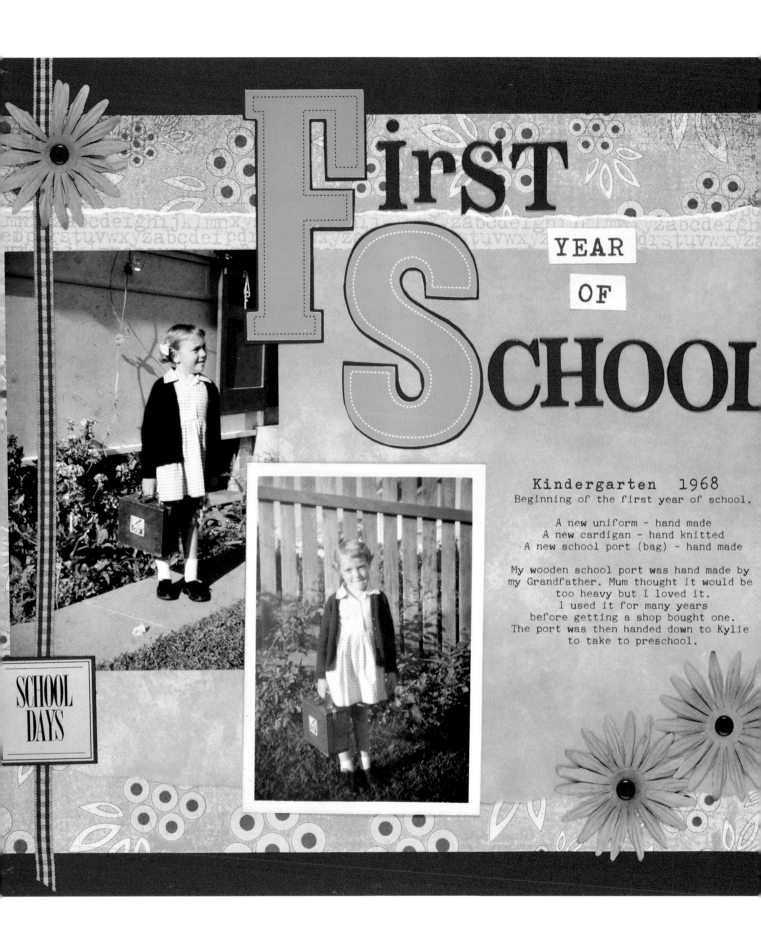

FiRST YEAR OF SCHOOL

Kindergarten 1968
Beginning of the first year of school.

A new uniform - hand made
A new cardigan - hand knitted
A new school port (bag) - hand made

My wooden school port was hand made by
my Grandfather. Mum thought it would be
too heavy but I loved it.
I used it for many years
before getting a shop bought one.
The port was then handed down to Kylie
to take to preschool.

SCHOOL DAYS

First Year of School
by Lynita Chin

Peacock blue was Lynita's inspiration for this layout featuring heritage photographs of her first year of school. Red, pinks and blues are part of Chinese cultural history in Southeast Asia, and the combination makes me think of Peranekan pottery (Straits Chinese from Malaysia and Singapore) when I see this layout.

Supply Credits Cardstock: Bazzill; Patterned paper: BasicGrey, KI Memories, Creative Imaginations; Flowers: Prima; Monogram letters: Colorbok; Chipboard alphabet: Heidi Swapp; Snaps: Making Memories; Stickers: 7gypsies/97% Complete; Ribbon

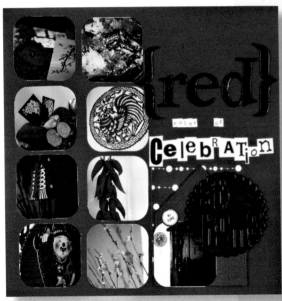

Red by Sharon Chan

Red holds significance as a color of celebration in Chinese culture, and this layout shows how the color is used in the home as a decorative element during the Chinese New Year holiday. Red is such a strong color that it often overpowers the other colors around it. Sharon paired red with black and white, allowing the color to stand on its own and shine.

Supply Credits Cardstock: Bazzill/Bling; Patterned paper: Scenic Route; Chipboard alphabet: BasicGrey/Undressed; Acrylic paint: EK Success; Alphabet stickers: American Crafts/At Home, Making Memories/Celebration; Chipboard house: Jenni Bowlin Studio; Flower chipboard : Technique Tuesday; Pen: American Crafts/Slick Writer; Glossy accent: Ranger

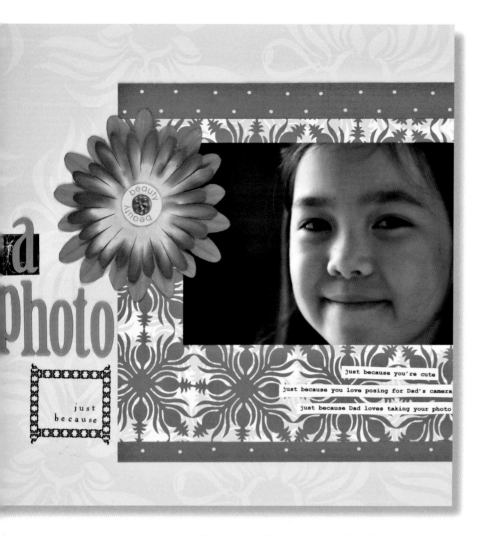

The projects below use traditional Chinese color combinations and emphasize how the use of the traditional color schemes can give an ethnic flair to the project without requiring the use of Chinese-patterned papers or embellishments.

Lime in the Coconut
Bringing Exotic Tropical Colors to Your Layouts

Tropical Asia can be experienced through the senses. The sites, smells and tastes of the tropics are all right there in the fruits and flowers of the region: the green palm trees, the abundant bananas, tangerines, limes and dragon fruits—the saturated yellows, oranges and fuchsia. Luckily, being based in Singapore grants me the opportunity to travel to some of the world's best tropical locales. Each time I come home from vacation I am refreshed and inspired by the sights of tropical Southeast Asia. Walking along the beach in Bali, for example, I feel stimulated by the brilliant bougainvilleas that I see. My taste buds go into overtime when I walk by the fruit seller's stall filled with papaya, dragon fruit, limes, and coconut. My whole body relaxes at the sight of the white sands and aqua sea. The tropics are warm, and the colors used to evoke them also tend to be warm and bright.

The characterization of a color's warmth is based on its location on the color wheel and its relation to the colors surrounding it. Generally, warm colors include the yellows, reds and bright pinks, symbolizing fire and the sun. Cool colors, which are represented by the sea, grass and sky, are obviously blues and greens. Purple, actually

A Photo Just Because by Lynita Chin
Tropical colors tend to work well together when you take inspiration from nature. Red, purple and lime green seem sort of incongruous, but you know what? It works in the dragon fruit, so it will work in your layout as well!
Supply Credits Cardstock: Bazzill; Patterned paper: Luxe Designs; Rub-ons: Luxe Designs; Alphabet rub-ons: 7gypsies; Plastic alphabet letters: Heidi Swapp; Chipboard ring: Heidi Swapp; Flower brad: Making Memories; Large flowers (pink): Heidi Swapp

Source It!

If you're lucky enough to live in a tropical locale, such as sunny southern Florida, or will be visiting one soon, you'll be delighted by the vivid, sun-drenched colors and heady aromas of exotic flowers and fruits. But even if you won't be near the equator any time soon, you can still get lots of inspiration and ideas simply by visiting a grocery store, where you'll find tropical fruits, or a florist, botanical garden or conservatory for tropical floral inspiration.

TROPICAL ASIAN COLORS
Let these bold and vivid colors guide you on your travels to tropical Southeast Asia:

Green: Lime, Palm Green and Fern
Yellows: Orange, Lemon, Bananna
Blues: Aquamarine and Sky
Reds/Purples: Fuscia, Dragon Fruit
Neutrals: Sand, Coconut Brown

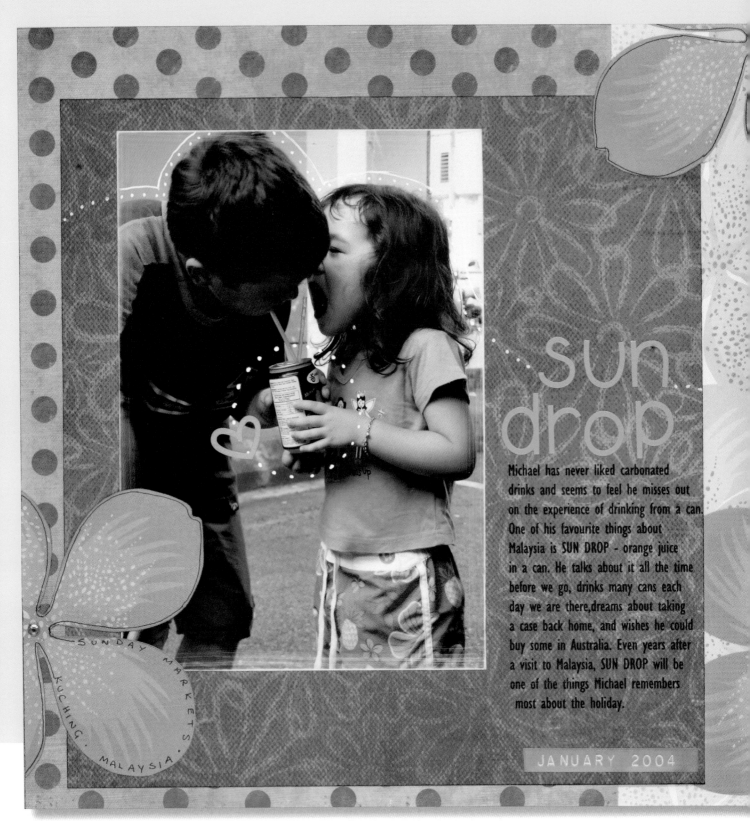

Sundrop by Lynita Chin

Warm, bright and fun, this layout just screams with energy. Fuchsia pink, lime, lemon and orange—colors that represent the tropics—accentuate the excitement of Lynita's children while sharing a favorite vacation treat.

Supply Credits Patterned paper: paper salon, Fancy Pants Designs; My Mind's Eye/Every Day Tango; Alphabet stickers: DoodleBug Design Inc.; Gems: My Mind's Eye/Bohemia: Other: Dymo tape

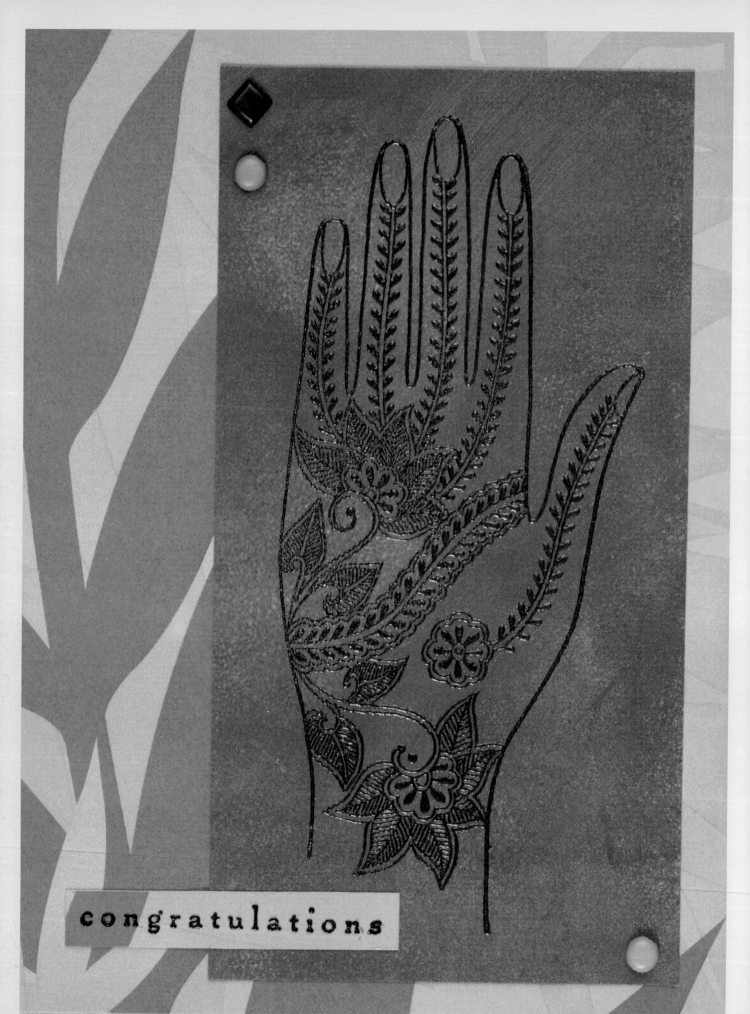

congratulations

Congratulations
by Heather Taylor

Using the relative warmth of the orange paper and balancing it with a cool color such as blue shows how well warm and cool colors naturally work together. When paired with tropical-inspired pattern paper and an Indian-based motif, this project imparts a tropical feel without overwhelming the senses.
Supply Credits Cardstock: Unknown; Patterned paper: Paper Salon; Stamp: Art Neko (Henna Hand), Savvy stamps (congratulations); Inks: Versacraft Black; Embossing powder: Moon Glow in Morning Glory Azure Teal; Other brads and orange-painted background with acrylic paints with gold

violet, falls in the middle of the spectrum and can be classed as a warm or cool color depending on the colors with which it is partnered. Warm color combinations make for energetic, stimulating and festive layouts, whereas cool color palettes

are more restful and soothing. It is possible to design a tropical layout featuring cool shades as well. For example, the combination of lime green with coral clearly gives a tropical feel, but is not so overwhelmingly "hot."

TIP Tropical layouts featuring oranges, reds and vibrant pinks will all feel warm, and by using these colors you can brighten up an otherwise ordinary photograph. You can also create tranquil tropical layouts reminiscent of a cool evening sunset by balancing the cool color of aqua with some neutral colors like sand and coconut brown and a warmer tone like burnt sienna to create a layout that is pure tropical Asia.

Jaylene's Beads by Julie Kosolofski-Kuo

Using the red, green and raspberry/purple colors found in the dragon fruit, Julie took a challenge I gave her to use these colors in a layout. Julie's layout is grounded by the use of light-colored kraft cardstock holding the three colors together without competing for attention. It is easy to see that lime green, raspberry and red are all warm colors, and the brown acts as a soothing complement.
Supply Credits Cardstock; Patterned paper: Creative Imaginations/Christine Adolph (pink wash), Green Tea Squared; Stamp: Heidi Swapp (Drama); Monogram: Colorbok; Letter stickers

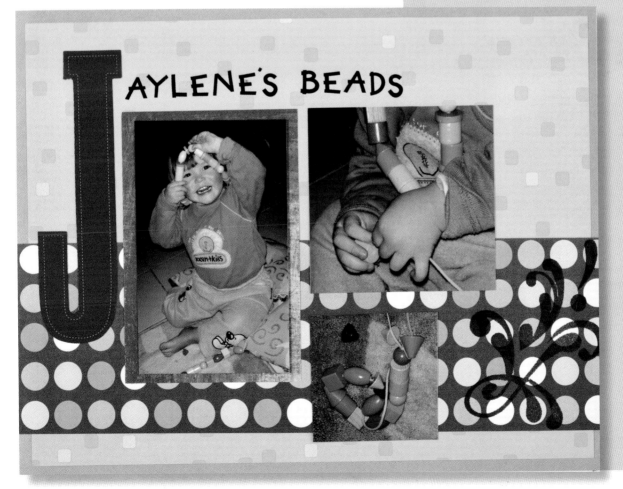

Cinnamon and Sapphire
The Colors of India

India is a nation of color where roses and marigolds are used for celebrations and offerings, brides are adorned in red silk saris and textiles of every color in the spectrum are seen on the streets. Many people think of the spice colors of cinnamon, turmeric, mustard and red chili in connection with India; but I also tend to think of women in their bright jewel-toned saris, in colors of sapphire blue, turquoise, amethyst purple and emerald green. The women of Rajasthan, India, are renowned for their love of color and will wear brightly colored saris, even when working in the cotton fields. While in Singapore's Little India, I purchased a few silk scarves that remind me of these saris—scarves in deep dark luxurious ruby, turquoise and purple adorned with golden paisley patterns. Working with these rich colors is inspiring!

How we use colors in our crafts can change the way that a project is interpreted. We know that warm colors such as yellow, red and orange add energy to a project and that the cool colors of blue and green tend to calm us down and center us. Rich deep colors such as the jewel tones impart an air of luxury and elegance to the projects and are wonderful when paired with glitter, gold and rhinestones.

Just as in other parts of Asia, colors in India are also associated with certain meanings. In India the color red, as in much of the rest of the world,

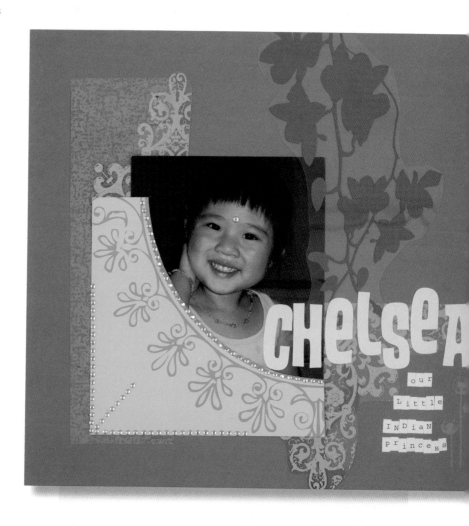

INDIAN COLORS

India is a land filled with a multitude of color, but most people identify the spice tones and handsomely adorned women in silk saris when they think of India. To bring a bit of Indian inspiration to your projects, consider using the following colors:

Spice: Cinnamon (reddish brown), Tumeric (bright yellow), Ginger (pale yellow), Green Peppercorn, Chili Red

Jewel Colors: Emerald Green, Sapphire Blue, Amethyst Purple, Ruby Red

***Chelsea* by Sharon Chan**

Sharon used a solid ocean blue cardstock as the base for this Indian-inspired layout. Her choice of bright pink, green and orange color accents was inspired by the vivid look of Indian saris. When coupled with the screen-printed transparencies from Hambly Studios resembling Indian prints and textiles, the Indian feel is complete.

Supply Credits Cardstock: WorldWin; Transparencies: Hambly Studios; Letter stickers: American Crafts; Bling: Heidi Swapp

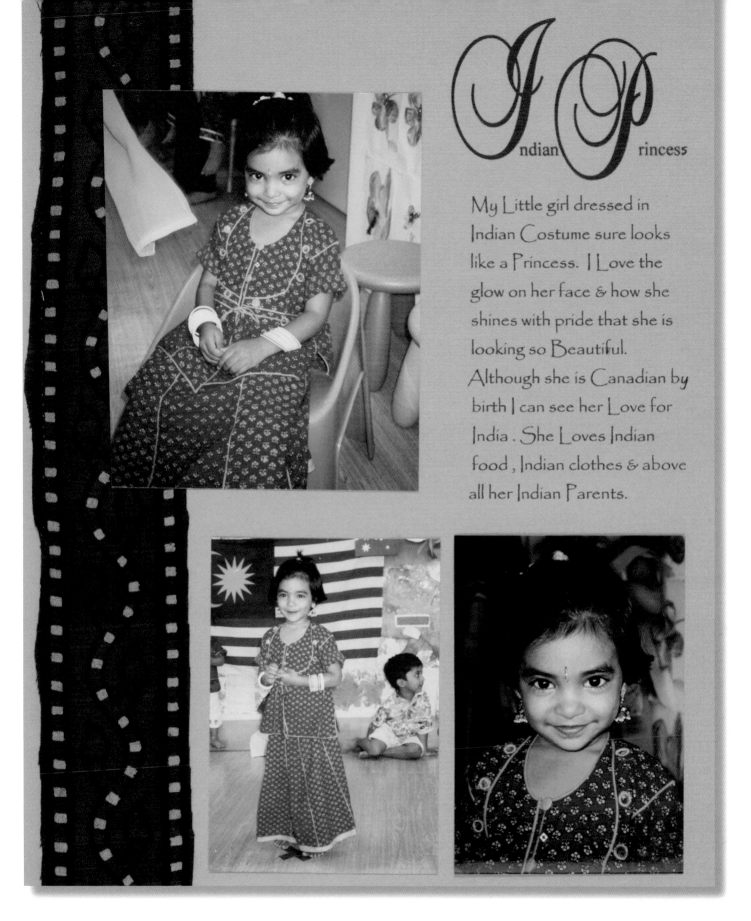

Indian Princess My Little girl dressed in Indian Costume sure looks like a Princess. I Love the glow on her face & how she shines with pride that she is looking so Beautiful. Although she is Canadian by birth I can see her Love for India . She Loves Indian food , Indian clothes & above all her Indian Parents.

Indian Princess by Nishi Varshnei
This bold layout showcases the spice colors of India and the adept use of recycled fabric. In this project Nishi had some leftover fabric that matched the dress worn by her daughter in the picture. A perfect case of environmental scrapbooking!
Supply Credits Cardstock; Indian cotton fabric; Computer journaling

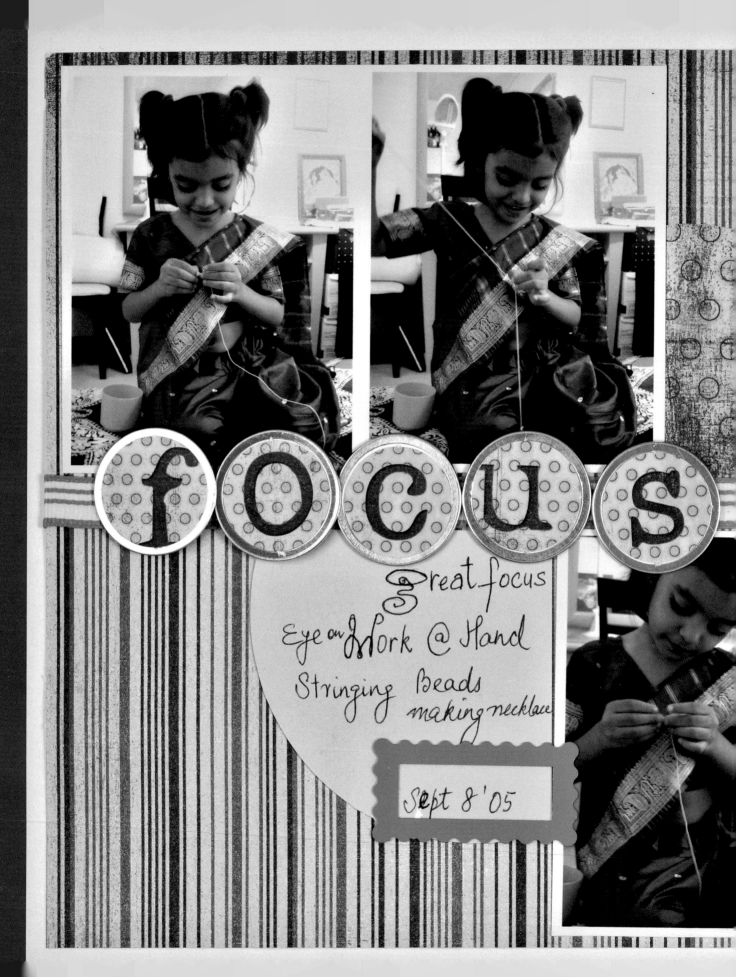

focus

great focus
Eye on Work @ Hand
Stringing Beads
making necklace

Sept 8 '05

Focus by Nishi Varshnei

The tourmaline pink in the background of the patterned paper coordinate with the pink Indian clothes in the picture. The layout uses the complementary accents of green and teal.

Supply Credits Cardstock: Patterned paper: BasicGrey; Others: Letter stickers, ribbon, tags

Source It!

A great source of inspiration for ethnically themed projects can be found as close as your local interior design center, import store or home design magazine. The use of brightly colored silk pillows with metallic trim is a great jumping-off point for using jewel tones. Look at the layouts in the magazines and don't be afraid to borrow color combinations. Asian-style home décor is a great place to start your journey into scrapping Asian style.

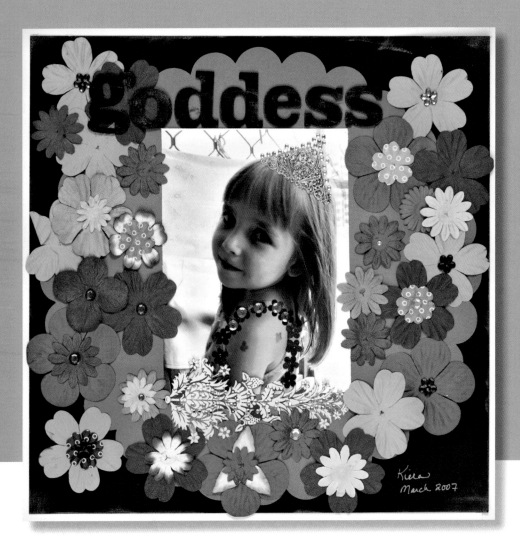

represents sensuality, but did you know that the color also represents purity? When a bride wears red in India it symbolizes both purity and passion, as well as devotion between two people and fertility and prosperity. Blue, another popular color in India, is the color of Krishna and the color of peaceful change. The color of saffron also holds religious meaning in India, indicating joy, festivity and happiness. Green symbolizes fertility and nature. It is not surprising to see bold combinations of color in India, but as in China, the Indian people do not use the color black except to ward off evil; and, contrary to Western culture, white is the color of mourning.

Goddess by Kristy Harris

This layout was inspired by a photograph of an Indian shrine. The flowers, gems and vividly brilliant jewel colors highlight the dramatic nature of my daughter Kiera posing for the camera.

Supply Credits Cardstock: Bazzill; Flowers: Prima, mjdesigns; Ink: VersaMagic (bronze); Crystals: Swarovski, Making Memories; Crystal flowers: mjdesigns; Patterned paper: BasicGrey; Letter stickers: American Crafts/Thickers; Silver photo corner; Far Flung Craft; Other: Sequins

Bollywood Babes
by Wendy Steward

This layout by Wendy is an inviting example of an analogous color combination. Analogous colors are those adjacent to each other on a color wheel. The reds and oranges are a warm and inviting layout. Wendy centered the project by using cardstock strip down the middle and framing the photograph with the same color cardstock. Without this base, the colors in the photograph would be too similar to those in the photograph, and the shot would be lost in the busy patterned paper.

Supply Credits Patterned paper; Brown chipboard letters: Heidi Swapp; Velvet letters; Flowers: Prima; Brads; Paint: Making Memories

TIP When bright, vivid colors such as Indian jewel tones are used, it is often best to either ground the colors in a dark neutral such as brown or black or match them with complementary colors to give visual definition to the project.

Jarrod, Emily, Sammi, Nicholas & Jess, enjoying the Indian costumes we brought them from our trip. So Adorable...

BOLLYWOOD babes

Scrapping with Asian Motifs

Lions, Dragons and Stars – Oh my!

Living and working in Asia over the past decade has given me an appreciation for indirect methods of communication. I have learned that a subtle nod from a vendor, or the way that he says "This is my best price," means that our negotiation still has room for movement. I have also noticed that indirect communication, while very common in daily life in Asia, also extends to the art world. Asian cultures often use traditional design elements, motifs and symbols to impart meanings beyond just the simple beauty of the object. Looking closely at Asian artwork, the trained eye recognizes the similarity between Chinese, Korean and Japanese artistic patterns; and over time I have learned that the symbols used in the three cultures often have the same meanings. For example, a picture of a crane with a pine tree, both symbols of longevity by themselves, combine to mean determination, perseverance and power. So, after living in Asia I have started to recognize these symbols and realize that there is much being said through art.

Thinking about motifs and their meanings from the scrapbooking perspective, wouldn't it be cool to create beautiful layouts that also hold significant meanings based on the design itself? Art in Asia has used symbols—either animals, plants or combinations of them as well as geometric designs—to act as both a visual stimulation and a medium of communication. In this chapter I will introduce you to a number of types of motifs and designs as well as explain the meanings behind them in Asian culture. I will also show how to incorporate these elements into your projects in order to add symbolic meanings to your projects and add a new dimension to your scrapbook pages.

Good Fortune and Luck
Chinese Motifs for Wealth, Health and Love

Let me tell you about Cathay, a fantastic land in China that existed during the eighteenth century. Filled with mystical forests, parks, poets, intellectuals and artists, Cathay caught the attention of the Europeans. In this land, Chinese intellectuals, known as mandarins, lounged or painted in bamboo pavilions and walked in gardens filled with dragons, phoenixes and other mythical beasts. Cathay was overflowing with beautiful women and intelligent men with nothing better to do than create wondrous art and literature. Of course, Cathay was a figment of the imagination, nothing more than the interpretation of stories told by Marco Polo and other adventurers who traveled to the exotic East. But the magical land of Cathay did create Chinoiserie—a revolution in design and style starting as early as the late 1600s and continuing on through the early 1800s in cultured Europe and its colonies.

The term *Chinoiserie*, meaning "the Chinese style," was coined by the French royalty in the seventeenth century to describe this new design style. As with many other trends, the court's adoption of the style and its fascination with the

Chinoiserie **by Heather Taylor**
This card by Heather uses traditional Chinese motifs of butterflies, peonies and chrysanthemums to create a Chinoiserie-themed card. The use of the motifs, combined with the traditional Chinese color blue, is evocative of the wallpapers that epitomized the Chinoiserie style in the royal courts of Europe.
Supply Credits Cardstock; Stamps: About Art Accents; Inks: Ancient Page indigo dye ink

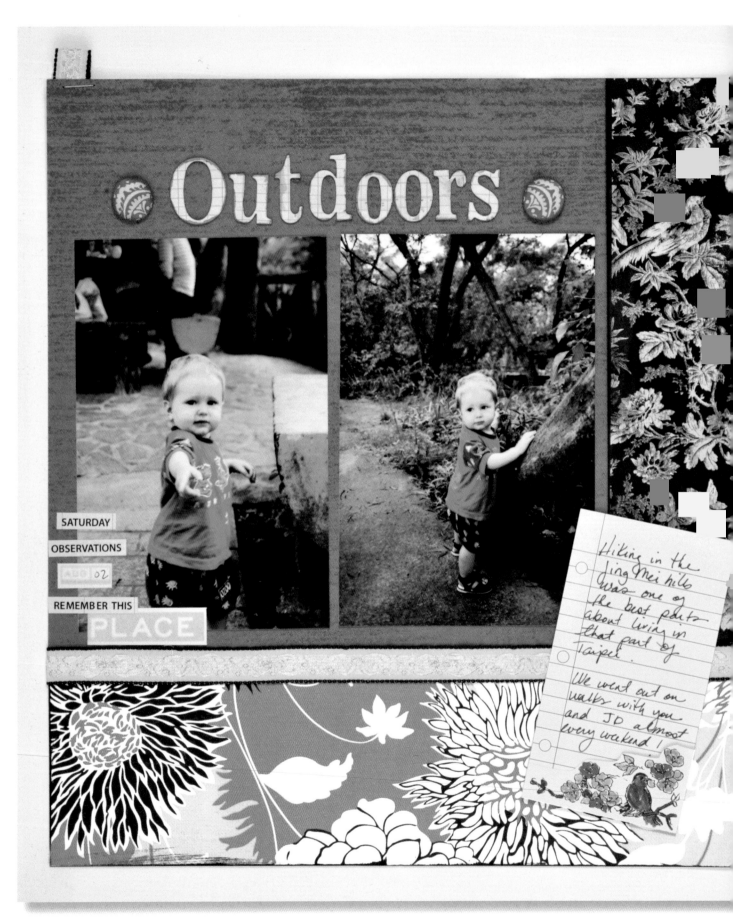

Outdoors

SATURDAY

OBSERVATIONS

AUG 02

REMEMBER THIS
PLACE

Hiking in the Jing Mei hills was one of the best parts about living in that part of Taipei.

We went out on walks with you and JD almost every weekend!

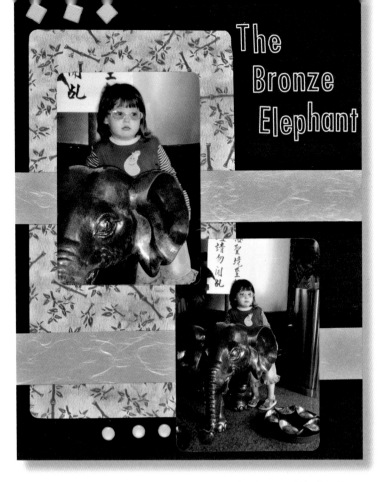

Outdoors by Kristy Harris

Scenes comprised of large peony bushes, flowering trees and birds were common on Chinoiserie-style wall coverings throughout the eighteenth century. In the homes of the European elite, wall panels were hand painted and therefore differed one from the other. These hand-painted patterns were then copied to create mass-produced wallpapers to be sold to the general public. The rub-ons used in this project are a replica of a wallpaper panel that would have been used in a Chinese-inspired home décor during the peak of Chinoiserie style. I distressed the rub-ons for this layout by adding StāzOn ink to make them appear more "antique."

Supply Credits Patterned paper: Target/ Kay, "Marcella," K&Company/Amy Butler; Cardstock: WorldWin; Rub-ons: Daisy D's; Flocked stickers: K&Company/Amy Butler; Word sticker: 7gypsies; Journaling spots: Jenni Bowlin Studio; Chipboard letters: Heidi Swapp; Ink: StāzOn (brown), Ranger (distress inks: Milk Can, Vintage Photo); Ink pens: Tsukineko/Impress (green, brown, blue, fuchsia, pink); Cloth-covered brads: K&Company/Amy Butler

The Bronze Elephant by Julie Kosolofski-Kuo

Julie's layout uses patterned paper with a bamboo print, which sets the tone for a Chinese-inspired layout. In this layout, Julie's daughter is riding an elephant, which, according to Chinese folklore, will bring good luck. The bamboo in Chinese culture, when used in art, means strength, perseverance and longevity. As a design element, while using a traditional Asian pattern, Julie was still able to coordinate the colors of the paper and her daughter's glasses.

Supply Credits Cardstock; Patterned paper: EK Success/ Over the Moon Press; Other: Handmade paper, brads, letter stickers

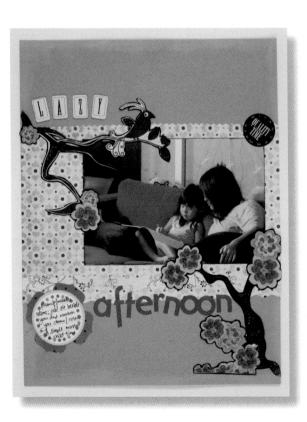

Lazy Afternoon by Jennie Yeo

Trees, branches and other botanical images have long been combined in the mystical lands associated with Chinoiserie. In this project, by hand cutting the trees, flowers and bird elements from the BasicGrey paper, Jennie mimicked a classic example of the use of botanical elements and birds common in the Chinoiserie wallpapers of the 1700s.

Supply Credits Cardstock: Bazzill; Patterned paper: BasicGrey, My Mind's Eye/Magnolia; Letter stickers: Arctic Frog (red), Junkitz (cream); Tag: Sassafras Lass; Sticker: 7Gypsies; Ink: StāzOn; Other: Inkssentials (crackle accents, sepia accents)

TIP Jennie used crackle accent on the branches to give the "trees" a more barklike appearance and more depth on the page.

Chahut by Odile Germaneau

Daisy D's used the Chinoiserie-style tree with flowers as
inspiration for the design of this contemporary patterned
paper. Though this paper is clearly an interpretation of
the motif, the basic style and layout—including the tree
and the shape of the flowers—give the strong impression
of the Chinese style.

Supply Credits Patterned paper: Daisy D's; Other: Rubber
stamps, brads, ribbon

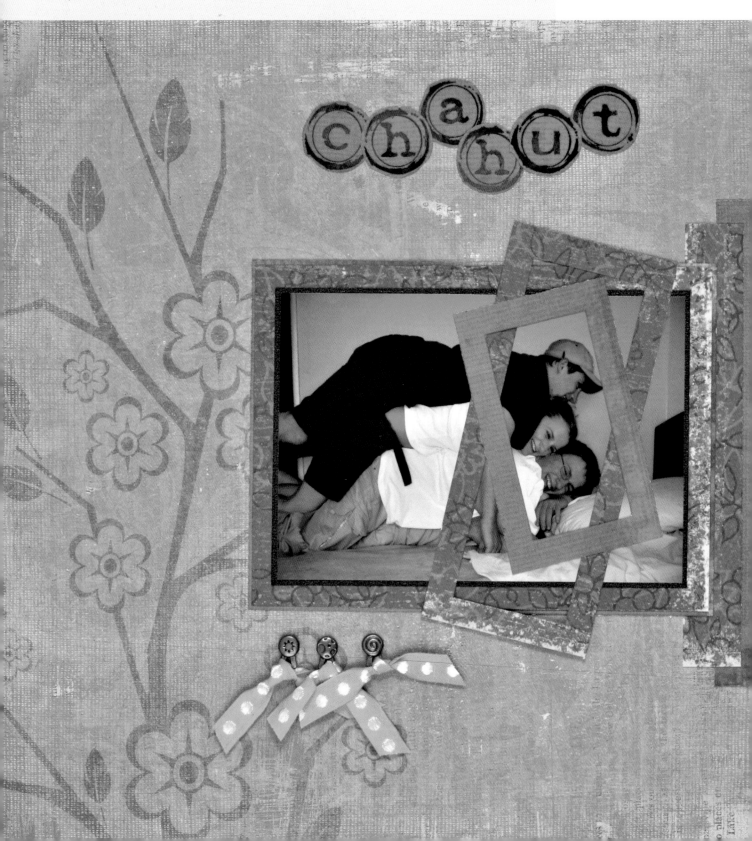

Eastern aesthetic lead to its popularity throughout the rest of Europe. Chinoiserie was so universally accepted from the late 1600s through the end of the 1700s that elements of the style could be found in homes as grand as Louis XV's Versailles as well as in the average home in colonial America. The Chinoiserie style is generally identified by the use of certain patterns and motifs, including stylized trees with birds and flowers, pavilions, dragons and phoenixes. And of course the use of bamboo as a background is a classic Chinoiserie technique. When these motifs are paired with traditional Chinese colors—combinations such as yellow and blue or yellow and red—the effect becomes even more striking. There are a number of products on the market today that can be used to create Chinoiserie-inspired layouts. By using rubber stamps, preprinted patterned paper and clip art images, you can transform an otherwise plain layout into one that is Chino-chic!

Source It!

A number of museums around the world have art works and decorative art objects in their collections that showcase the Chinoiserie style. Visits to permanent exhibits in the Freer-Sackler Museum at the Smithsonian in Washington DC, the Metropolitan Museum of Art in New York City and the Philadelphia Museum of Art all have regular exhibits of Chinese art and styles. In Europe, the Victoria and Albert Museum in England has one of the world's largest collections of Chinoiserie items as well as an online guide to the style. And, of course in Asia, the Sackler Museum at Beijing University, the National Museum in Taipei, Taiwan, and the National Museum in Bejing are excellent sources of inspiration! See the Resource Guide (pages 184-85) for links to online Web sites with chinese motifs.

Samurai, Sakura and the Royal Chrysanthemum
Design Elements from Japanese Family Crests

You know, scrapbooking is a pretty neat hobby by itself, but the interconnectedness of scrapbooking with other hobbies is, well, just kind of cool. My sister Trish and I are the genealogists for our family, and I love that I can take the family data and combine it with pictures to create our own unique personal history books. While researching my family ancestry, one of the great discoveries was that my family is descended from the British aristocracy. Okay, so the link is distant and my family has fallen, just a little, off the social register; but eighteen generations ago my ancestors had a family crest, and my children are able to see and appreciate the crest that belonged to their distant relatives some four hundred years ago.

Mon Card
by Brenda Marks
The *sakura mon*, or crest, is one of the most commonly identified of the Japanese mon and has become a national symbol in Japan. The *sakura*, or cherry blossom, is a national treasure in Japan, and the mon itself has been used to brand everything from pens to fish food. *Supply Credits* Patterned paper: Target/Paper Reflections; Punches: Carl Craft (Sakura punch, $1/2$-inch (12.5-mm) circle, 1 inch (2.5 cm) circle); Other: Cardstock, ink

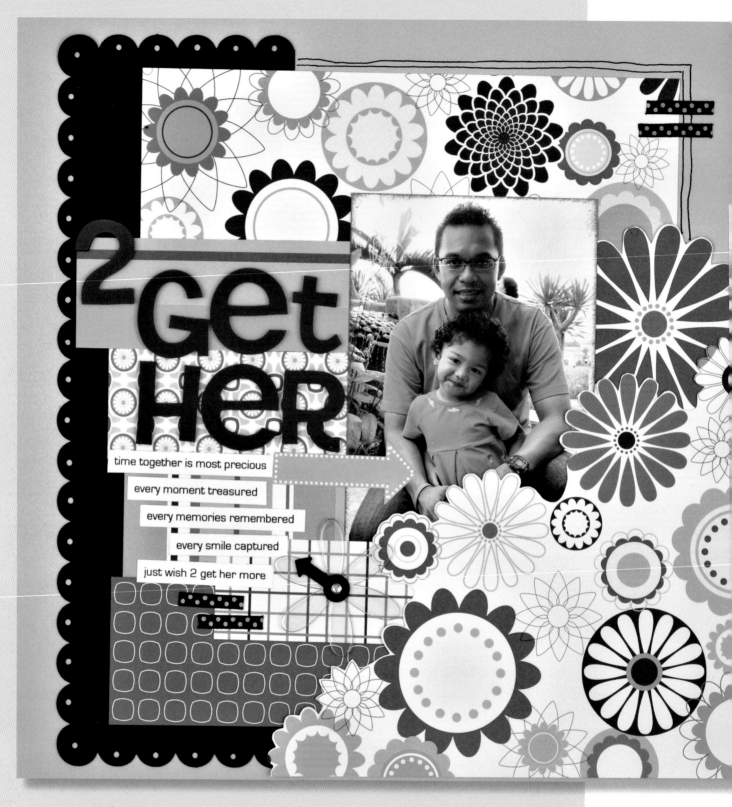

2 Get Her by Claudia Lim

Notice how these SEI papers use a chrysanthemum mon and have modernized it by using bright colors of orange, blues and pinks. The mon in this paper looks very different from those used in the layout called *This Is How U Do It* (page 43). Claudia was able to create a harmonious layout by using only papers from SEI, so she did not have to worry about finding colors that would work together. In this layout, the use of the black scalloped cardstock does a nice job of balancing out and grounding the patterned paper.

Supply Credits Cardstock: Bazzill; Patterned paper: SEI; Lettering: American Crafts; Ghost flower: Heidi Swapp; Photo anchor: 7gypsies; Brad: Making Memories; Arrow sticker: EK Success; Ribbon: made with love

This Is How U Do It by Claudia Lim

Claudia's layout features paper using the chrysanthemum mon designed by Sassafras Lass. Contrasted with the SEI paper, you can see the similar design, but these papers in light-colored pastels are cute and fun and I think represent the *kawaii* (cute) side of Japanese-inspired design.

Supply Credits Cardstock: Bazzill; Patterned paper: Sassafras Lass; Lettering: Heidi Swapp; Photo anchor: 7gypsies; Stars: American Crafts

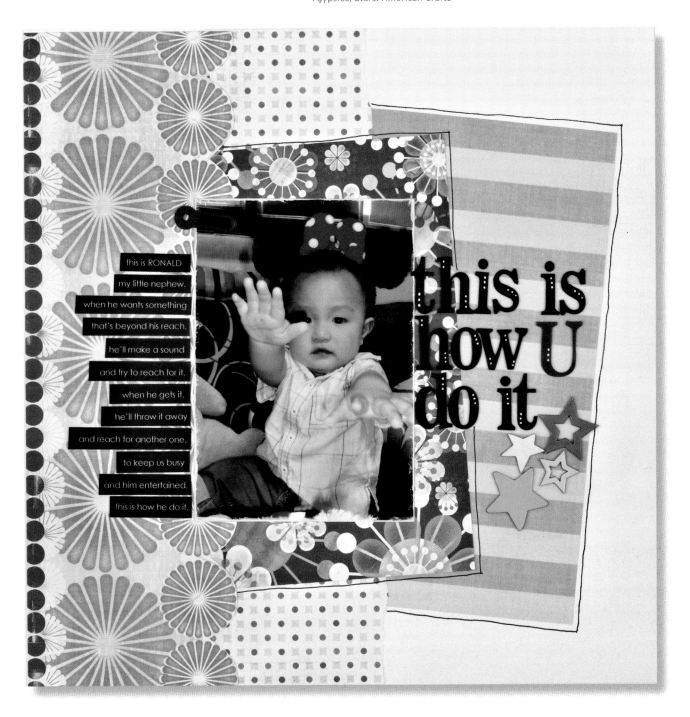

this is RONALD
my little nephew.
when he wants something
that's beyond his reach.
he'll make a sound
and try to reach for it.
when he gets it.
he'll throw it away
and reach for another one.
to keep us busy
and him entertained.
this is how he do it.

this is
how U
do it

While family crests were important throughout many parts of Asia, the kamon was especially important in Japanese culture and history (*ka* means "family" and *mon* means "crest" or "emblem" in Japanese). Originally, kamon(s) were used as family crests or emblems of different samurai clan. But, with the registration of the kamon(s) starting in the late 1600s, families began to use their mon to identify their own businesses, and the mon became known as trademarks for companies, goods and services.

Modern designers have a renewed interest in the traditional stylized designs of the crests, finding applications for them in modern interior, fabric and stationery design. In fact, these mon designs have found their way into a few major scrapbooking paper lines. I have noticed that at least three traditional mon patterns—the chrysanthemum, the sakura and the ume—are frequently used in today's scrapbooking designs. One of the most famous mon is a graphic interpretation of the chrysanthemum. The chrysanthemum mon design was originally used exclusively by the Japanese royal family. Over time the mon was modified and is now seen all over Japan—it is even featured on the front of the Japanese passport! Walking the aisles of the scrapbooking store, I have noticed that several scrapbook paper companies use a chrysanthemum mon design on lines of patterned paper. Once you start to recognize the mon, you will notice it appears everywhere. All of the projects in this section incorporate different mon, either via preprinted images or rubber stamps.

Arabesques, Vines, Flowers and Jewels
Indo-Persian Motifs

India is a big country, much bigger than people imagine. India has artistic traditions that are thousands of years old, a population of more than a billion people and more than four hundred

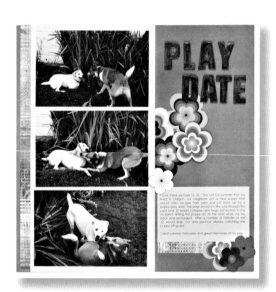

Play Date by Kristy Harris
The Chester line of scrapbook paper, which was licensed from the fashion accessory company by My Mind's Eye, takes a great deal of inspiration from Japanese floral mon designs. The floral ume designs (the plum blossom symbolizes long life in Chinese culture) is a perfect accent to a layout honoring the memory of my fun-loving, long-lived dog.
Supply Credits Cardstock: Bazzill, WorldWin; Patterned paper: me & my BIG Ideas/Chester, BasicGrey; Letter stickers: American Crafts/Thickers; Ink: ColorBox (violet); Other: Glossy accents

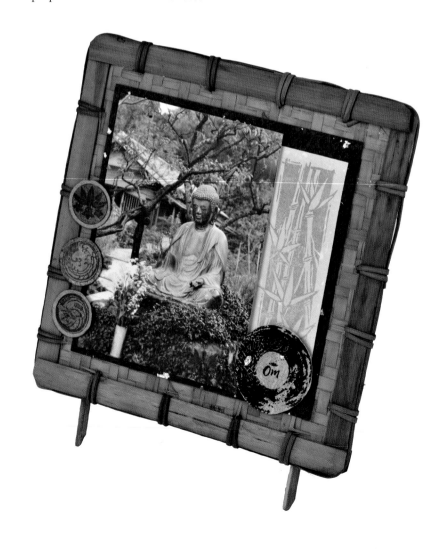

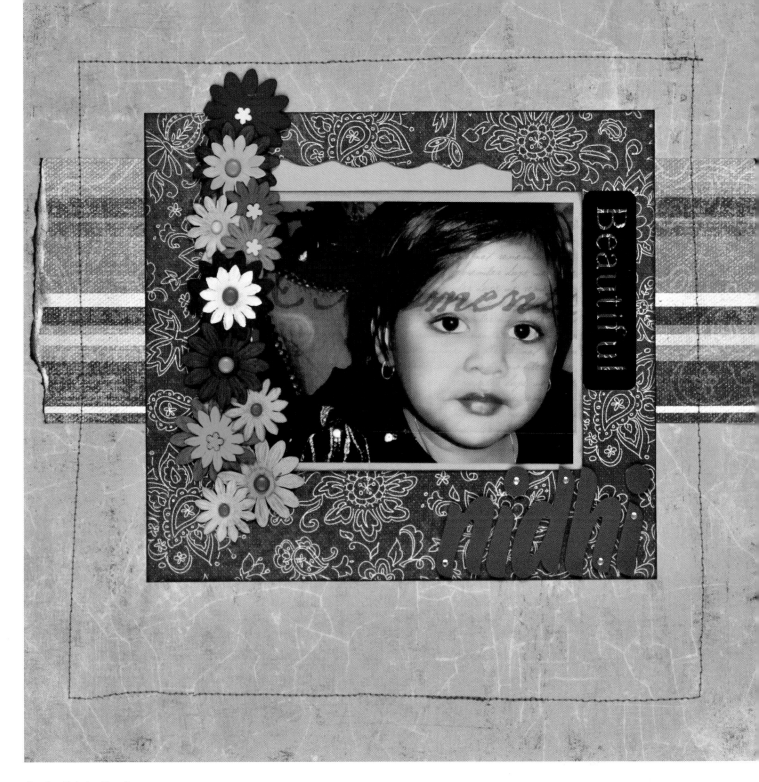

Om by Kristy Harris

Mon can be inspired by flora, botany, geometry or nature. This project, shown on page 44, uses botanical-inspired mon to represent the connection between the outdoors and the statue of the Buddha. This picture, taken in a Japanese temple, is representative of the Japanese connection between earth and religion. While the mon used in this layout do not have specific symbolic meanings, all represent specific Japanese plants. Kamon, when used as a family crest of a specific clan, would often represent an element that connected the family, either by place or by item. Therefore, you will see common kamon as interpretations of plants native to certain locations or representations of certain elements of nature.

Supply Credits Bamboo photo frame: Daisy D's; Patterned paper: Provo Craft; Handmade paper: FancyPaper.ca; Washi paper: Grimm Hobby/Ginburi Momigami; Rubber stamps: Art Neko (mon), Hero Arts (om) Stampendous (bamboo), and other; Ink: StäzOn (black), VersaColor (evergreen), Ranger (distress ink: Vintage Photo, Milk Can, light green); Other: Punches, glue dots

Nidhi by Sasha Farina

The brown patterned paper features floral and paisley motifs that are common elements in Indo-Persian design. The paisley pattern, while originating in India, became a common design element in the rest of the world after being featured in women's shawls manufactured in the 1800s in England.

Supply Credits Cardstock: Bazzill; Patterned papers: Flair Designs (brown), BasicGrey; Brads: Making Memories; Rub-ons: Urban Lily; Flowers: Prima; Overlay: Daisy D's; Letters: American Crafts/Thickers; Bling

Warhammer

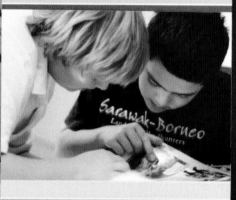

happiness: To be dissolved into something comple

ng about something. We grOw g

ut I can look up and see their beauty, believe in them, and

a weekend of Warhammer - model making and battles with Josh 6/06

he edge. Listen hard. Practice wellness. Play with abandon. Laugh. Choose with no regret. Continue to learn. Appreciate your friends. Do wha

Warhammer by Lynita Chin

The double-sided patterned paper from imaginisce has a light arabesque pattern on one side and a simple repeated pattern on the other. Lynita used both sides of this paper and combined it with a striped patterned paper in complementary colors. I find that patterned papers with natural elements, such as the vine in an arabesque pattern, combine well with geometric patterns. Notice how Lynita used brads to lead into the title of the layout, taking the design element from the patterned paper.

Supply Credits Cardstock: Bazzill; Patterned papers: DMD, imaginisce; Chipboard alphabet: Heidi Swapp; Other: Brads

***The Baoli* by Wendy Steward**

The BasicGrey paper Wendy used in this layout could have been designed during the Mughal era! The use of the vine arabesque on the tan patterned paper and the leaf motifs on the blue patterned paper are classic Indo-Persian-inspired design motifs. The use of these papers and the faux Hindi font used for the title immediately tell you that the buildings in the photographs are in India, even before reading the journaling.
Supply Credits Cardstock: Bazzill; Patterned paper: BasicGrey (Motifica); Font: Samarkan (downloaded from the Internet); Ribbon: Strano Designs; Other: Brads (brown)

this is a stepwell built in the 14th or 15th century. it was built by raja ugrasen, an ancestor of the merchant community, to provide water and shelter for travellers to delhi.
this ancient ruin was in the next street to ours (mind blowing huh). there are high rises all around it and modern homes.
i spent many many days playing here on the steps leading to the water and in the shady courtyard at the top of the stairs. i think my fascination to water started here. there is a tiny mosque on one corner at the top of the stairs.

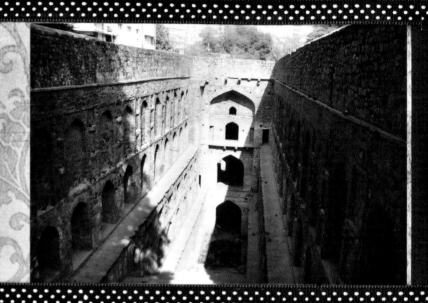

the baoli

we were not allowed to come here without an adult and even then only on rare occasions. needless to say i sneaked off here with my servants kids whenever i could and always managed to twist my servants arm to take me here. to and from school or tuition or anytime we were passing by. i always got into trouble. but i just loved this place and came here whenever i could find a way.
a very dear friend of my granny's. aunty pat lived in this street and going to visit her meant a trip to the baoli for sure.
i have visited the baoli every trip back to delhi and was thrilled to see that it has been maintained and preserved.

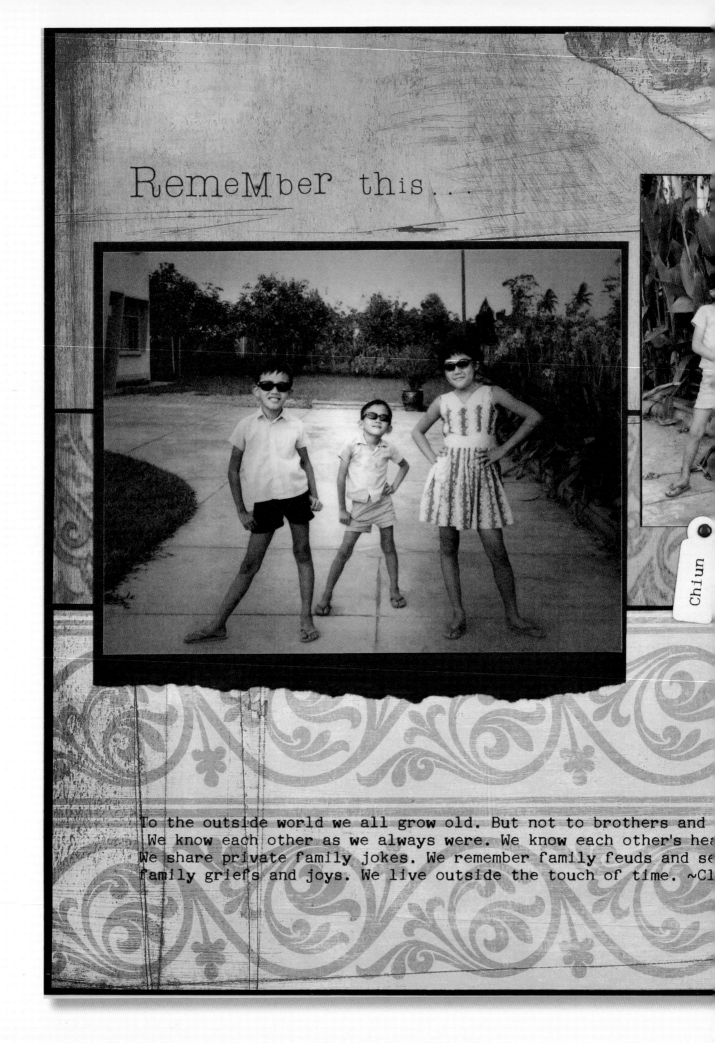

RemeMber this...

Chiun

To the outside world we all grow old. But not to brothers and
We know each other as we always were. We know each other's hea
We share private family jokes. We remember family feuds and se
family griefs and joys. We live outside the touch of time. ~Cl

Trike a Pose
by Selena Hickey

The damask motif originated in Damascus around the same time as many of the Mughal elements and is very closely related to Indo-Persian design. This paper contains arabesque leaf forms that are similar to what might appear in a Mughal design. Here, the foliate motifs on this paper by BasicGrey seem to curve right around the picture, framing the adorable picture of Selena's son on a tricycle. *Supply Credits* Cardstock: Bazzill; Patterned paper: BasicGrey; Chipboard letters, punctuation: Lil Davis Designs; Acrylic paint: Making Memories; Rub-ons: American Crafts; Other: Flowers, big brad, stickers

Remember This
by Lynita Chin

Using patterned paper that features an Indian-inspired floral arabesque pattern, Lynita created a heritage layout that includes pictures from her husband's childhood. Lynita has coupled the old black-and-white photos with patterned papers that evoke the cultural heritage of Sarawak Malaysia in the 1960s. *Supply Credits* Cardstock: Bazzill; Patterned paper: BasicGrey; Tags; Brads: Making Memories; Bookplate; Rub-ons: Chatterbox

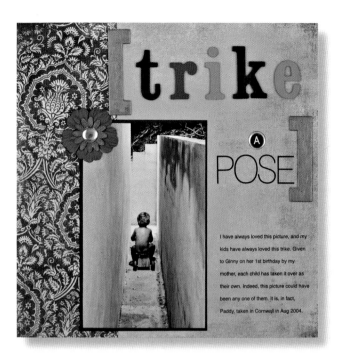

known languages. The country is filled with a multitude of different peoples and cultures, and of course the artistic influences of the country are huge. One of the most recognizable artistic/design movements to come from India is the Indo-Persian, or Mughal, style. William Morris, the father of the arts and crafts movement in England, was strongly influenced by Mughal design. Its graceful floral motifs and the arabesques common in the Indian style became common themes in Morris's tapestries and carpet designs and even in his stained glass work.

The Taj Mahal, arguably the most famous monument in India, was built in the late 1600s during the era of Mughals as a testament of love by the Shah Jahan for his late wife. The Taj is the perfect example of Mughal architecture and design. The carved marble building features floral motifs, vines and carved inscriptions from the Koran; and the intricate flower motifs are inlaid with precious and semiprecious stones. The use of certain flowers in the decorative details, such as roses, were seen as symbols of the kingdom of Allah while the carved vases filled with fruits and grapes were a representation of the bounty of Paradise.

The use of the floral motifs and geometric designs as well as graceful arabesque vines that originated during the Mughal era became the inspiration for much of Western art in the nineteenth century as a result of colonization. As mentioned above, the arts and crafts movement gained a great deal of inspiration from the Indo-

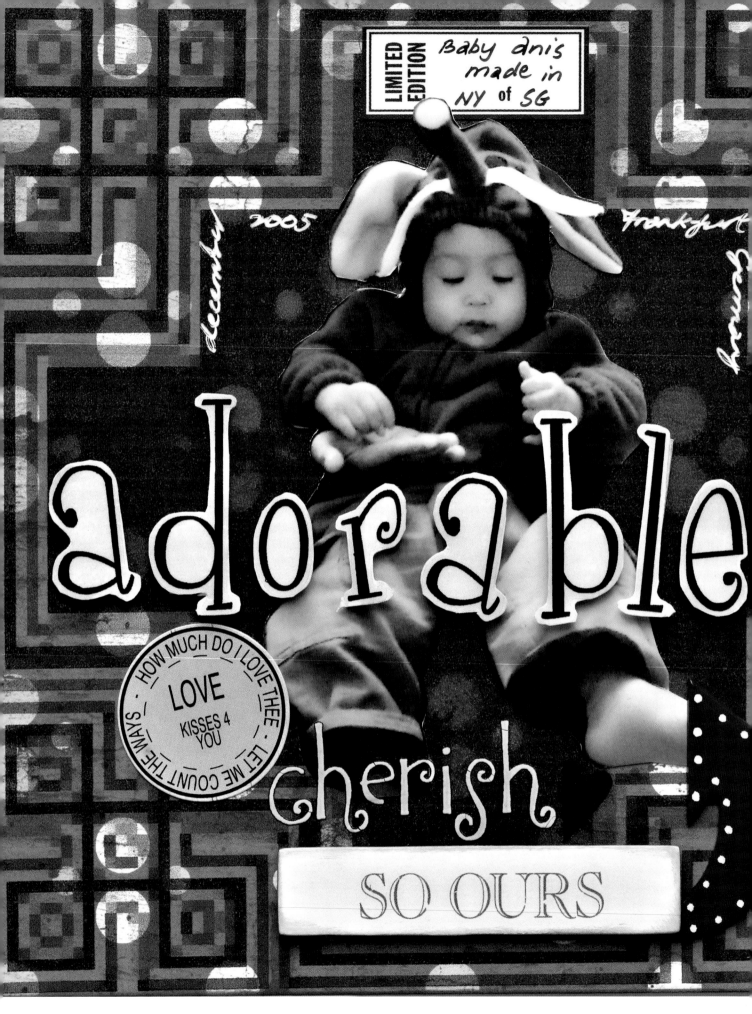

LIMITED EDITION

Baby ani's made in NY of SG

december 2005

Frankfurt January

adorable

HOW MUCH DO I LOVE THEE · LET ME COUNT THE WAYS ·
LOVE
KISSES 4 YOU

cherish

SO OURS

Adorable A by Edleen Maryam
In this hybrid digital-and-traditional scrapbook layout, Edleen took inspiration from Islamic and Chinese geometric deigns. Edleen created her own patterned paper with royalty-free clip art on the Internet and by coloring the design in Photoshop.
Supply Credits Patterned paper: Artist's own, created from clip art downloaded from the Internet; Stamp: 7gypsies: Stickers: Doodlebug Design Inc. (letters), 7gypsies (words); Other: Photoshop

TIP Brenda Marks, one of the contributors in this book, shared a great tip with me about cutting geometrically patterned paper. If you cut by eye you will almost always end up with crooked pieces. This is because your eyes tend to play tricks and try to compensate for different angles. To cut straight lines and clean angles every time, use a grid mat and clear ruler!

Source It!

Using Asian-inspired geometric designs in your scrapbooks can include either Islamic-based circles and stars or Chinese lattice screens. Additionally, the use of Japanese chiyogami and washi papers with geometric patterns would add a certain flair to your pages that is uniquely Asian.

Persian arts, and it was not uncommon to see artists from Europe traveling to India in the nineteenth century to soak up the beauty and return home with suitcases filled with watercolors and sketches of inspired motif work.

Lattice, Circles, Squares and Angles
Taking Inspiration from Asian Geometric Designs

First, I have a little secret; I hated, despised and abhorred geometry in school. I saw little application to real life; and besides, I am sure my math teacher hated me. I still don't quite understand the concepts of angles and circumference and how to determine the area of a triangle. In fact, my general opposition to all things geometrical still exists today, and I cringe at the thought of having to tutor my children someday. That being said, after I opened my eyes to design elements in Asia, I realized that I was surrounded by geometric patterns. From the lattice screens used by the Chinese to the patterns of intersected circles found on antique floor tiles from Malacca, geometry is everywhere. Living in Asia may just force me to change my mind about all of the geometry lessons I so hated.

In China and Japan lattices are used as doors, screens and windows, and I like the idea of using this element in scrapbook layouts. Lattice designs use geometric shapes, usually squares and rectangles in repeating joined patterns. Most Islamic geometric art is based on the use of patterns that all radiate from a circle. The circle, in Islamic design, represents creation; and it is the intention of the artist to portray that all of life radiates from that point. Using a compass, the designer starts with a single circle and draws additional intersecting circles. From this design base, stars, floral interpretations and other patterns could be created.

Geometric designs are as much a part of Asia as the paisley is linked to India. The use of a geometric design found in Asia–whether a hand-cut lattice or patterned paper inspired by intersecting circles– lends an Asian flair to your page with a simple design-driven style.

Cousins by Avina Lim

Geometric patterns, such as this Japanese-inspired design based on the geometric interpretation of a Japanese floral mon, can easily overwhelm a layout. However, when partnered with floral or other botanical elements, the geometric pattern is softened, making it friendly on the eye. Avina used coordinating floral papers from the same manufacturer to add a feminine touch to this layout.

Supply Credits Cardstock; Patterned papers: Kodomo; Letters: American Crafts/Thickers; Ribbon; Other: Inkssentials (glossy accents), foam dots

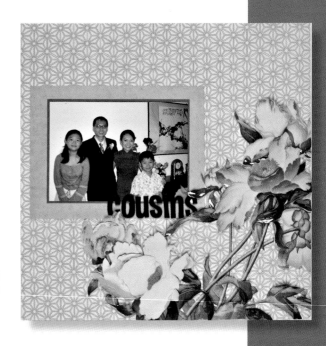

Remember by Lynita Chin

Lynita created a faux lattice border by stamping the edges of the paper with a stamp by Maya Road. The background paper by DCWV contained a number of Chinese characters that Lynita did not want as a design element in her layout. To keep the color scheme and continue to use the patterned paper with elements that matched the mood she was trying to create, she covered the characters with stamping or creative embellishments.

Supply Credits Patterned paper: DCWV/ Far East Collection, Fancy Pants Designs; Chipboard circle: Urban Lily; Rub-on: Making Memories; Definition stickers: Making Memories; Stamps: Maya Road/Fresh Stamps; Ink: Archival ink (plum)

TIP When using papers with Asian characters, if you aren't sure about the meaning of Asian characters on your patterned paper or don't like the way they look, don't be afraid to cover the characters, distress them or otherwise disguise the design.

You by Lynita Chin

Lynita highlighted the Asian feel of these patterned papers by combining them with Asian colors, accenting in red and using other Asian elements. Note the use of the Asian-inspired red accents (the red bamboo sticker), the red acrylic letters and a red chop (stamp) in the corner. (The chop, an Asian stamp, is used in China, Taiwan and Korea as an official signature, and in this case the chop is a stamp of the last name Chin in Chinese.)

Supply Credits Patterned papers: BasicGrey; Ghost alphabet: Heidi Swapp; Chipboard alphabet: Heidi Swapp; Sticker: Creative Imaginations; Square decorative brad: Making Memories; Ink: Sepia archival ink; Stamps: Stamp Craft, traditional Chinese chop; Ink: Chinese red; Tag; Other: fiber, buttons

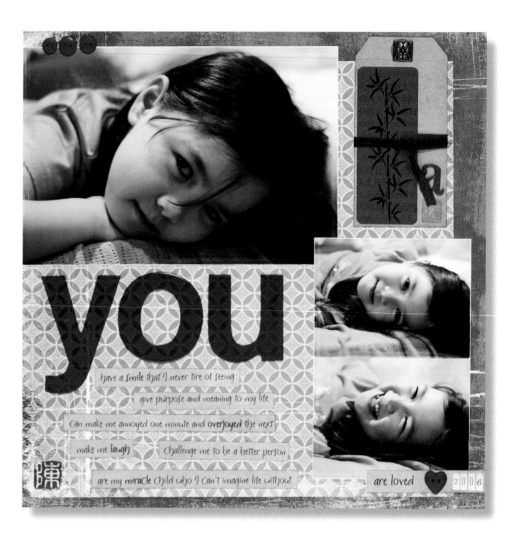

Plants and Mythical Beasts
Motifs from Asian Life and Lore

Flowers and plants have long been used as a way of conveying messages. In the West, red roses have traditionally meant romantic love, while sunflowers convey deep affection. You may not know that the original meaning of mistletoe hanging from the rafters at Christmas was one of affection, but you probably still equate it with that stolen kiss from someone you like. Using botanical items as a method of communication has become second nature in everyday life—whether you live in Cambridge, England, or Tokyo. The English love the rose, the French love the lavender plant and the Japanese hold the delicate sakura in such esteem that it has become a national symbol. The Chinese place specific meanings on plants and use these plants in decorative details and in their homes to create luck, and Islamic artists use flowers and

plants to convey meanings in artistic works as well.

Certain botanical motifs are synonymous with Asia. Bamboo, for example, has long been identified with China and symbolizes longevity and strength. The chrysanthemum means long life in Japan and forever in China. The Chinese gourd (*hulu*) is the same shape as the number eight; and because the word *eight* in Chinese a homonym for *long life*, the hulu is a symbol of longevity. The lotus is a common symbol in Asian art: It symbolizes birth and rebirth because it opens and closes with the sun. The lotus also represents fertility, creation and purity. Peonies denote wealth and abundance, and when in bloom the Chinese attach meanings of love and affection to them. Pine trees and boughs represent long life as well as endurance and hardiness. The cherry blossom, called the sakura in Japan, has gained a universal appeal and has come to be recognized as a symbol of the fleeting nature of spring. And the plum (*ume* in Japanese and *mei*

Lac Inle 1
by Odile Germaneau
A simple layout is all that is needed to highlight these pictures taken of a Burmese temple. The use of this Turkish/Ottoman-inspired flower works well with this layout because the blues in the flowers complement the sky and the yellow background highlights the golden roof and idols.
Supply Credits Cardstock: Bazzill; Patterned paper: BasicGrey

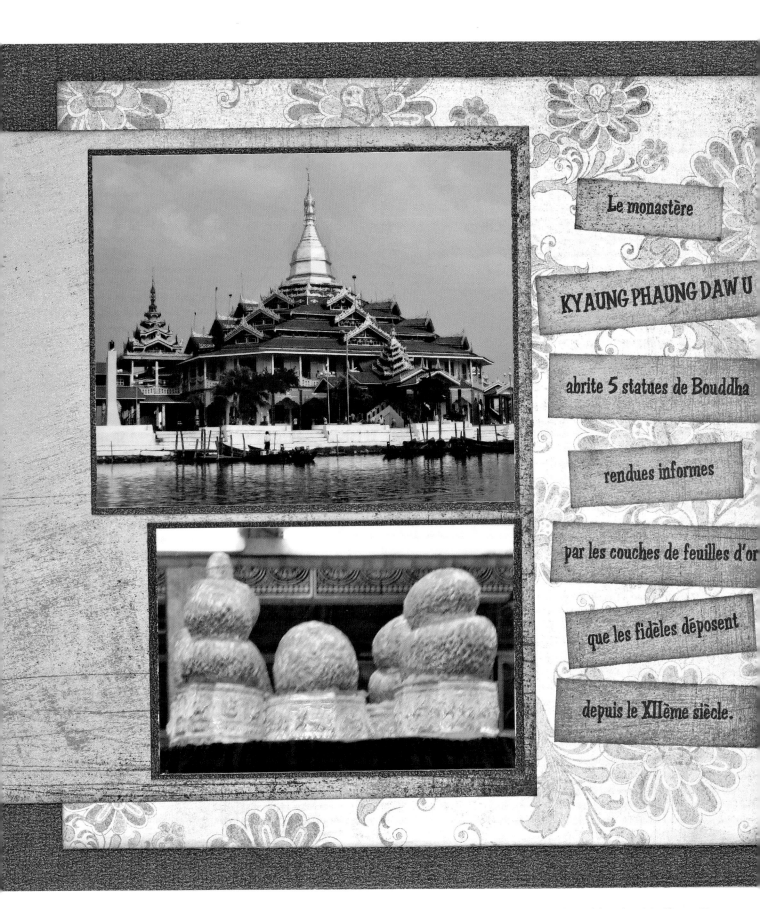

Le monastère

KYAUNG PHAUNG DAW U

abrite 5 statues de Bouddha

rendues informes

par les couches de feuilles d'or

que les fidèles déposent

depuis le XIIème siècle.

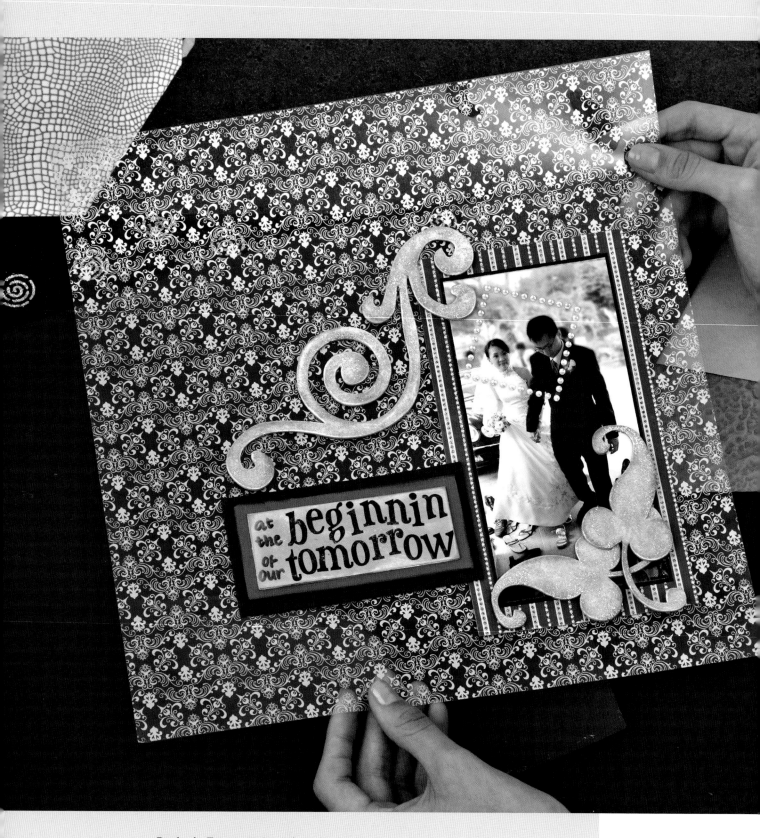

Beginnin Tomorrow by Avina Lim

Avina has placed a botanical element in the lower right-hand portion of this layout to draw your eye to the focal point—the picture of her wedding day.

Supply Credits Transparency: Hambly Studios; Chipboard shapes: Maya Road

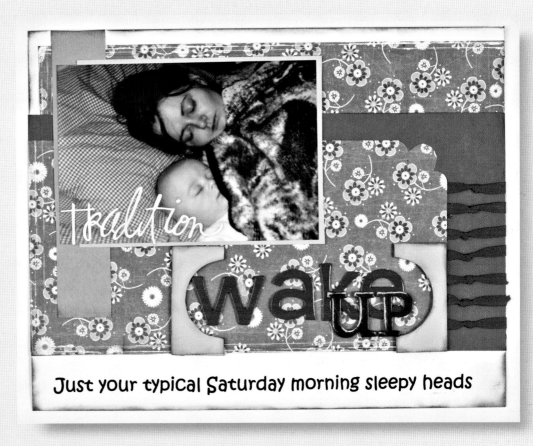

tradition

wake up

Just your typical Saturday morning sleepy heads

Wake Up by Andrea Blair

The pattern on the paper in this layout was inspired by Japanese floral designs. Andrea converted the photograph to black-and-white so that the colors in the photograph don't compete with the colors of the patterned paper.

Supply Credits Cardstock: Bazzill; Patterned paper: Crate Paper; Rub-ons: Making Memories; Letters: Scenic Route (wake), Heidi Swapp (up); Chipboard brackets: Scenic Route; Ribbon: Offray

in Chinese), because it blooms in winter, is seen as an example of perseverance in the face of adversity; and mainland Chinese see the plum blossom as a symbol of revolutionary struggle.

Animals, fantastic and real, are also common reoccurring themes in Asian art. The dragon—one of the most frequently used symbols in Asian art—symbolizes strength. When the dragon is partnered with the phoenix, the image represents a happy and harmonious union. This combination, as well as the use of a pair of mandarin ducks (which mate for life), are often used as decorations for Chinese weddings, embellishing wedding gifts and stationery around Asia. There are many other animal motifs in Asia. For example, the bat represents good luck, the goldfish wealth and prosperity; and both the crane and tortoise represent longevity.

Joy by Avina Lim

Asian-inspired patterns is a hallmark of BasicGrey paper designs. In this layout, Avina creates depth and definition by cutting out the elements. The flowers, featuring Asian flowers such as the mum, and bright, tropically inspired colors create a visual bouquet in her layout.
Supply Credits Patterned paper: BasicGrey; Charm: 7gypsies; Brads: Making Memories: Other: Foam dots

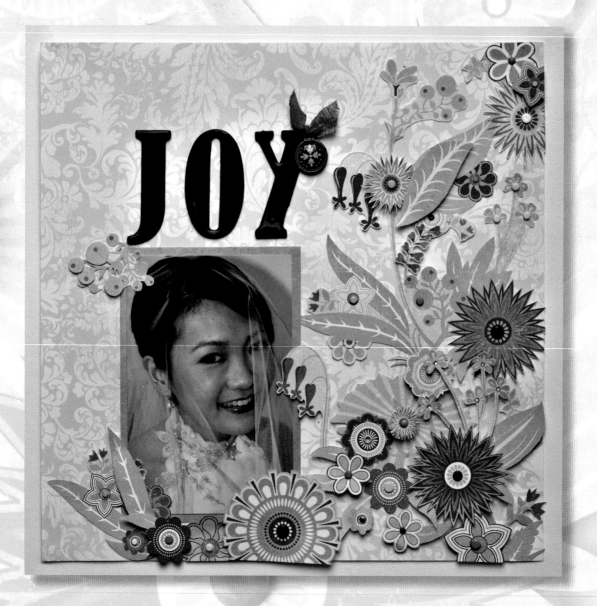

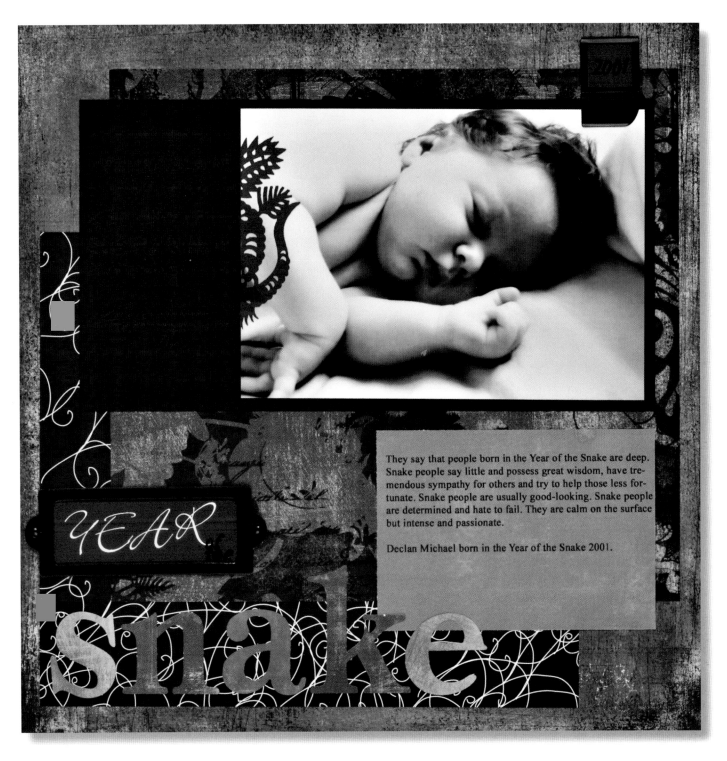

They say that people born in the Year of the Snake are deep. Snake people say little and possess great wisdom, have tremendous sympathy for others and try to help those less fortunate. Snake people are usually good-looking. Snake people are determined and hate to fail. They are calm on the surface but intense and passionate.

Declan Michael born in the Year of the Snake 2001.

YEAR

snake

Year of the Snake by Kristy Harris

Each of the twelve zodiac animals in the Chinese horoscope have certain characteristics attributed to them. People born in the year of the Snake are bright, hardworking and quiet (as they soak up information) and of course can be nasty if crossed. I wanted to do a layout of the zodiac animal that was connected to the year of my son's birth. To keep within the theme of a Chinese zodiac, I chose red and black as my color scheme. This simple layout was fairly quick to assemble once I picked all of my embellishments and paper that met my color requirements.

Supply Credits Cardstock: Die Cuts With A View; Patterned paper: BasicGrey (gray, red pattern), Luxe Designs (black-and-white); Die cut letters: BasicGrey; Rub-ons: Making Memories (white), DECAdry (black); Chipboard bookplate: Heidi Swapp; Metal index tab: 7gypsies; Other: Paper cut snake

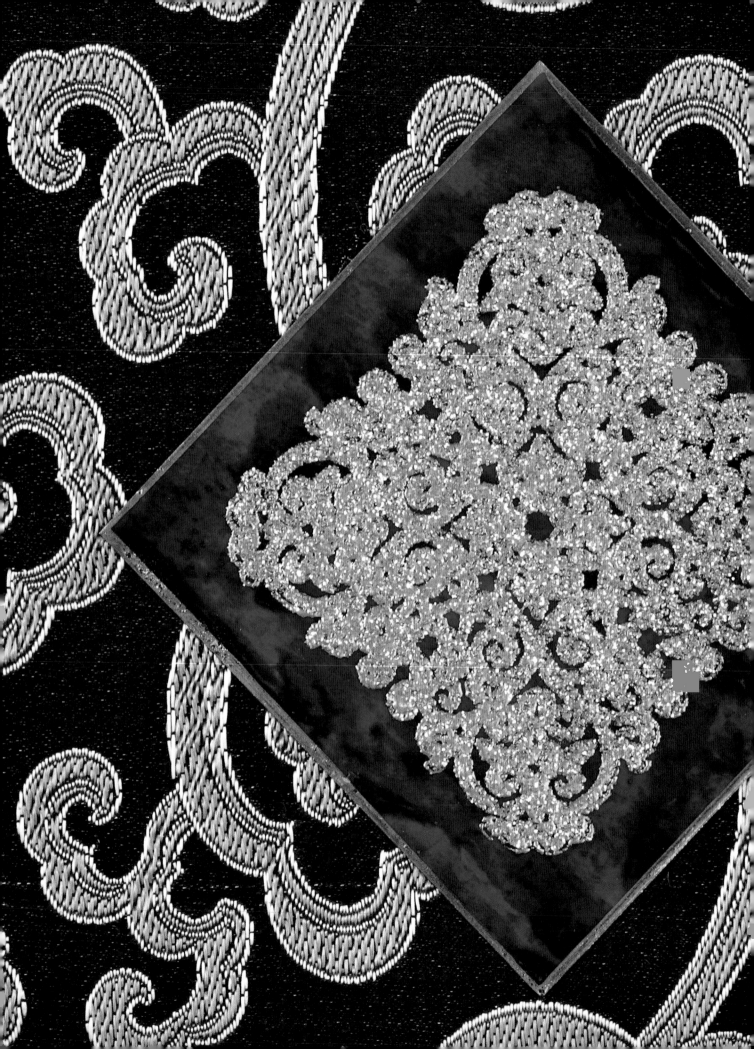

Exploring the Beautiful World of Asian Fabrics

Chinese Blues (detail) **by Heather Taylor**

Heather used a rubber stamp to create the centerpiece that complements the silk brocade fabric on this card. To make the blue background, Heather added blue calligraphy ink to a piece of white glossy cardstock with a brayer. She finished the embellishment by stamping a gold lattice design and embossing with Ranger embossing tinsel using a heat gun. Heather's treatment works well with the heavy weight of the pattern in the material.

Supply Credits Stamp: About Art Accents (lattice); Ink: VersaMark (blue calligraphy ink); Cougar white cardstock; Gold embossing tinsel: Ranger; Pen: Krylon (gold); Other: Silk fabric, cardboard

From Silks to Cottons and Beyond

Marco Polo's travels across the vast Asian continent were, in part, driven by the desire for the beautiful fabrics of Asia. Countless stories have been told of traders who acquired silks from China, printed fabrics from India, batiks from Indonesia and raw silks from Thailand. The heroes of these stories, like Marco Polo, were often real people who have now become the basis for legends—exaggerated tales of travels by brave and daring souls to distant lands in search of exotic wares. Now, while I enjoy an excuse to travel as much as the next person, the good news is that you don't have to travel farther than your local fabric or craft store to find a plethora of beautiful fabrics. Silks can be found at any fabric store, batiks—real and printed copies—are readily accessible at quilt stores and even sari fabric can be found in the ethic sections of major cities. And of course everything can be bought online!

As a scrapbooker, reformed quilter and textile lover, I think fabric is a wonderful medium for crafts. It is flexible, has a wonderful texture and is safe, in most cases, for use in even your most delicate and archival scrapbook projects. When I need a bit of a creative boost, I love to walk through the fabric markets of the cities I travel to: Shanghai, Taipei, Singapore and Bangkok. Each has beautiful and amazing fabric markets. Just walking through row after row of vibrant colors fills my creative well. I touch the silks and linens, look at the patterns of the printed cottons and admire dozen upon dozen of buttons and baubles. As soon as I return home I am ready to craft, to take those bits and pieces of fabric that I have collected from around the world and make beautiful items with them.

Jaipur
by Wendy Steward
The paisley pattern, originally developed in India, became famous worldwide after it was mass-produced for women's wear in Paisley, England. The use of the paisley patterns in this layout about a fabric market in Jaipur, India, is culturally as well as decoratively appropriate.
Supply Credits Cardstock: Bazzill; Patterned paper: Debbie Overton Designs; Alphabet stickers: Creative Memories; Alphabet stamps: Pixie Designs; Other: Creative Memories (hexagon-shaped cutter)

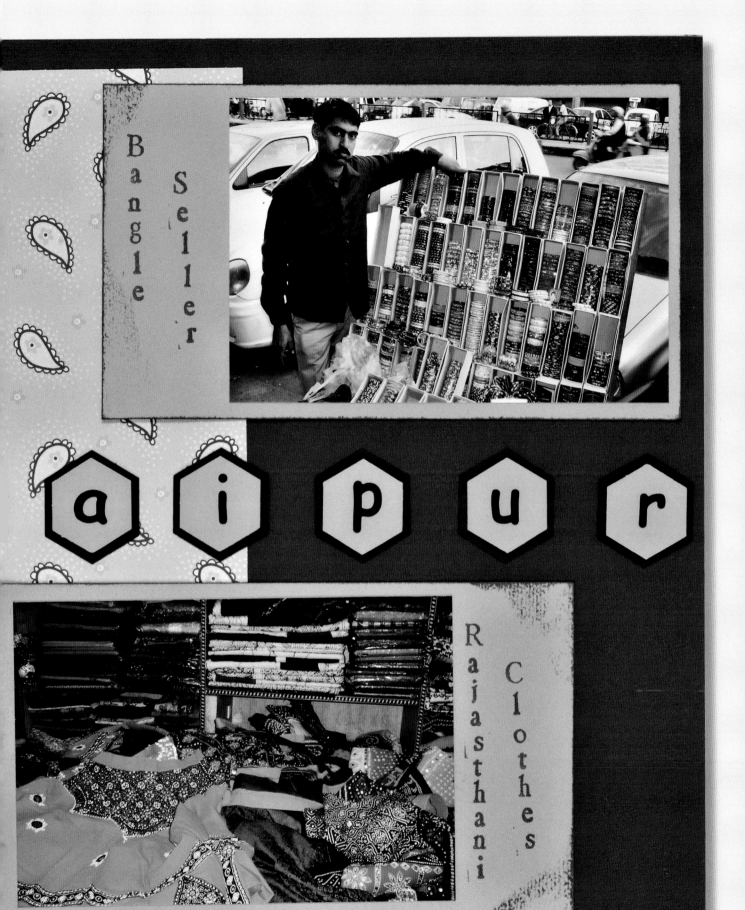

Bangle Seller

aipur

Rajasthani Clothes

MY

paradise found

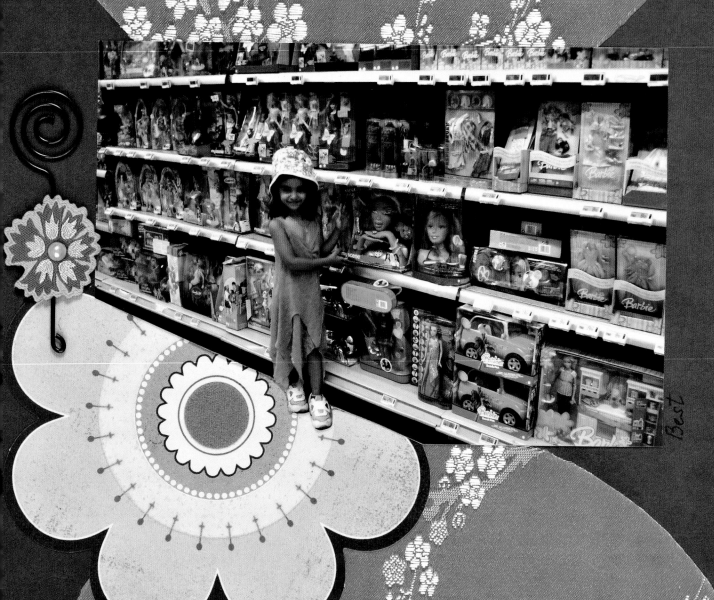

Best

Before we dig into how to use Asian fabrics in scrapbook projects, let's discuss ways of attaching fabric and fabric embellishments to the layouts. If you've never used fabric in your scrapbook layouts, the thought of using it might be a bit overwhelming. Don't worry, though; the good news is that when scrapbooking traditional layouts, generally what works for paper will work for fabric. You can simply attach fabric with glue or by using brads and eyelets, or double-sided tape. Each method may take a bit of experimentation to see what works the best with the type of fabric you are using. (One of my favorite ways to attach fabric is with a machine called Xyron 500 "Create a Sticker." Any model this size or larger will work.) I run the fabric through the machine, peel off the back and attach it like a giant sticker! I also use glue sticks, tape runners and liquid glues. Be moderate at first when using liquid glues because a little goes a long way. Even fabric glues can be a bit tricky because the glue will often seep through the fabric. Use test strips first to see if the glue shows through the fabric you are using. Then apply the liquid glue to the paper and let it dry a bit and become tacky before you glue the fabric down. Of course, fabric also can be attached with pins and by other traditional sewing techniques such as hand or machine stitching.

Using fabric is a unique, tactile way of expanding your crafting supplies in a relatively inexpensive way. Fabric looks great, feels wonderful and is just plain fun. In this chapter we will explore using silks and ribbons from China, India and Thailand, batiks from Southeast Asia and Indian sari fabrics. We will also look at some gorgeous projects using woven Japanese cotton fabrics with amazing prints. Using fabric in your scrapbook projects allows you the flexibility to create one-of-a-kind embellishments that are dimensional yet won't scratch or harm your pictures. Plus, frankly, as a crafter, I just love working with fabric and combining the two mediums. So let's explore some Asian fabrics and how we can use them in your paper crafts.

My Paradise Found
by Nishi Varshnei
Brown cardstock works well as a base for this girly layout done by Nishi. The half circles of pink silk act as a frame for the picture of her daughter, and the creative cropping of the photograph gives the optical illusion of the row of toys continuing on and on. The silk used here is a fine brocade with a lovely floral pattern.
Supply Credits Flocked flower: My Mind's Eye; Floral photo clip: K&Company/Amy Butler; Rub-ons: Making Memories; Chipboard letters: Provo Craft/Alphaletterz; Other: Cardstock, silk fabric

Marco Polo's Quest
The Beauty of Asian Silks

The Chinese were the first to perfect the art of making silk fabric, and they kept this skill as a closely held secret for a couple of thousand years. Prior to the Han Dynasty, which began around 200 BC, silk was limited to use for the royal family. But thereafter the skill was released to the Chinese public, and China became well known for its silk. Before long silk became a popular fabric and a valuable commodity for global trade. Once the news got out about the luxurious fabric that was smooth to the touch and kept you cool in summer and warm in winter, the value and allure of silk was heralded by travelers across the great Gobi Desert to the rest of the world. To this day silk is one of the most sought after types of fabrics in the world.

There are a number of types of silk, from fine sheer Chinese silk to rich textural raw silk from India and Thailand. The sheer silks make wonderful clothing and ribbons and of course light-weight embellishments for your scrapbook pages. The raw silks from India and Thailand are slightly nubby with imperfections in the fabric and are great textural materials to work with. Raw silks, which are commonly used in home décor, make great backgrounds for scrapbooks. One of my favorite types of material is the beautiful silk brocades from China and Japan that have delicate patterns woven into the bright, vivid silks.

Thankful Book
by Nishi Varshnei

This raw silk fabric from India makes a great cover to a minibook of special pictures. The raw silk has been woven with couched thread to create a pattern of squares. Nishi used double-sided tape to attach the edges of the fabric underneath the mat to avoid fraying, and she used stitching to attach the fabric to the overall book. The advantage of using fabric to cover this book is that Nishi was able to sew the embellishments directly onto the fabric before she attached the fabric to the book cover. This gives the book cover a much more finished appearance, and she didn't have any loose threads or ends that she needed to cover on the inside cover of the book. *Supply Credits* Fabric: Far Flung Craft; Minibook: Making Memories; Other: Thread, white cardstock

Source It!

Silk brocade fabrics give an air of luxury to any project—whether you're stamping or scrapbooking, or even creating a sewing project. This touch of luxury is readily available in most fabric stores.

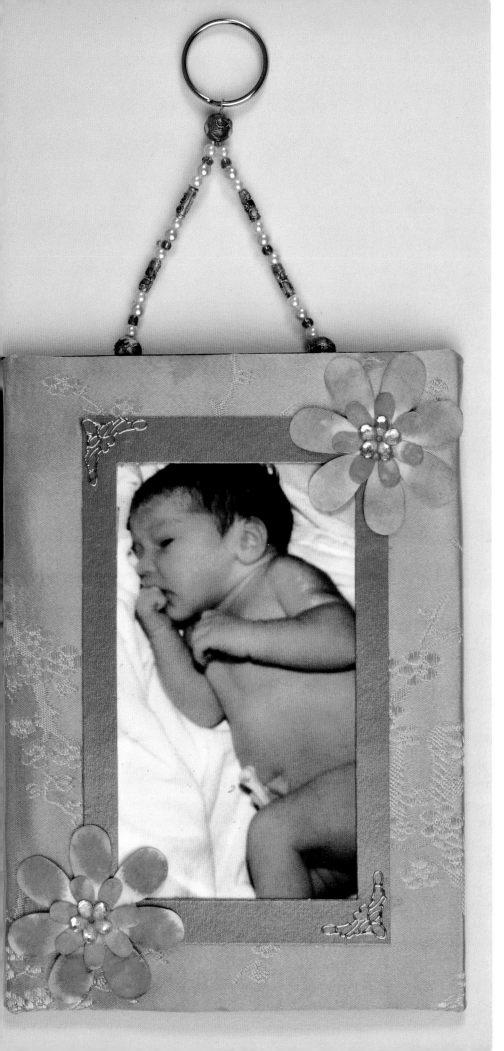

Silk Frame by Ann Pennington

Silk frames are all the rage and can cost a pretty penny when you purchase them in a home décor shop. The good news is that they are fun and inexpensive to make yourself, and more importantly, you can embellish them to match your existing interior design. To make the frame, attach batting to one sheet of cardstock using double-sided tape. Place the silk on top of the batting and fold the edges around to the back of the cardstock, then secure in place with double-sided tape or glue. Attach the second piece of cardstock to the back of the frame with strong double-sided tape to finish the back side. This frame is embellished with paper flowers, gemstones and cloisonné beads strung on jewelry wire.

Supply Credits Cardboard or heavy cardstock; Silk fabric; Quilt batting; Paper flowers, gemstones, peel-off corners: www.stampattack.co.uk; Beads, pearls, seed beads, Oriental cloisonné beads, Tigertail Jewelry wire: eBay; 1-inch (2.5-cm) split ring

TIP Brocade fabrics such as the one used in this project tend to unravel easily. You can use the frayed edges as an element in your design; but if you want the edges to remain smooth, I recommend the use of a product such as Strano Designs Ribbon Stiff, which is applied to the fabric edge (or ribbon) and allowed to dry. Once the product is dry the fabric will no longer fray. You should also be aware that when using silk as a fabric matt for photos, you need to use extra adhesive or glue dots because photos don't tend to stick well to the slick surface of silk fabric.

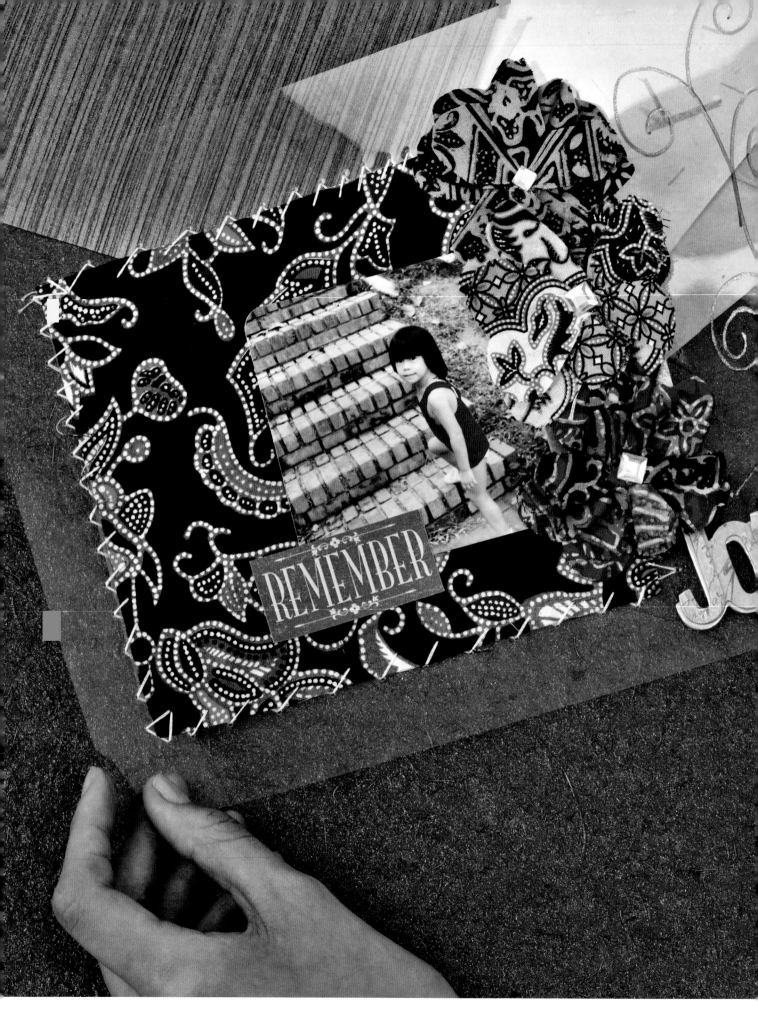

Using Batik Fabrics
From the Beach to the Boardroom . . . It's Not Your Ordinary Tie-Dye!

Southeast Asia is world famous for its batik fabrics, the art of using wax and dye to create patterns on fabric. There are a number of methods of making batik, but the two main types are done either by hand drawing designs using a penlike device filled with wax called a canting, or by using a large patterned stamp, made of either wood or metal, that is dipped into the wax and then applied to the fabric to create a uniform pattern. The fabric is then dyed and the wax is melted off, and the process is done again with different colors of dye.

In Indonesia, where the art of batik is a symbol of national pride, batik fabrics are taken very seriously. Batik shirts and sarongs are considered formal dress attire; and certain patterns are exclusively worn at weddings, bankers and lawyers wear batik shirts to the office and senior Indonesian politicians wear batik clothing to state functions. In this section we will show how batik can add an exotic touch to your layouts but can also be used as an accent in a non-Asian layout. The following layouts demonstrate how using the same fabric need not limit your design choices. For example, Nishi used batik fabric to showcase the architecture of Europe by cutting part of the design from the fabric and using it as an accent rather than as a key element of the layout. Lynita used the same fabric in a layout about her children at the beach. She focused on the colors of the fabric, giving her layout a very different feel.

Journey by Sharon Chan

Sharon made this fun layout by sewing fabric directly onto a transparency. In order to make the flowers from the batik and Indian prints, Sharon cut small, heart-shaped pieces freehand from fabric and layered them together to create a flower, placing the point of the heart-shaped petals in the center. Once the flower was the right size she sewed the flower together in the center with a simple stitch. *Supply Credits* Fabric: Far Flung Craft (batik); Indian block print; Sticker, chipboard word: K&Company; Pens: American Crafts/Slick Writer, Uni-ball Signo; Other: Transparency, rhinestones, thread

Summary

Summer Days by Lynita Chin

The browns and blues of the batik fabric accent the ocean and sand in Lynita's layout about the beach. This layout is fairly straightforward to reproduce. Lynita cut one strip of fabric and placed it on the left side of the layout. She cut a second piece of the same fabric and cut around the pattern in order to give the scalloped effect and attached it to the right side of the cardstock. To highlight the sentiment "Enjoy," she cut a coordinating piece of batik and created a mat for the title. She then attached her photos and used different embellishments evocative of summer to further the theme.

Supply Credits Patterned paper: My Mind's Eye/Bohemia; Fabric: Far Flung Craft; Beach stickers: Making Memories; Slide mount; Journal block stamp: 7gypsies

By the River by Nishi Varshnei

You need not limit the use of Asian materials or products to Asian-themed layouts. In this case, Nishi used an Asian-inspired paper and batik in her layout about her family vacation to Europe. The batik was cut and used as an accent to emphasize the details of the buildings.

Supply Credits Patterned paper: Die Cuts With A View; Fabric: Far Flung Craft; Rub-ons: Making Memories; Letter stickers

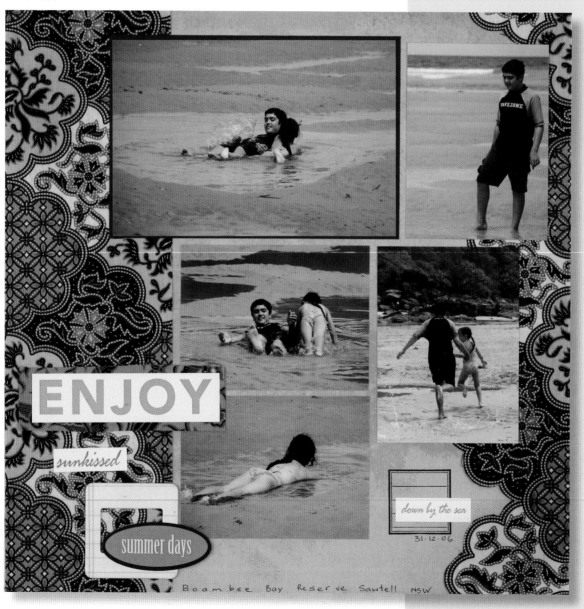

ENJOY

sunkissed

summer days

down by the sea

31·12·06

Boambee Bay Reserve Sawtell NSW

by

the

River

*absolutely
fabulous*

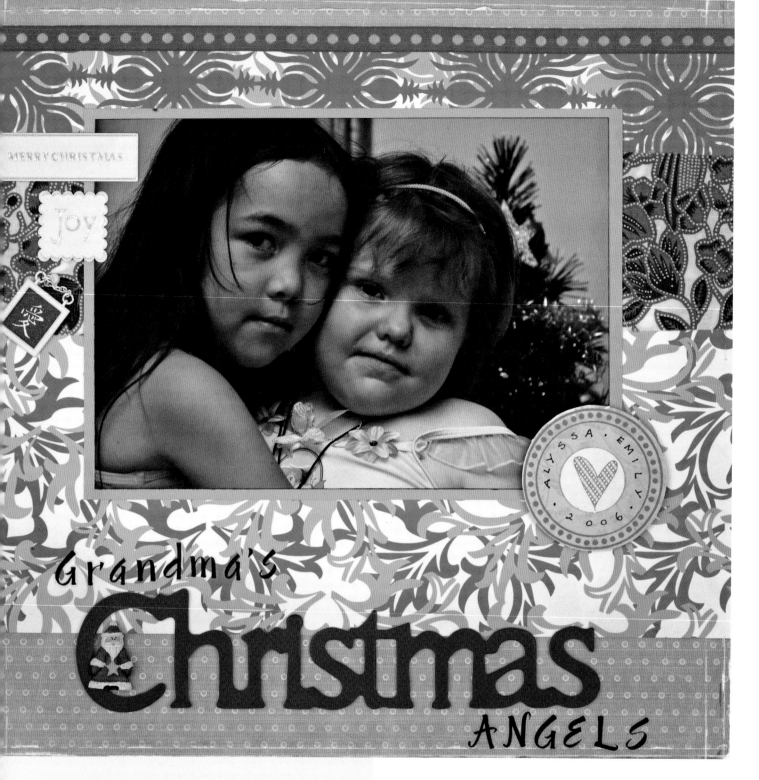

MERRY CHRISTMAS

Joy

ALYSSA · EMILY · 2006

Grandma's
Christmas
ANGELS

Grandma's Christmas Angels
by Lynita Chin

The floral batik with bright tropical colors in this nontraditional holiday layout evoke a warm and sunny tropical Christmas in Australia.

Supply Credits Cardstock: Bazzill (linen); Patterned paper: Crate Paper, Luxe Designs; Fabric: Far Flung Craft; Metal plaques: Making Memories; Mini metal frame: K&Company; Chipboard coasters: Blue Cardigan Designs; Chip chatter word, pressed petals, alphabet stickers: Stickopotomus; Stamps: Stamp Oasis (Love chop); Ink: Archival ink (plum); Other: Ribbon, button

Source It!

When most people think of batik, the image that comes to mind is the ubiquitous sarongs found on beaches worldwide. While many contemporary examples, on the beach or elsewhere, are often printed rather than true batik, the designs and patterns are wonderful to use and very inexpensive. Fabric artists, quilters and people in search of beautiful fabric for clothing have created a demand for batik, and the great news is that batik fabrics can be purchased in most fine quilt stores and of course online.

Silk Saris and Paisley
The Intricate Fabrics of India

The fabrics that come from India make me swoon with excitement. The rich, lush colors of sari fabric with gold thread and bead embellishments make my heart flutter. But there is so much more to Indian textiles beside saris. In fact, many of the common prints and patterns that we see in fashion (and in scrapbooking) were originally designed in India. The paisley pattern was probably first seen in the Kashmir region of India/Pakistan. Madras plaids, those wonderful loosely woven cotton patterns that were the epitome of Preppy fashion, were named after the Indian city of Madras (known now as Chennai). Block-printed fabrics from India and lovely embroidery are also examples of the craftsmanship that is evident in Indian textiles. I love walking through Singapore's Little India and picking up a block print tablecloth or grabbing an inexpensive sari to use as a design element in my home décor. The thought of using some of these fabrics and textures in my scrapbook layouts is irresistible.

Many of the layouts on the next several pages use Indian fabrics and others use Indian fabric designs as inspiration. In some cases, traditional scrapbook supplies are used to make some fun projects inspired by Indian fabrics.

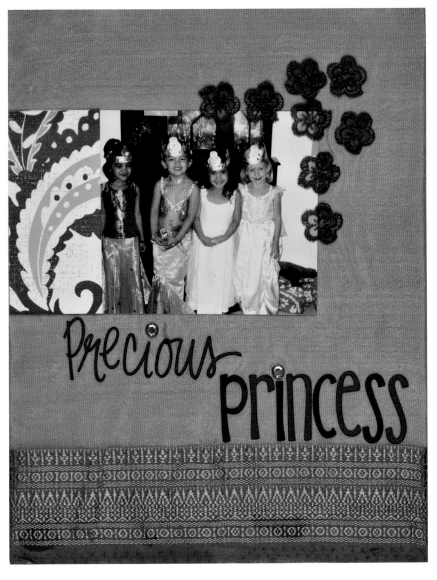

Precious Princess
by Nishi Varshnei

Nishi used fabric from an Indian sari for this layout and attached the fabric to a plain piece of heavy cardstock before adding her patterned paper and other embellishments. The lightweight fabric was cut about 2 inches (5 cm)larger than the cardstock and then attached by folding the edges of the fabric over the cardstock and taping it on the back side.
Supply Credits Patterned paper: NRN Designs; Rub-on letters; Rhinestones; Fabric, flowers: Sari fabric from India

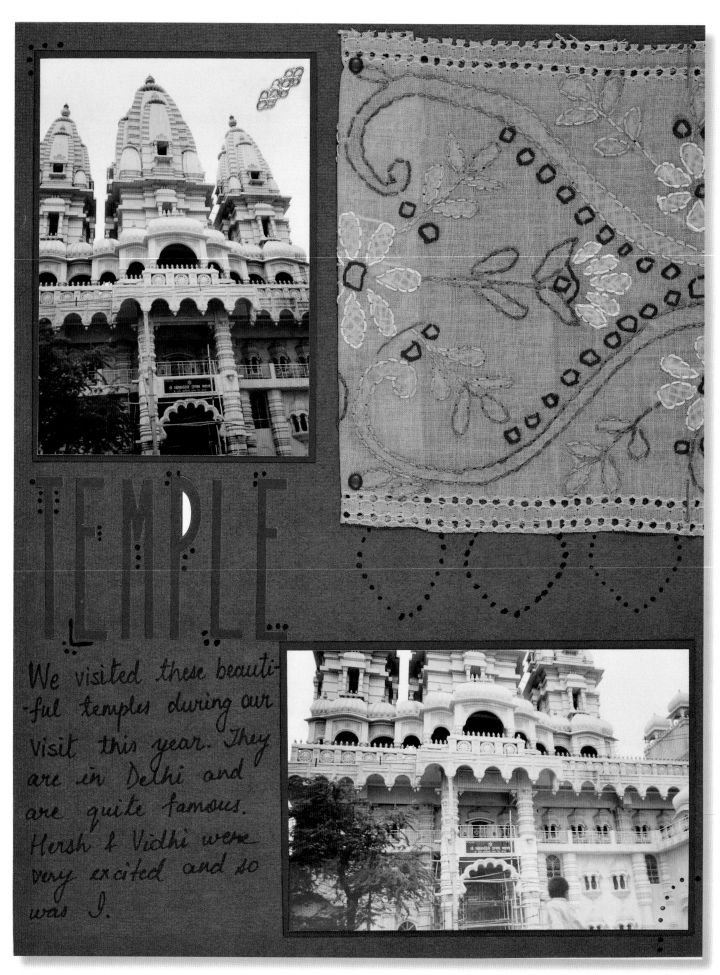

TEMPLE

We visited these beauti-
-ful temples during our
visit this year. They
are in Delhi and
are quite famous.
Hersh & Vidhi were
very excited and so
was I.

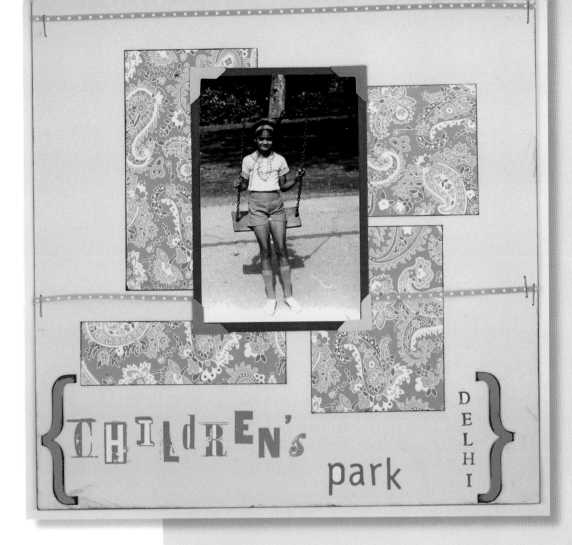

Children's Park
by Wendy Steward
The paisley pattern, found in many Indian fabrics, originated in the Kashmiri region in what is now part of Pakistan. Wendy's use of a paisley pattern with heritage photographs from her childhood in India provide a historical connection as well as a decorative touch.
Supply Credits Cardstock: Bazzill; Patterned paper: Making Memories; Ink: Versa Cube (brown); Rub-ons: Making Memories, Scrapworks; Ribbons: Pink, white spotted from local craft store; Chipboard: Heidi Swapp; Photo corners: Heidi Swapp

Source It!

Paisley has become one of the most recognizable patterns in use today. You can find it on everything from women's scarves to men's ties. A trip to your local fabric store will give you lots of ideas for paisley colors and combinations. The scrapbooking industry has also jumped on the paisley bandwagon. Companies such as Chatterbox, Making Memories, Autumn Leaves, 7gypsies and Rusty Pickle have all incorporated paisley patterns in their scrapbooking paper; and other companies such as Maya Road have followed the trend by creating chipboard albums in paisley shapes. More information about the history of paisley can be found in books about the weaving industry in England.

Fun with Japanese Fabrics
Calico, Prints and Natural Fibers

The Japanese have a very large handcrafting culture, and the use of simple elegant natural fabrics plays a key role. The Japanese love to quilt, crochet, knit and create "softies," adorable hand-sewn stuffed toys. The appreciation for Japanese crafting and printed fabrics is on the rise in the West, with many fabric designers in the US and Europe gleaning inspiration from Japanese craft magazines and books. I find myself fascinated by the books—now if only I could read Japanese! You can gain similar inspiration and can use these wonderful fabrics in your projects. Japanese printed cottons are often a loose-weave fabric with an almost linen look and feel to them, and the prints range from the cutsie Hello Kitty to botanical and Asian prints that resemble works of art in their own right. Japanese fabrics, books and magazines are often available at major fabric and quilt stores and of course can be ordered online.

Temple
by Nishi Varshnei
The Indian textile industry has long been known for its fabrics embellished with beads, sequins and embroidery. Indian textiles are famous for the attention to detail and elaborate designs. In this layout Nishi has paired a piece of fabric featuring an embroidered floral motif with photographs of traditional Indian temples, which are also highly ornate.
Supply Credits Cardstock: Bazzill; Fabric: Cotton embroidered fabric from India; Other: Pen, letter stickers

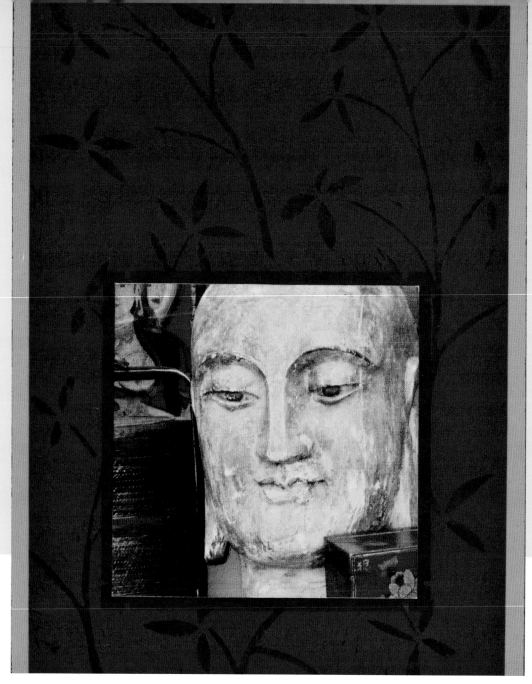

Buddha Face
by Brenda Marks

Using Indian block printing as inspiration along with a Japanese-inspired design, Brenda created her own rubber stamp using a block-print design. She then created this card to show the versatility of the stamp. Block-printed fabrics were some of India's first mass-produced textile patterns.
Supply Credits Cardstock: Bazzill; Hand-carved Stamp: Artist's own design; Ink

Play by Lynita Chin

The Japanese cotton print fabric adds texture as well as design to this layout. The cotton fabric has a loose weave that adds a deeper layer of dimension. Lynita sewed the fabric onto this page and added Asian-inspired pattern paper by K&Company, rice paper with Asian text, and a page from a Chinese almanac for a collagelike layout.
Supply Credits Cardstock: Bazzill; Patterned paper: K&Company/Amy Butler, Making Memories (ledger paper); Chipboard letters: BasicGrey; Charm: Far Flung Craft; Rub-ons: Urban Lily; Stamp: Shiny Stamp (date, time), Hero Arts (Chinese newspaper word print); Other: Rice paper, Chinese almanac pages, brads, tags

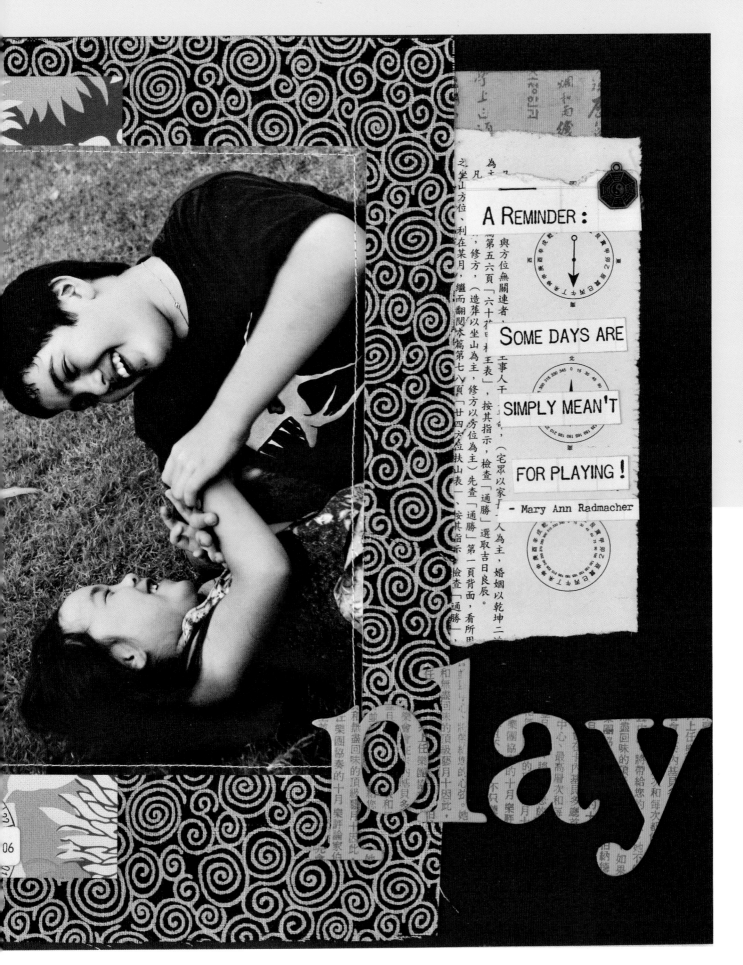

A REMINDER:

SOME DAYS ARE

SIMPLY MEAN'T

FOR PLAYING!

— Mary Ann Radmacher

play

First Home by Kristy Harris

Using the yo-yo flower pattern for fabric by quilt artist Heather Bailey, I made fabric flowers for a layout about the first house my husband and I bought. The fabric flowers are a quick and fun project and can be embellished by adding brads or buttons in the otherwise empty center.

Supply Credits Cardstock: Bazzill; Patterned paper: EK Success; Brads: imaginisce (ancient brads), Foof-a-La (epoxy brads); Fabric; Stickers: Francis Meyer; Felt letter stickers: American Crafts; Hipboard letters: Gin-X; Paint: Plaid; Other: Felt photo corners, glossy accents

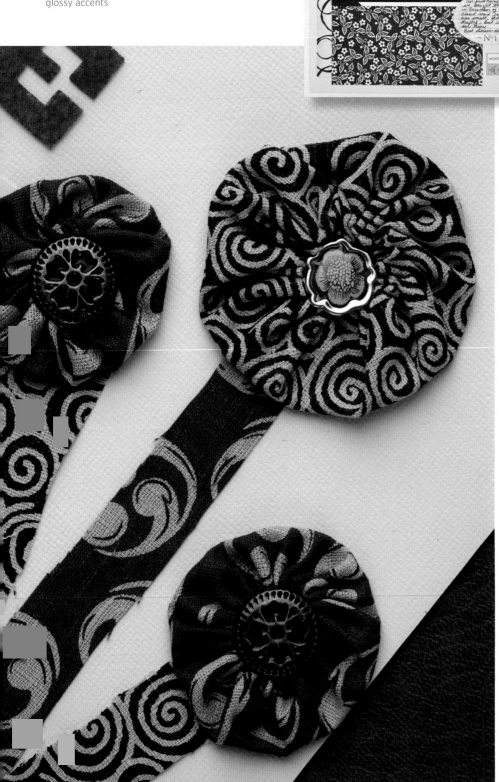

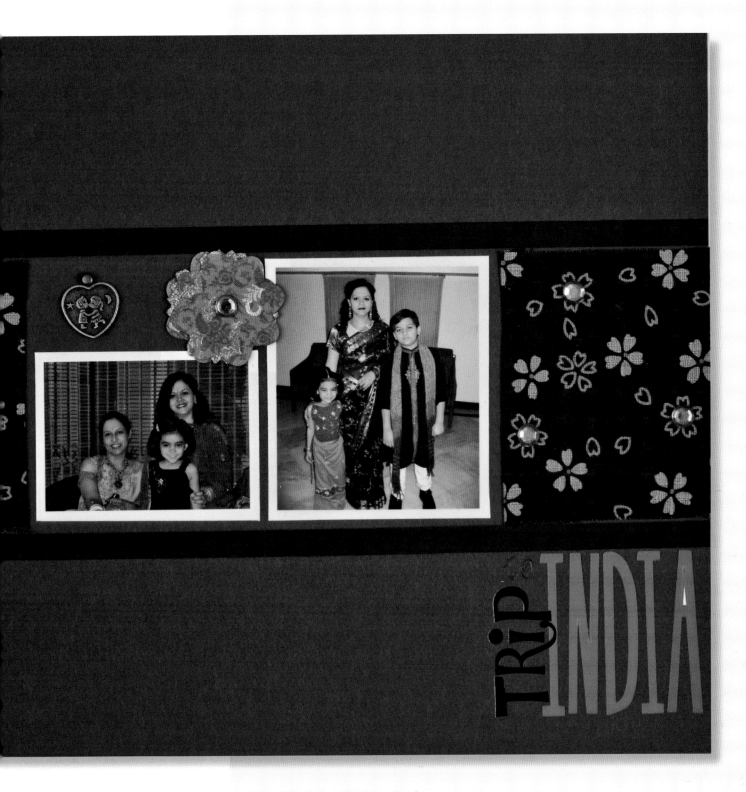

Trip to India by Nishi Varshnei

This clean Zenlike layout uses Japanese-style fabric in place of patterned paper. Nishi has made an effective use of white space around the photographs and has divided the layout into thirds, using the fabric only in one third. This layout is a great example of how versatile a simple pattern can be—this Japanese print fabric extends itself even on a layout about India. *Supply Credits* Flower brad: K&Company/Amy Butler; Heart charm: Far Flung Craft; Rub-ons: Luxe Designs (trip); Other: Letter stickers, cardstock, brads, ribbon

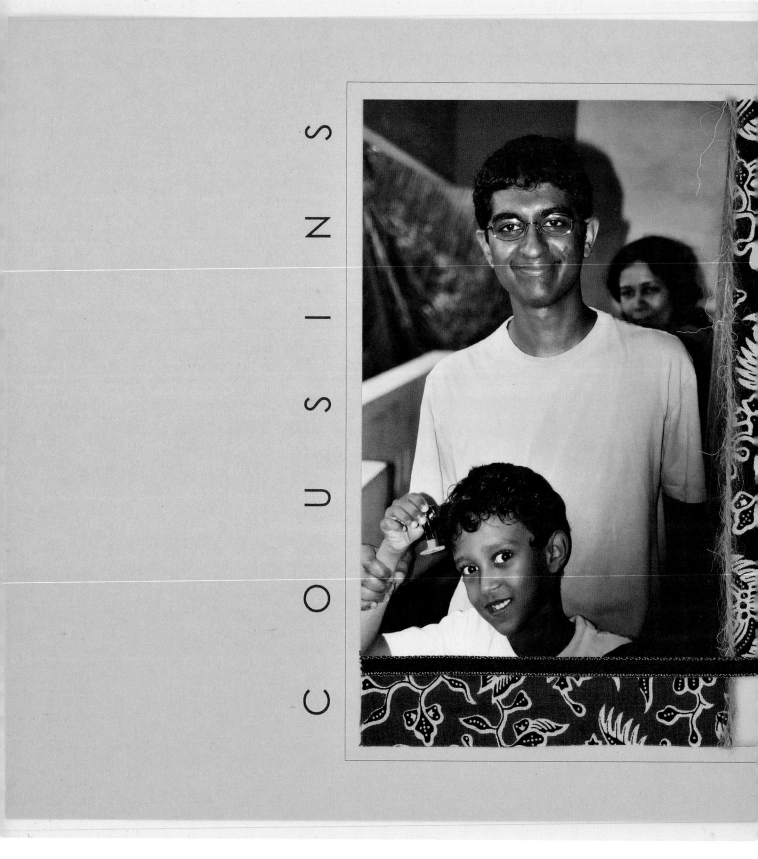

COUSINS

Cousins by Vidya Ganapati

Vidya uses hybrid scrapbook techniques when she is scrapbooking with paper.
In this layout she created the title and block on her computer, printed it out and
then added the fabric, ribbons and fibers. The combination of the batik fabrics in
dark red and blue give this layout a boyish feel.
Supply Credits Cardstock: Bazzill; Fabric, fibers: Far Flung Craft; Other: Ribbon

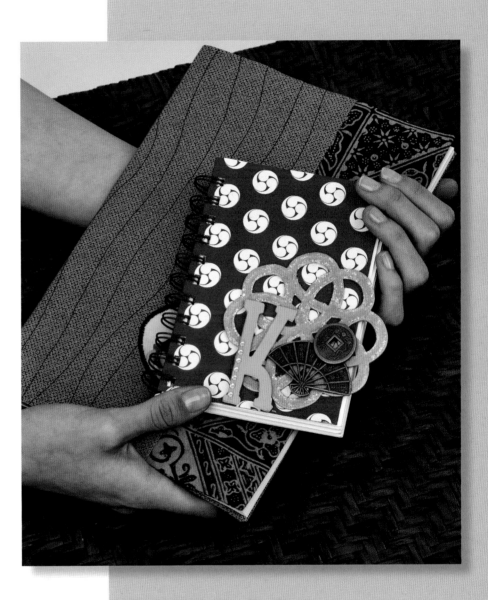

"K" Notebook by Sharon Chan

Sharon's hand-bound book consists of chipboard covered with paper that has a similar pattern to many of the Japanese cotton print fabrics available in quilt stores. While this project features paper, it could have been done just as easily with fabric.

Supply Credits Patterned paper: Origami paper; Charms: Far Flung Craft; Letters: Chip Chatter; Paint: Ranger (gold dauber); Chipboard: Maya Road; Other: Zutter/Bind-It-All

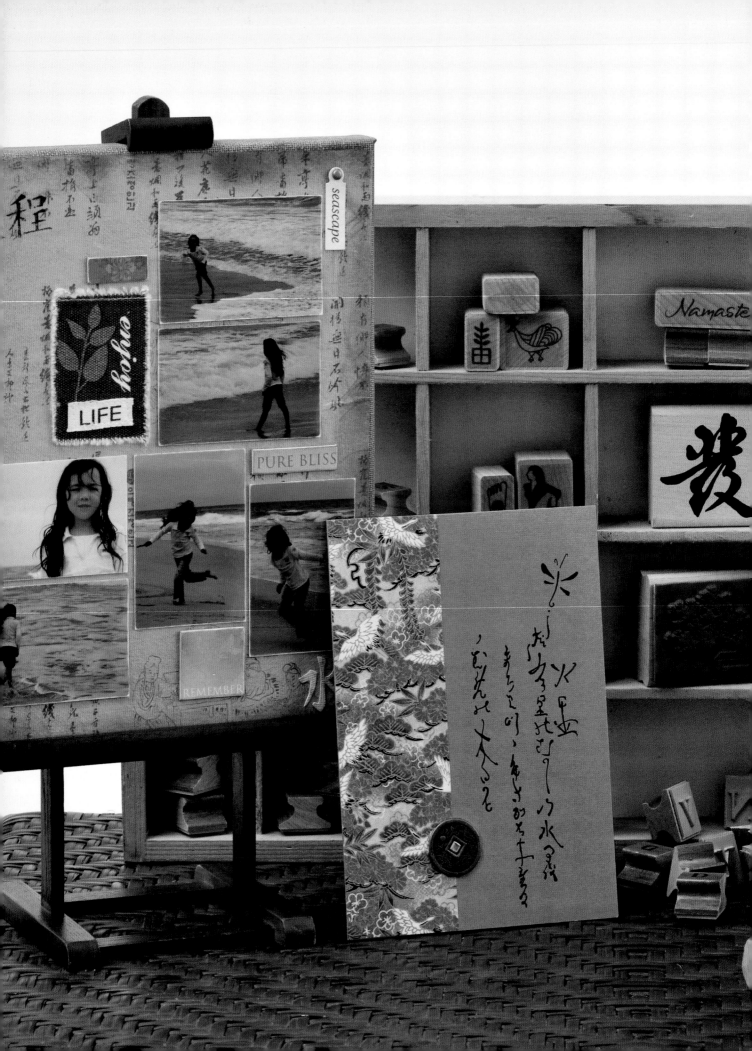

Working with Asian Papers and Paper Craft Techniques

The scrapbooker's dream is to find him- or herself surrounded by luxurious, rich and colorful paper. The projects in this chapter feature papers found throughout Asia: rich washi papers from Japan, handmade rag paper from India, patterned paper manufactured with Asian-inspired design. The projects by Heather Taylor and Lynita Chin feature washi and rice paper as well as paper featuring Asian text.

From Mass-produced to Handmade Paper

I think it is a given that scrapbookers are fascinated with paper. We like to play with it, cut it, rip it, ink and distress it. We like to touch and manipulate it, and I have even heard of scrapbookers claiming to smell new paper! Let's face it—even digital scrapbookers still make "papers" for their layouts. I admit it; I am an addict, and I love the tactile nature of paper— the feel of it, that little rush when I rip it before I place it in a layout. Put me in a scrapbook store or stationery store and I get giddy. I never walk out empty-handed!

Living in Asia has been a great cultural experience on a number of levels, but the quality and depth of the Asian papers I've come across has been a great adventure. I love the fact that I can pick up handmade Indian papers at the local sundry store, that one of my favorite paper sources is an independent wrapping-paper company that is creating amazing designs too good to limit to gifts and that Japanese papers (even if just the printed copies) are sold in every stationery store.

The wonderful thing is that now you don't have to live in Asia to have the same access to these supplies. Most of the papers we use in this chapter are available year around in most major metropolitan areas around the world. A good place to begin your Asian paper search is an Asian "town" or neighborhood. Even if you don't live in or near an Asian neighborhood or shopping district, the Internet makes it possible to buy these papers online and have them delivered to your door within days.

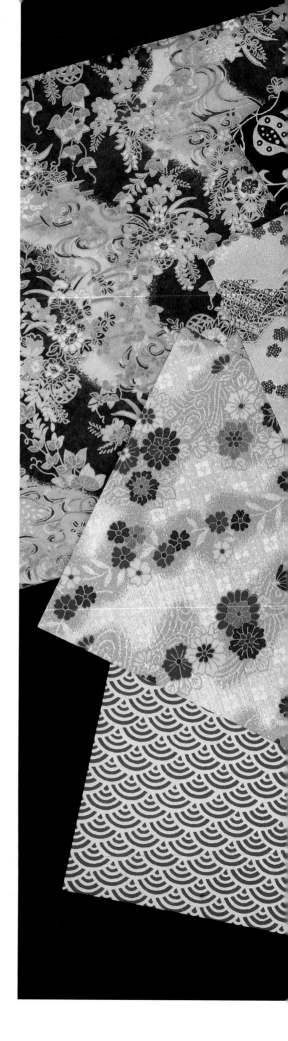

Japanese washi papers

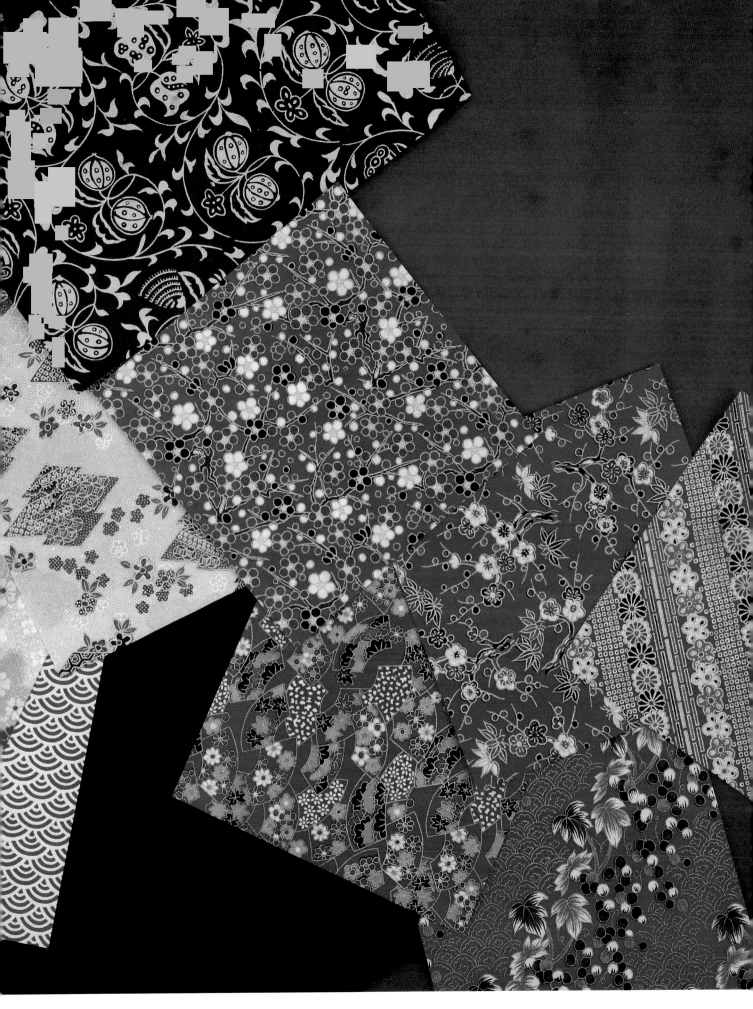

History Corrected—It Wasn't the Egyptians
The Invention of Paper and Asian Papermaking Traditions

Here is a bit of trivia for you, sure to help in the next trivia game you play: Paper was invented in Asia, not the Middle East. Yup, it is true. I always thought paper was invented in Egypt, but in fact modern paper was invented in China around 100 BC. Much earlier the Egyptians were using papyrus (plant leaves) and parchment (animal skins) to write and draw. Though the Egyptians' development is not insignificant in itself, paper made from wood pulp was first developed in China.

It is easy to see that paper crafts date back as far as the invention of paper itself. As soon as paper was developed, people started playing with it. For example, both the Chinese and Japanese place great value on art works prepared on handmade paper. China boasts of four great inventions, two of them related to paper: the invention of paper itself and the invention of both woodblock and movable type printing. The Japanese art form of origami dates back to the era of the samurai; and handmade papers from Southeast Asia and India, filled with flowers, leaves and other botanicals, are works of art in their own right.

The photographs on this page (and pages 84–85) show some of the different types of handmade artisan papers that are still made in Asia, including Chinese papers, Japanese washi and chiyogami papers, papers from India and saa paper from Thailand. These papers are fun to look at, touch, rip and alter; and more importantly, they can be used to create unique projects that are Asian in style.

Saa, the Thai mulberry paper

The Ephemeral Beauty of Chinese Paper Cuttings
It's All in the Details

Chinese paper cutting can be traced back 1,500 years, to at least the sixth century AD, and may go back as far as shortly after the invention of paper in China. Chinese paper cutting is an art form that requires fine handwork and attention to detail to create fine paper cuttings from brightly colored tissue paper. The paper cuttings are often of auspicious motifs common in Chinese art. At first the hobby of paper cutting was limited to the wealthy and noble class in China as the cost of paper was beyond that of the average person. In fact, the elite in China felt that a woman's ability to create beautiful paper cuts (in addition to her ability to write calligraphy) should be one criterion for her eligibility for marriage. As the cost of paper became less expensive, the art of paper cutting spread beyond the elite and became a folk art in China. The art form is making a comeback, and certain areas of China are now famous for their paper-cutting artists. Paper cuts in China are often used as decorative items in the home, as decorations or on cards for special occasions and holidays or to herald good tidings at weddings and other celebrations.

There are two traditional methods of paper cutting in China. The first involves stacking up to eight layers of thin tissue paper together and cutting the design with scissors. The second method of traditional Chinese paper cutting involves the use of a craft knife and multiple layers of paper placed in a soft foundation of tallow and ash. When using this style of paper cutting, the artist holds the knife vertically (similar to the way a Chinese calligraphy brush is held) in order to cut the design. As the art of paper cutting spread around the world and each place put its own spin on the art, much of paper cutting is now done with small, sharp scissors. In Germany and Switzerland the art of Scherenschnitte can be traced back directly to Chinese paper cutting, and over time styles of paper cutting traveled around the world all the way to colonial America and Latin America.

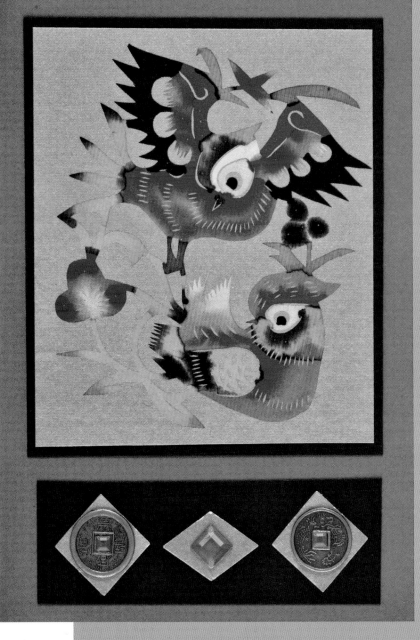

Birds by Ann Pennington
By placing the paper cutting onto gold-textured cardstock the paper cutting retains its position as the focal point of this card. Not only does Ann's placement of the paper cut on a separate mat retain its significance in the card, it also protects the paper cut from the other elements that may scratch, tear or otherwise damage the paper cut.
Supply Credits Cardstock; Coin charms: Far Flung Craft; Other: Chinese paper cut, rhinestones

WOOD RaBBiT

from the time Wood Rabbits were small children delighting in Story time. Wood Rabbits have pursued knowledge. Charming conversationalists. they regale others with anecdotal glimpses into literature, history, and current events. they are lifelong members of the Legendary Rendezvous for People in the Arts and are frequenters of bookstores. libraries. and halls of academia. Their innate cunning makes them superb players not only in the game of chess but the game of life. No wrong moves allowed! Wood Rabbits are alert to new experiences. hang-loose philosophically. and very generous to friends and love ones. . Love Life for the Wood Rabbit is filled with rapturous sweetness. so incredibly generous in affection. it puts the partner's head in a spin. Fireplace cuddles are the way of life.

http//www.tuvy.com

1975

Wood Rabbit
by Sharon Chan
Chinese paper cuts are very delicate and can be difficult to work with, as they tend to tear easily and bleed colors when wet. For this layout Sharon placed single drops of glue in areas of the paper cutting that were busy and easy to hide. Note that the glue will probably seep through, so it is good to place the glue in a place where only one color is present.
Supply Credits Cardstock: Bazzill; Patterned paper: American Crafts; Die cut alphabet: Quick Cuts Metro, Sunshine; Flowers: Prima; Bling: Heidi Swapp; Others: Green ink, Chinese paper cuts, rhinestones

It's important to note that though Chinese paper cuts are a really fun and creative technique to explore in your scrapbook layouts, they are not ideal for heritage projects. Because Chinese paper cuts are made with tissue paper, they will fade over time. Also, paper cuttings are probably not acid free, and you should treat them accordingly. As they are delicate and not preservation quality, you should treat them with caution when choosing to use them in your projects. There are a few ways of working with paper cuts to reduce the risk of damage to your projects as well as to lengthen the lifespan of your paper cut.

First, and probably the best method, is to spray the paper cutting with archival spray. Please note, you must spray from a distance because if the paper cut is sprayed to closely, the color may bleed. Buffering the paper cut by placing it on a cardstock mat and not having it directly touch other elements of the layout is another way of reducing the risk of an acid harming your photos, but this will not protect the colors of the paper cut itself.

Source It!

Real Chinese paper cut works, usually hand cut in China, can be purchased online, in brick-and-mortar import stores or in sundry stores in most Asian neighborhoods. You can also sometimes find them in stationery/card stores as well as in Asian grocery stores during the Chinese New Year holidays, usually in late January or early February.

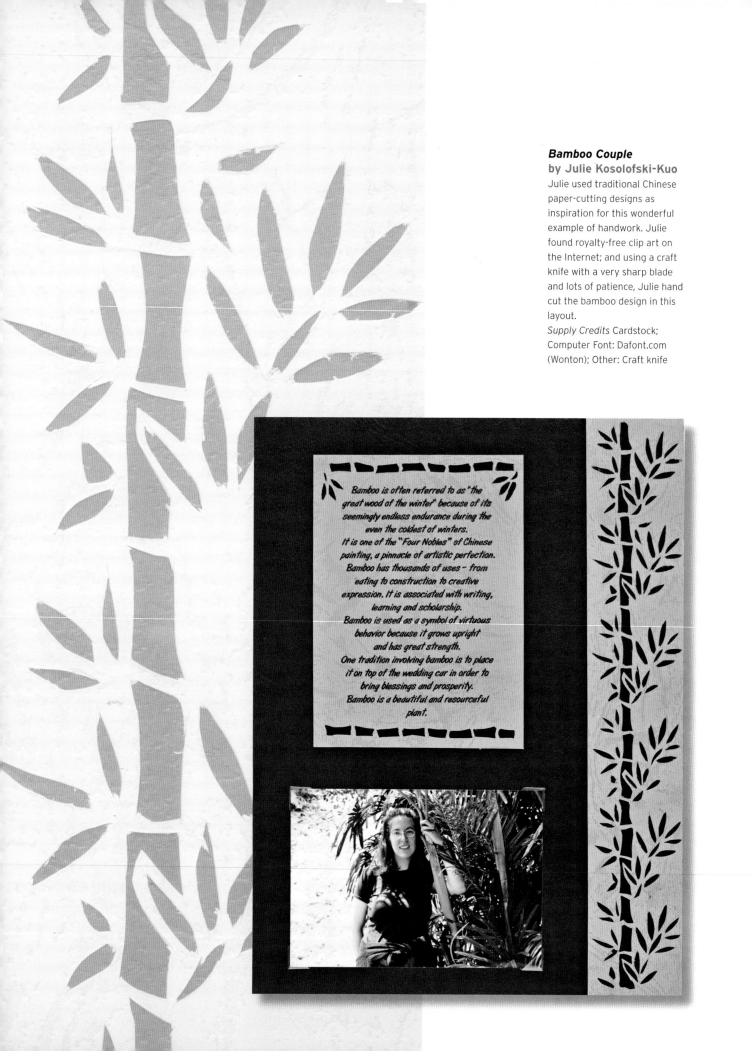

Bamboo Couple
by Julie Kosolofski-Kuo
Julie used traditional Chinese paper-cutting designs as inspiration for this wonderful example of handwork. Julie found royalty-free clip art on the Internet; and using a craft knife with a very sharp blade and lots of patience, Julie hand cut the bamboo design in this layout.
Supply Credits Cardstock; Computer Font: Dafont.com (Wonton); Other: Craft knife

Bamboo is often referred to as "the great wood of the winter" because of its seemingly endless endurance during the even the coldest of winters.
It is one of the "Four Nobles" of Chinese painting, a pinnacle of artistic perfection.
Bamboo has thousands of uses - from eating to construction to creative expression. It is associated with writing, learning and scholarship.
Bamboo is used as a symbol of virtuous behavior because it grows upright and has great strength.
One tradition involving bamboo is to place it on top of the wedding car in order to bring blessings and prosperity.
Bamboo is a beautiful and resourceful plant.

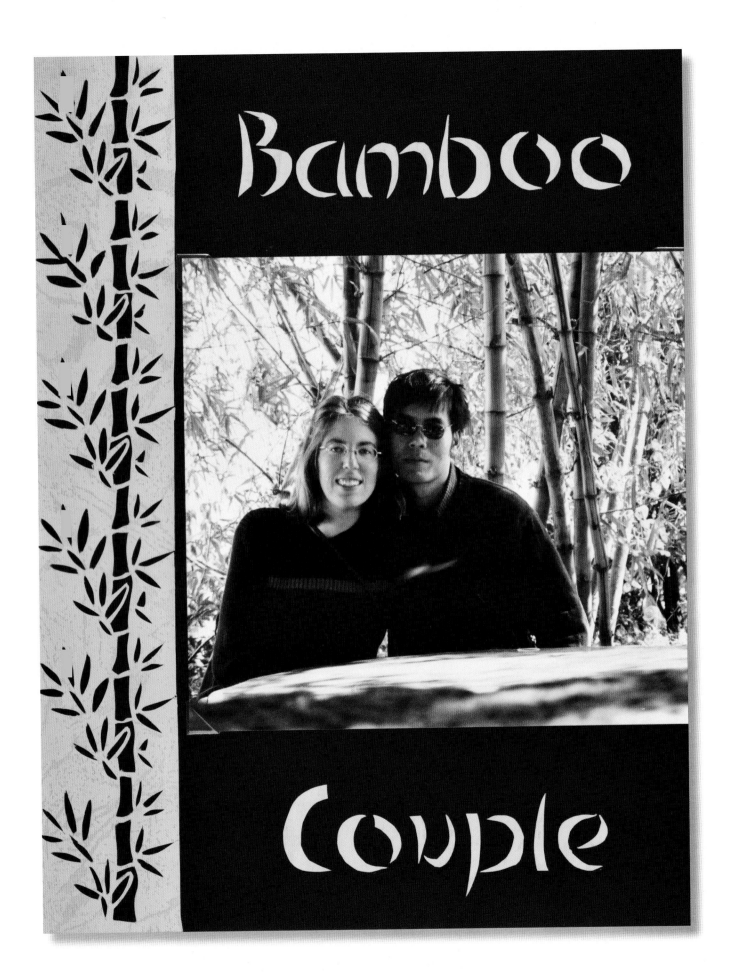

Bamboo Couple

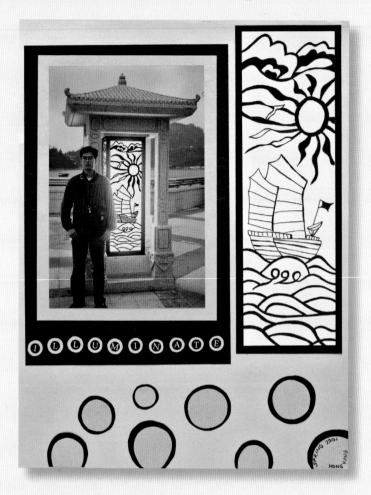

Illuminate by Julie Kosolofski-Kuo
Another way of creating the look of a paper cutting, but without the hard precision work of cutting it yourself, is to do a design in pen and ink. For this project Julie liked the design of a stained glass lantern in Hong Kong. She took the same design, scanned and enlarged it, and traced the pattern in black ink on a white background. Because the ink lines are thick and tend to flow together, it gives the impression that the design was cut out.
Supply Credits Cardstock: Pen: Sakura (gel pen); Letter stickers: Bradwear Impress-ons

Still by Michelle Anne Elias
Michelle easily blends washi paper with traditional scrapbooking supplies. She wove strips of washi to create a background for this photograph of her mother- and father-in-law. She placed the woven strips onto a piece of cardstock for stability and then mounted the photograph on cardstock. Highlighting the gold accents in the washi, Michelle used gold glitter accents to really bring this page to life.
Supply Credits Cardstock: Bazzill; Twinkle type letters, frame, flourish: K&Company; Washi paper; Letter brads: Making Memories; Metal accents: Nunn Design; Metal key: ARTchix Studio; Clock pin: Rebecca Sower/Nostalgique Collection; Ribbon: Designer's personal stash; Journaling card: Jenni Bowlin Studio; Number 50: We R Memory Keepers

The good news is that not all your projects need be archival, which frees you up to explore products such as Chinese paper cuttings in fun and exciting scrapbook layouts.

To create your own hand cut design, print your pattern (either use clip art, rubber stamps or your own drawings) on the back side of the paper—and if you are printing letters, don't forget to reverse them! You can cut your designs either by using a sharp craft knife or small scissors. When doing paper cutting with a craft knife, make sure you have a new sharp blade because dull knifes will rip paper or leave tags. When working on intricate cuts, a great trick is to place your paper on top of a glass surface. The glass allows you to keep your knife straight, and you can turn the paper when you need to make a curved line, which reduces the number of tags and dead ends in your paper cutting.

The advent of computer-based die-cutting systems has created the ability for you to choose royalty-free clip art or design your own. You can create a cut design or pattern without all the hard work. Simply find the design you want, load it into the computer and press "enter"!

The Bright and Vivid Patterns of Japanese Papers
From Silk Screens to Mulberry

Can you imagine walking into your favorite scrapbook store to find it has magically transformed back in time to a store from the late 1800s, with an antique cash register and shelves filled from end to end with glorious silk-screened papers: papers printed on handmade paper so vividly colored with intricate patterns and so beautiful that you can't help but want to touch them; papers with flecks of gold and silver and papers with woodblock prints; kites, notebooks, greeting cards and stationery supplies? Back in

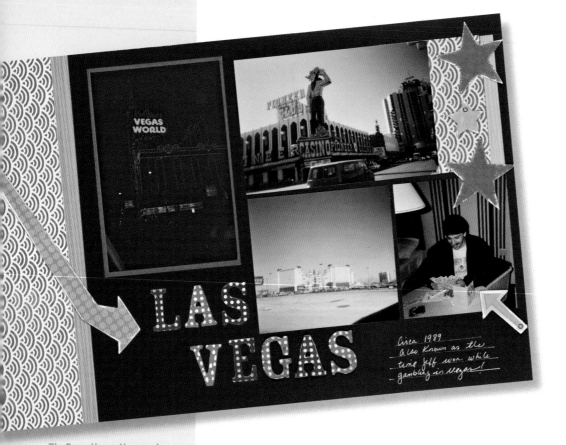

Tip Sometimes the most important function of a scrapbook page is to keep memories alive. These pictures of my husband's trip are not the best quality, but they are the only ones that he has. Rather than lose the memory, I scrapped them. I didn't try to take them and enhance them, fix them or brighten the images. I just took the pictures as they were, created the page and preserved the memory. Easy peasy! Besides, putting these pictures out there is a great visual reminder of how things change over time. One of these pictures was taken from a parking lot looking at the then "brand-new" Excalibur Hotel and Casino. Today the whole corner has changed, and this photograph would be impossible as it was shot from smack-dab in the middle of the gambling floor of the MGM Grand Casino. Don't lose those memories!

1995, on my first, and probably favorite, trip to Tokyo, I ended up walking into a small paper store in Asakusa called Kurodaya to see this magical scene. Kurodaya has been in the same location and has had the same basic products for more than a hundred years. During my visit, I was just out of law school and on a very tight budget. My whole week-long trip to Tokyo was done with pocket change. I flew on a courier flight, stayed at a friend's house and had about two hundred dollars total for spending during the whole trip. Once I walked into the paper shop, I was hooked. I don't really recall how much I spent, but I do know that the majority of my souvenirs from that trip were all purchased there. That store was the start of a love affair with paper, and I have never looked back!

Washi paper has become synonymous with origami papers in the West, but washi papers are actually handmade papers made from natural fibers of native Japanese plants whereas other origami papers can be mass-produced. The type of washi paper that is most commonly used in paper crafting is made from the kozo (mulberry) plant and often will be called Japanese mulberry paper rather than washi. Because it is handmade and unbleached, true washi paper is often naturally low in acidity, but the same cannot be promised of mass-produced

"washi"-like papers. It is fairly easy to tell true washi paper: It feels different than mass-produced paper. There are slight imperfections in true washi paper; and it has a feeling of warmth as compared to the smooth, slick and cooler feel of mass-produced paper. Washi feels almost fabriclike in texture and can be manipulated much easier than standard bond paper.

One further note of introduction to washi paper is probably needed. The terms *yuzen* and *chiyogami* are used interchangeably, but these are the brightly colored silk-screened papers that we have come to identify with "washi" in the West. Washi itself can be yuzen paper, or it can be noncolored plain paper. Throughout the text I will refer to traditional silk screen yuzen/chiyogami papers with the term *yuzen* for simplicity.

If you are using reproductions, not true mulberry paper, the paper will be nonarchival and should be treated with archival spray. Real washi

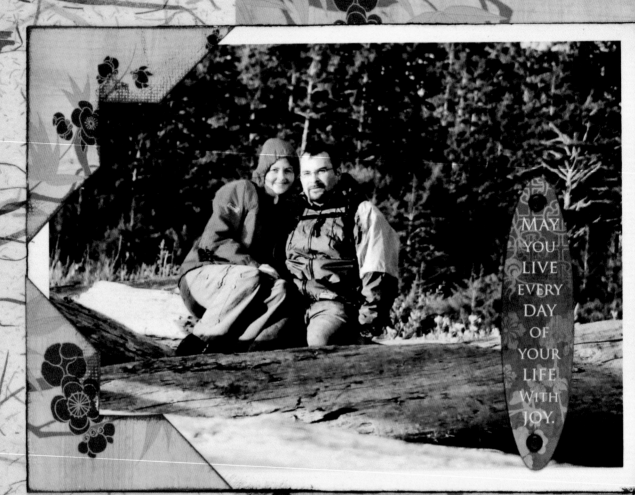

MAY
YOU
LIVE
EVERY
DAY
OF
YOUR
LIFE
WITH
JOY.

TO FINO
LONG BEACH
VAN. ISLAND
SEPT. 2004

just our
Spot

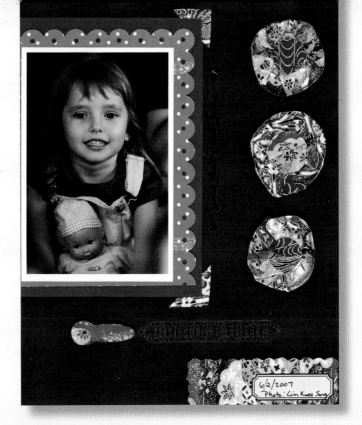

Just Our Spot **by Andrea Blair**
Thai paper, known as "saa," with botanical inclusions works beautifully in this layout of Andrea and her husband at the beach. The Asian feeling of this layout is further enhanced with Andrea's use of an Asian motif from Die Cuts With A View and an Asian coin from Far Flung Craft.
Supply Credits Cardstock; Patterned paper: Die Cuts With A View (Asian); Handmade paper: Target/DMD; Rub-ons: Luxe Designs (Just, Our); Letter stickers: Bo Bunny (spot); Stamp: 7gypsies; Chinese Coin: Far Flung Craft; Other: Brads, ink

paper can be used in a layout as is. When true yuzen papers are compared to offset-printed papers, you will see the difference right away. Real yuzen washi paper is easy to identify. The colors are much brighter, and you can often see the layers of ink on top of the paper. Additionally, the paper may have a residue on the back side where it was attached to boards during the printing process. Again—though I do want to stress that sometimes it is okay just to play with scrapbooking supplies and explore new techniques and materials without worrying about the preservation issue—just remember not to use your only copy of great-grandmother's picture in that project!

From the Cotton Plant to the Mulberry Bush
Thai and Indian Handmade Papers

While we have long recognized the Japanese skill in making handmade papers from the mulberry bush, paper from Thailand has also had an impact on the paper arts field. Thai mulberry paper, usually made by hand by a small group of craftsmen in Thailand, is known as "saa" paper (after the Thai word for *mulberry*). Saa paper from Thailand is often recognized for its natural and rough-hewn texture. Where the Japanese mulberry paper is often finished and screen printed with vibrant colors, saa paper is more often left in a natural state. Saa paper is also famous for inclusions of natural and

TIP Due to the heavy embroidery in this paper, you'll find it a challenge to attach your photographs directly to it. You can either use strong, acid-free adhesive such as E6000 or glue dots, or you can mount your photographs on a mat of cardstock before attaching them to your layout.

Photographie
by Kristy Harris
Working with washi paper is so much fun. The paper itself is soft, flexible and more forgiving than other papers when bunching, folding and otherwise manipulating it. Washi paper, of course, is the favorite paper for many Asian paper crafts because of these qualities. When I started to play with these papers I had just finished a layout using fabric flowers and wondered if I couldn't create a similar look with paper. So, after cutting long strips of paper I just bunched the paper together, pinching it in toward the center to create the funky little flowers. In order to finish the flower I punched a circle from the corresponding-color paper and placed it on top of the hole created by the flower.
Supply Credits Cardstock: Bazzill; Patterned paper: Creative Imaginations/Karen Russell: Narratives; Washi paper; Rub-ons: 7gypsies; Chipboard embellishments: BasicGrey; Journaling spot: Jenni Bowlin Studio; Pen: American Crafts/Slick Writer

***Happy* Hearts**
by Nishi Varshnei
This embroidered art paper from India is a great accent for scrapbook pages and works well when paired with traditional scrapbooking supplies such as the patterned paper from My Mind's Eye. Notice how the colors in the striped paper are enhanced by the embroidery, and the curved lines cut by Nishi coordinate well with the free flow of the embroidered pattern.
Supply Credits Cardstock: Autumn Leaves; Indian paper; Patterned paper: My Mind's Eye/Chester; Flower sticker: EK Success/Jolee's; Word sticker: Deja Views

Chinese Card
by Andrea Blair

The torn edges of the saa paper and the inked edges of this project (page 99) give the card an organic rustic appeal. The stamped Chinese text, backed with the simple botanically flecked papers, leads one's imagination to a simpler, less-stressful time. Finishes include knotted corners of fiber in the same tone as the red saa paper. *Supply Credits* Cardstock; Handmade paper; Fibers: Far Flung Craft; Stamp: Hero Arts; Ink: Colorbox

botanical elements, including leaves, straw, flower petals and often whole flowers. The popularity of this paper is rising; and as a result, major paper craft companies are now producing saa paper specifically for the scrapbooking market. Saa also can be purchased at most chain craft stores.

In India handmade art rag papers are often made from recycled cotton. I love these papers, and I love the fact that they are made from the remnants of the textile industry, using up scraps of fabric that would have added to landfills or been otherwise disposed of. The cotton paper creates a wonderful texture for art mediums of all types, and the silk-screened patterns on these papers are vivid and wonderful for use in scrapbook layouts. Cotton paper is also acid free, making it perfect for heritage and long-lived projects.

Origami and Other Exciting Asian Paper Crafts

For some time—at least a couple of hundred years—after its invention, paper was expensive and therefore was available only to the wealthy or for use in ceremonial functions. Regardless of the cost, or perhaps in part because of the cost, the allure of playing with paper and the desire to make creative items still existed. For example, the art of origami began early in the Japanese history of papermaking. It is thought that origami evolved from the samurai practice of folding a small piece of red-and-white paper into an envelope, called a "noshi," and giving it to another Samurai as a token of luck. Over time the symbolic act became a cultural tradition, and noshi became a symbolic token of

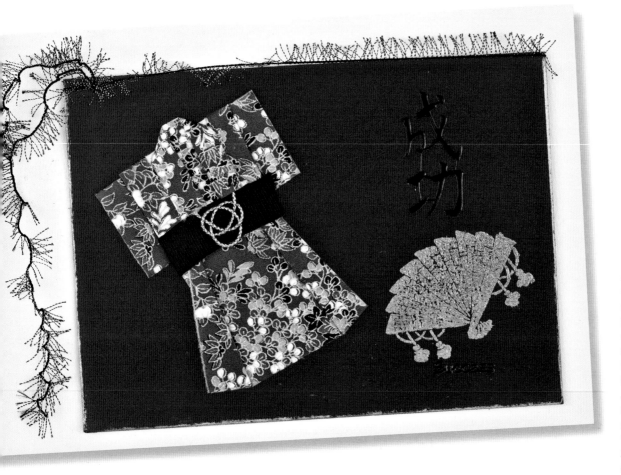

Success
by Ann Pennington

Ann used a yuzen washi paper to create an origami kimono fold. (The kimono fold is a fairly common origami fold, and you can find a pattern online or in a number of origami books.) This kimono was embellished by adding a black obi (belt) and a gold thread. Ann completed the card by adding a Japanese-inspired rubber stamp embossed in gold and the kanji character for "Success."
Supply Credits Fan stamp: Katy's Corner; Yuzen washi paper: Stone House stamps; Oriental peel-off stickers: LynnR Papercrafts

彼而卒莫消長也蓋將
其變者而觀之則天地
不能以一瞬自其不變
而觀之則物与我皆無
也而又何羨乎且夫天地

good luck throughout Japan. When paper became less expensive, paper crafts and paper folding in particular took off in Japan. While other paper-folding traditions have appeared around the world, most people still think of origami as the pinnacle of the art.

When doing origami and other paper folds, many people use washi paper (or other mulberry papers) because of its durability and flexibility. Of course other papers can be used; but they take a bit more manipulation, and you may need to work patiently with these papers. I find it interesting that rubber stamp artists have used folding techniques and designs in their projects for quite a while, but the scrapbookers have not adopted it to the same extent. There are a number of folding and paper art techniques that could be used in scrapbooking to create dimensional projects, embellishments or even mini-albums and scrapbooks. In this section I hope to introduce you to a number of projects that will inspire you to use paper folding and handmade papers in your scrapbooks.

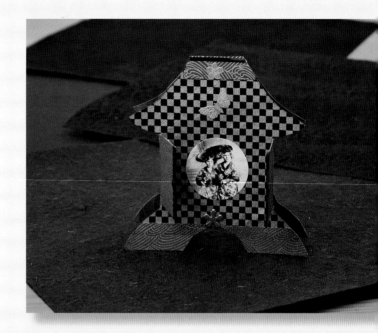

Temple Card by Ann Pennington

This temple card is a fun way of displaying family photos. The card, if made from sturdy cardstock, can function like a standing picture frame with doors that can either be opened to show the pictures or tied shut. Ann used red cardstock and washi paper to add a distinctly Japanese flair to this card, but it could be Chinese inspired as well by altering the colors and using Chinese motifs when embellishing. Ann adapted the pattern by adding brads to the bottom of each side of the card. She used a string tied between the two sides, rather than a folded paper, to make it stand easier.

Supply Credits Cardstock; Photographs or vintage images; Eyelets, brads, stickers, buttons/beads; Pattern: Temple pattern

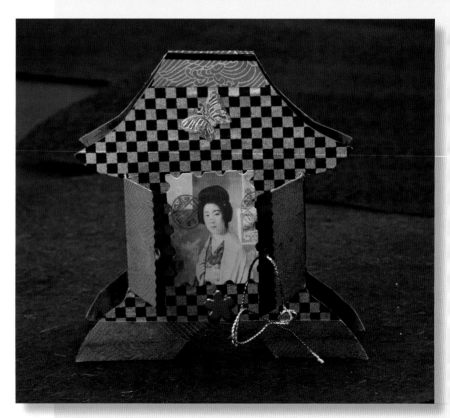

A Life Remembered
by Lynita Chin

A mini-album made with cardstock and covered with a wonderful embossed paper was a tribute album for Lynita's grandmother. Simple without much embellishment but filled with heart-felt journaling, this portable minibook was passed around the memorial service and appreciated by all.

This mini-album was based on a fairly common explosion-book pattern used by paper artists. To learn step by step how to make this type of mini-album, see the project called *Grandma's Brag Book* on page 140. *Supply Credits* Patterned paper: Chatterbox; Handmade paper: Solum; Small alphabet stickers: Making Memories; Chipboard sticker: DCWV/ Far East Collection; Other: Ribbon, gold tassels

Decoding the Art of Asian Writing

The art of lettering, calligraphy, and the use of pen and ink are rapidly becoming things of the past, but the art of the hand-written word will continue perhaps due to the influence and beauty of Asian calligraphy and the Western fascination with the style. These projects by Andrea Blair, Sharon Chan, Heather Taylor and myself feature the use of either pen and ink or products that simulate pen and ink to create layouts inspired by some of the oldest written texts in the world.

From Pen and Ink to Digital Typefaces

The written word is an art form, of that there is no doubt. But how often do we look at the structural form words take—whether they are hand written, digitally printed, or hand printed on a letterpress. More often we simply absorb the meaning of a word. Perhaps as paper crafters we look at writing styles more often than the average person, and I have to admit I even check out typeface styles in the books I am currently reading. As a scrapbooker I look at words and the typeface in which they are set and see them more than simply as conveyers of meaning. I see beauty in the style of the typeface as well.

Looking at writings around Asia from the artist's perspective, there are so many exciting ways to use text and script in scrapbook layouts and paper projects. I love using text and script for background patterns in my scrapbook projects. Many paper companies have created patterned paper with text backgrounds, using different fonts for journaling and different languages for journaling or titles when appropriate. In this chapter I will introduce you to a few examples of Asian text, show you some inventive and creative ways to use different language and scripts in your projects and teach you some tricks for determining the correct orientation of the letters (or how to tell if they are upside down!). The study of the Asian art of writing cannot be complete without a discussion of the art of Sumi-e from Japan or the fine ink-and-brush paintings of China and Korea. This art form takes a lifetime of mastery, and where appropriate I will give tips on creating faux Sumi-e type projects in order to embellish your scrapbooks.

Thai, Japanese, Chinese, Korean
It's All Greek to Me . . . Learning to Use Asian Writing in Your Pages

One of the joys of living in the cultural milieu of Singapore is the daily interaction with multiple types of writing styles. Every day I see examples of English, Malay, Tamil and Chinese on signboards and in newspapers and even TV advertisements. When traveling around the region I see further examples of beautiful writings from Thai script to Korean, from Japanese to Khymer (the language of Cambodia). Each of these languages uses a different form of symbols or scripts to convey meaning through the written word. Some languages use characters that are similar to one another. For example, both written Japanese and Korean languages evolved from written Chinese characters. Other languages in the region are so strikingly dissimilar, there are no common letters or symbols, resulting in a real-life Asian version of the tower of Babel that gives the region an unparalleled exotic appeal. With a little bit of background knowledge, and a few tricks of the trade for telling the characters of one Asian language apart from another, you will become accustomed to using Asian characters and be able to spot the differences among them like a seasoned pro.

Chinese Text

Chinese characters have strongly influenced the writing systems of China's closest neighbors in north Asia; both Korea and Japan base many of its characters on traditional Chinese words. When using rubber stamps or other supplies that have Chinese text, one trick I use to make sure the characters are right side up is to think of the writing as a form of calligraphy. Chinese was traditionally

生 日 快 乐

MICHAEL WANTED TWO THINGS FOR HIS 13TH BIRTHDAY. TICKETS TO THE A1 GP RACE THAT WAS ON THE SAME WEEKEND AND A NEW TENNIS RACQUET.

十 三

少 年

A TEENAGER AT LAST !

MICHAEL CELEBRATED HIS

13TH BIRTHDAY ALONG WITH

MAX WHO TURNED 3.

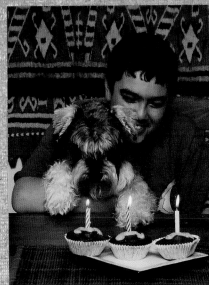

DAD HAPPILY BOUGHT MICHAEL A WEEKEND PASS TO THE GP RACE AND THEY SPENT TWO FULL DAYS WATCHING ALL THE ACTION. ON SUNDAY THEY CAME HOME AND WE CELEBRATED WITH A LAMB ROAST AND CAKE THAT MUM AND ALYSSA HAD BAKED FOR MICHAEL AND MAX. MICHAEL WAS ALSO GIVEN A CLOCK RADIO AND A HOT DOG MAKER FOR HIS BIRTHDAY.

Thirteen by Lynita Chin
Lynita often uses Chinese text in her layouts in order to connect her children to their cultural heritage. In this layout Lynita uses Chinese numbers and the words *Happy Birthday* (in Chinese) as the title of the layout as well as part of the story behind the pictures.
Supply Credits Patterned paper: BasicGrey, Scenic Route; Word twill: Making Memories; Brads: Making Memories; Stamp: Chinese "seal" and red ink

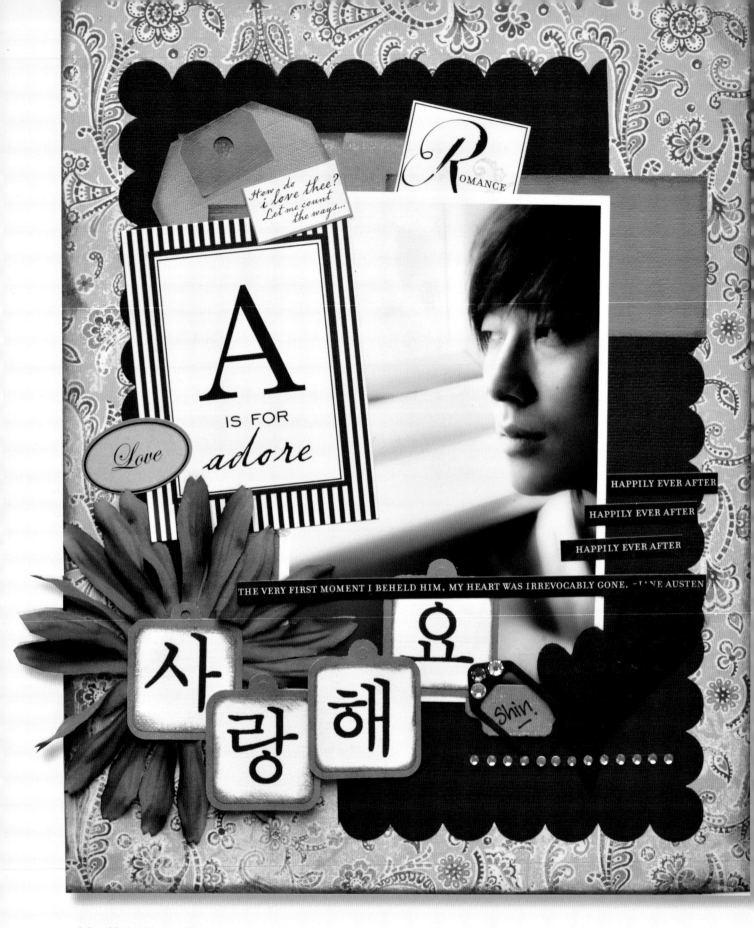

How do i love thee? Let me count the ways...

ROMANCE

A IS FOR *adore*

Love

HAPPILY EVER AFTER

HAPPILY EVER AFTER

HAPPILY EVER AFTER

THE VERY FIRST MOMENT I BEHELD HIM, MY HEART WAS IRREVOCABLY GONE. — JANE AUSTEN

사랑해요

Shin.

Adorable by Sharon Chan

Sharon uses Korean script to express her "love" for the Korean heartthrob Joo Ji Hoon, star of the Korean drama *Princess Hours*.

Supply Credits Scalloped cardstock: Bazzill; Patterned paper: My Mind's Eye/Bohemia; Die cuts: QuicKutz (tags, felt hearts); Stickers: 7gypsies/97% Complete; Flower: Prima; Bling: Heidi Swapp

Common Chinese Characters and Their Meanings

In most of this chapter we will focus on Chinese characters. There are good reasons for this! First, Chinese characters are found in Korean and Japanese languages and are often a unifying method of communication in Asia. Second, most of the mass-produced paper craft products that feature Asian text use Chinese characters. Using this list of common Chinese characters as a reference, have fun experimenting with the language and adding layered meanings to your projects.

Character	Pinyin (Phonetic Pronunciation)	Meaning
福	Fu (foo)	Blessings, good luck
和平	He Ping (huh ping)	Peace
和	He (huh)	Harmony
禄	Lu (loo)	Prosperity
寿	Shou (show)	Longevity
喜	Xi (she)	Happiness
喜喜	Shuang Xi (schwang she)	Double Happiness (used only for weddings/couples)
爱	Ai (i)	Love
美	Mei (may)	Beautiful
永	Yong (yong)	Eternity
友	You (yo)	Friend
心	Xin (shin)	Heart/mind
家	Jia (jaw)	Home
天	Tian (tea-n)	Heaven
土	Tu (to)	Earth
日	Ri (r)	Sun
月	Yue (uway)	Moon

written with a brush and ink. Most often (about 99 percent of the time) the strokes of the brush will end up with a downward stroke. When looking at the characters, if they look as if the strokes of the brush were going up, they are probably upside down. You can also use this trick with Japanese and Korean writing as well.

Korean Text

The Korean language has slight variations, when looking at the fonts, from Chinese and Japanese. When trying to determine in what language the text is most likely to be, I try to find visual clues in order to identify it. I can almost always identify the Korean language, and here is my secret. Korean characters tend to have true circles on the tops and bottoms of the words. (*Note*: In the layout on page 106, you can see the circles on characters printed in the bottom left on white cards.) While Japanese and Chinese characters may have curves, the Korean writing system is the only one with circles!

Japanese Text

Trying to identify Japanese writing is particularly challenging because the language itself is complicated. And the fact that the Japanese have four types of writing doesn't ease the matter either. The Japanese use Kanji, the Chinese formal characters, as one form of writing; and it is generally used for traditional Japanese or older words. The Japanese also developed two additional forms of writing, Hiragana and Katakana, for the modern language. To make matters more confusing, the three forms of writing are supplemented by a fourth, the Romaji—the Romanization of Japanese words. Most Japanese words are written in a combination of Kanji, Hiragana and Katakana, with Romaji used in street signs, passports and dictionaries.

When looking at the types of Japanese writing, Hiragana looks like a combination of traditional Chinese characters and Western cursive script. The letters have traditional brushstroke marks with loops or swirls. Katakana, the simplest of the Japanese texts, contains short straight strokes and angular corners. When you see Japanese Katakana

Indian Wedding
by Wendy Steward

In this layout Wendy uses preprinted papers with an Indian script and supplements the theme with her own writing in Hindi. This heritage layout of her grandfather blessing a Hindu wedding would feel less authentic with just English. Saving a piece of Wendy's cultural heritage by using Hindi truly makes this layout more special.

Supply Credits Cardstock: Bazzill; Patterned paper; Indian script; Mulberry paper; Ribbon: Francheville (Christmas Stripe); Fabric; Charms: Far Flung Craft; Felt flowers: Fancy Pants Designs; Stamp: Autumn Leaves; Other: Gold embossing powder

Kimono by Alanna Yeo

This digital layout by Alanna uses Japanese characters to further the Japanese theme of the layout. Alanna used a free digital kit called Echoes of Asia provided by *Creating Keepsakes* magazine to create this layout and then used Japanese writing to create the title.

Digital Layout Credits Creating Keepsakes/Jessica Sprague: Echoes of India kit (downloaded from www.creatingkeepsakes.com)

text next to Kanji or Chinese, the difference is obvious and noticeable. Compare the title in Alanna's Kimono layout (page 108) to the Chinese characters in *Thirteen* by Lynita (page 106) and see if you can tell the difference.

Hindi Text

Indian scripts look entirely different than north Asian script. The flowing script, which is read from right to left, is unified by what I call a bar across the top of each word.

Adding Some Hot Peppers to Your Projects
Spice Up Your Layouts with Asian Characters

Now that you know how to identify Asian characters, it's easy to begin using them in your layouts. But what do all those characters mean? I have heard from many scrapbookers and stampers that they wish they knew more about the words and their meaning, and how to use them correctly. Let's start with stamps. It's a logical place to start because there is an abundance of characters available in rubber stamps.

Rubber stamp companies have long seen a market for manufacturing rubber stamps using certain key words and phrases in Chinese. Mixed-media artists and rubber stampers love these stamps but often don't know the true meanings behind the words or phrases, using only the rough definition provided by the company. Personally, I know it is hard to get past the fear of working with a stamp: I've often thought a particular stamp was beautiful but was afraid to use it if I didn't know what it meant. To make your life easier, I have highlighted some of the most common symbols, explaining their meaning and most fitting use. A few example layouts will give you ideas on how to incorporate stamping into your layouts. I hope you are encouraged to expand your crafting horizon!

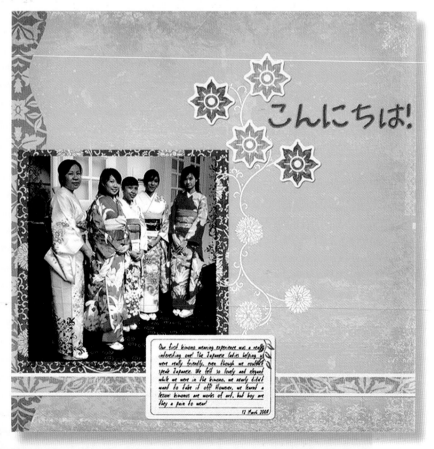

समुद्रे महंमहः सुवे पितरमस्य सर्वान्मम योनिरपस्वन्तः समुद्रेगमस्य मुखं

पृष्ठ ततोवितिरे मुक्तान्तमुं द्यां वर्षनीपस्पृष्णं अन्तु

महं एद्वेमित्यादिस्तद्दाचा वःपयो गायच्च मन्त्र

ममत्त्वो माद्या देवी देवता: देवीसूक्तजपे विनियोग: देवी देवता: देव्र

ग्रधदेवे: र्मिर्वसुमिध

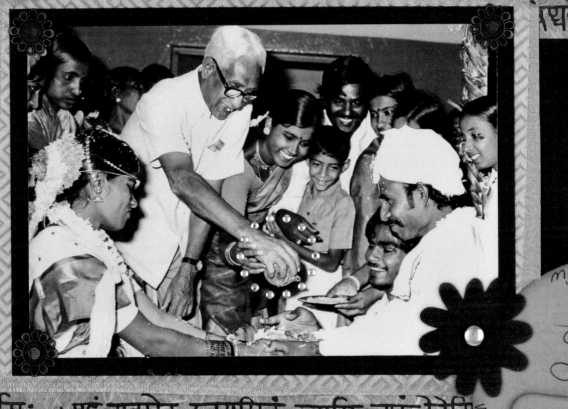

नमि: । गहंगहमेव स्वयमिदं वदामि तुएं देवेमि

नं समे कामये तं तमुत्र कृणोमि तं ब्रह्माण

गा उ रुह्याय घनतानितोमि अन्नदिसे पूर्वे

विवेश ।। गहं जनाय यमदं कृणोम्यहं द्यावापृथिवी मा कृण

My Grandfather Cyril Flory, blessing the Couple.

शादी
मुबारक

Vasantapai's

Wedding Congratulations

Bangalore India 1985

i
love
you

forever
for always and endlessly; forever now

july 2007

Forever by Lynita Chin

In this layout, Lynita uses the Chinese character for the word *happiness* (found on a small stamped embellishment to the left of the photograph). When creating the layout Lynita had originally intended to use her stamp for "Double Happiness." She knew that the characters for "Double Happiness" meant "love," and she thought it would be nice to use it in this layout in order to express her love for her son. After discussing this choice with her Chinese husband, she learned that the "Double Happiness" character should only be used to represent love for your partner/spouse or in connection with marriage and should not be used in other layouts. This is one of the cultural nuances that can really bring a level of authenticity to your work!
Supply Credits Cardstock: Bazzill; Linen patterned paper: Rusty Pickle; Chipboard coaster: Urban Lily; Chipboard coaster: Blue Cardigan Designs; Defined sticker: Making Memories; Brads: Making Memories; Dymo tape; Stamps: Stamp Craft; Ink: StāzOn

Double Happiness by Mei Ling Low

The characters "Double Happiness" are traditionally used in Chinese weddings to symbolize the union of the couple. While a number of folk tales surround the origin of the use of the "Double Happiness" characters the most popular one is that of a young man who had taken his college exams right before his wedding to a beautiful maiden. On the day of his wedding he also obtained the results of his exams and learned he had passed with flying colors. The day was one filled with double happiness, and now the use of the two characters intertwined is almost exclusively used for weddings.

Supply Credits Cardstock: Doodlebug Design Inc. (sugar-coated cardstock); Patterned paper: Chatterbox (Garden Medallions); Flowers: Prima; Bling frame: Heidi Swapp; Brads: Making Memories; Date rubber stamp: Cat's Life Press; Frame: Ikea

Strong Man by Kristy Harris

The character "Shou" is often seen on gifts and on birthday greetings. *Shou*, which means "long life," is a greeting of continued prosperity and a wish for a long and happy life. In this layout, the hand cut character was taken from clip art on the Internet and traced onto patterned paper. I then used a craft knife and cut the character to use as an embellishment in the layout.
Supply Credits Cardstock: Bazill; Patterned paper: Die Cuts With A View; Chipboard letters: Gin-X; Ink: VersaColor (green) StāzOn (black); Glossy accents: Hambly Studios; Journaling stamp: Autumn Leaves

Chinese New Year by Heather Taylor

The character "Fu" (which is seen upside down in this card) means "good luck" and "best wishes." The character is often seen inverted during Chinese New Year festivals, as the character in the Chinese language when upside down is a homophone of the phrase "luck comes" or "luck has arrived." During the Chinese New Year festival, the Chinese place the character upside down on their doors to assure that their homes will be lucky in the coming year.
Supply Credits Stamps: Art Neko/Taylored Stamps; Inks: VersaMark, VersaCraft, Encore; Embossing powder

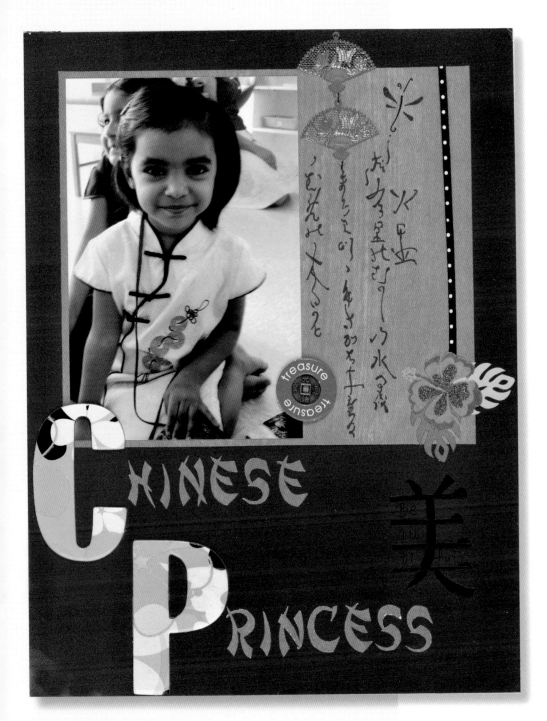

Chinese Princess
by Nishi Varshnei
The character for "Beautiful," "Mei," is one of the most common characters used in rubber stamping and other products manufactured with Asian text. Nishi has used the character as an accent in a layout featuring her daughter dressed up in a Chinese dress—a very fitting use. In this example, the character was applied as a sticker.
Supply Credits Cardstock; Patterned paper: Heidi Grace; Chipboard letters: Daisy D's; Charms: Far Flung Craft; Flower sticker: Jolee's; Other: Button

Source It!

Using Asian characters as design and decorative elements creates a unique style, but I find that it is much more fun, and adds an element of authenticity, if you can learn the meaning of the character. It is quick and easy to pick up a few books about Chinese/Asian culture (feng shui books are often a good start) to learn about auspicious and meaningful Asian words and sayings. It is also easy to find Chinese characters and their meanings online at Chinese language sites such as Zhongwen.com and Helena Jole's Scrapbooking Chinese Font, which includes common words found in Japanese, Chinese and Korean cultures.

More Than Just Words
Using Asian Text as Patterned Paper

Many paper craft manufacturers have found that using text, both Asian and Western, makes a striking patterned paper. You can find papers that look like old love letters and papers that are manufactured to look like newsprint. Chinese text is a favorite of many manufacturers, and you can almost always find variations of this paper in your local scrapbook stores. Rubber stamp artists have often made their own paper by using a Chinese text stamp and collaging it with other stamps to create one-of-a-

GONG XI FA CAI

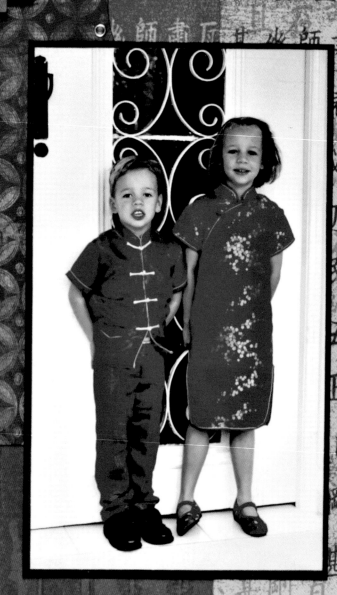

I bought these for Chinese New Year 2006 as the kids needed to wear traditional costumes to school. Instead of going to Chinatown and trawling the street market I did the rather easier and quicker thing of being ripped off something rotten in Holland Village. Still, they look very cute, don't they?

The school has so many dress up days that we got another wear out of the outfits for Cultural Day in October. I might add, that Paddy disliked his outfit so much it took all my guile and powers of persuasion (or is that bribery) to get him to a) wear it again and b) pose for the picture.

And the meaning of Gong Xi Fa Cai? Happy and Prosperous New Year, the Lunar one, that is.

Gon Xi Fa Cai **by Selena Hickey**
The blue paper used in this layout is decorated with Chinese text, which works well with its Chinese New Year theme. The colors of the papers coordinate with the children's red clothing, a classic Chinese color.
Supply Credits Patterned paper: My Mind's Eye (brown), Far and Away (Chinese text); Inks: ColorBox/Cat's Eye; Eyelets: Making Memories

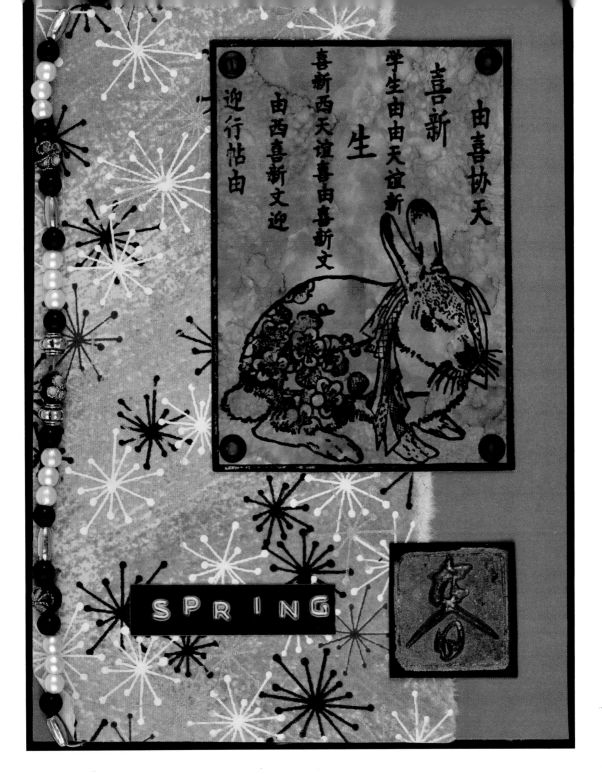

Spring Card by Ann Pennington

Ann stamped the image of the "haiku bunny" on a homemade patterned background. The background was created by applying alcohol inks—either Pinata or Ranger—onto a glossy cardstock and using a special blending liquid that allows the inks to run together and create a patterned background. She also stamped the Chinese word for *spring* into her own homemade mixture of Pearl Ex, UTEE and gold-embossing powder to create a faux Asian metal charm. To make the charm, Ann dipped the rubber stamp into melted UTEE and allowed the UTEE to harden around the stamped image before removing it in order to create a positive image of the stamp. Even up close the charm looks like metal! She embellished the card with pearls and cloisonné beads.

Supply Credits Stamps: Hero arts (haiku bunny), Stone House Stamps; Alcohol inks: Ranger; Washi/yuzen paper; UTEE: Ranger; Other: Pearl Ex embossing ink, gold embossing powder

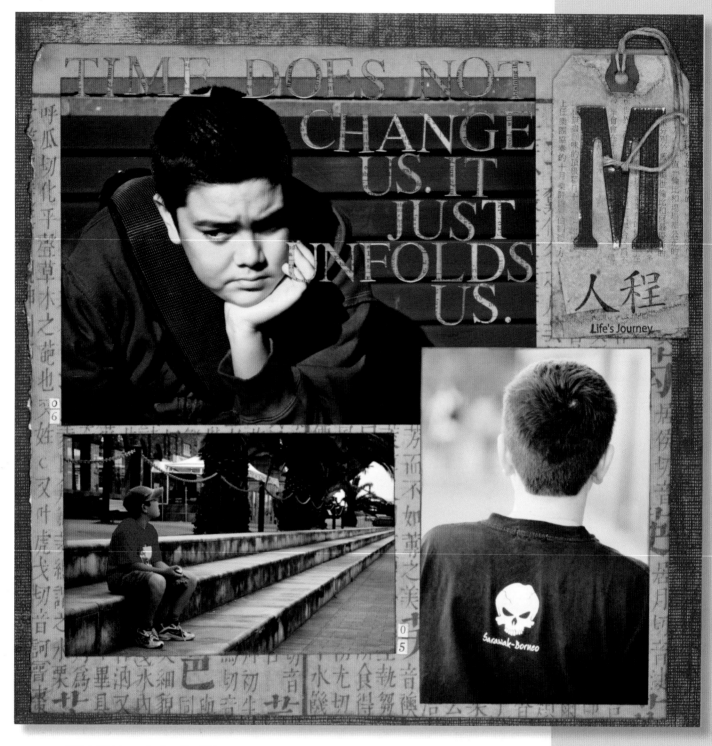

Time Changes by Lynita Chin

Rusty Pickle was one of the first manufacturers I came across that created a patterned paper made from a Chinese text. Their early papers are still some of my favorites, and I use those last few pieces I bought long ago whenever I can. The combination of the red paper with the antique-style Chinese text really accentuates the Asian flair of this project. In this layout Lynita has used the paper for sheer decorative effect. Though the subject of this layout isn't Asian, Lynita's use of Asian motifs, colors and text works beautifully. You can add Asian flair to any layout!

Supply Credits Cardstock; Patterned paper: BasicGrey; Chinese text: Rusty Pickle; Tag: Rusty Pickle; Alphabet stickers: Marcella; Chipboard letter: Pressed Petals; Tiny alphabet stickers: Making Memories; Inks: StāzOn Ink (black); Stamp: Kaiser Stamps (Life's Journey)

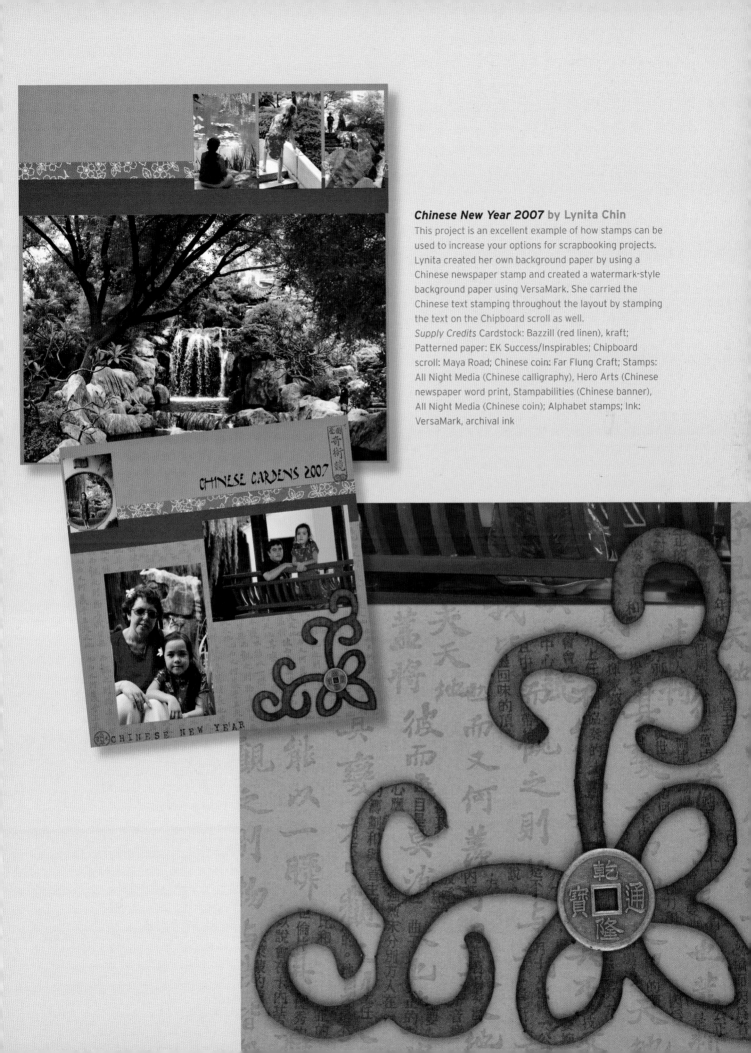

Chinese New Year 2007 by Lynita Chin
This project is an excellent example of how stamps can be used to increase your options for scrapbooking projects. Lynita created her own background paper by using a Chinese newspaper stamp and created a watermark-style background paper using VersaMark. She carried the Chinese text stamping throughout the layout by stamping the text on the Chipboard scroll as well.
Supply Credits Cardstock: Bazzill (red linen), kraft; Patterned paper: EK Success/Inspirables; Chipboard scroll: Maya Road; Chinese coin: Far Flung Craft; Stamps: All Night Media (Chinese calligraphy), Hero Arts (Chinese newspaper word print, Stampabilities (Chinese banner), All Night Media (Chinese coin); Alphabet stamps; Ink: VersaMark, archival ink

You're the....

Sunshine

On my shoulders

On a breezy spring day

♡ best

友friends

kind backgrounds or embellishment for layouts or as artworks in their own right. Don't forget that your craft need not be limited by what's available from manufacturers—you can create your own products as well.

The Digital Toolbox
Using Your Computer as a Scrapbooking Tool

The Internet is a huge part of my scrapbooking toolbox. I can't imagine a day without looking at layouts posted on message boards, reading blogs from my favorite scrapbookers and of course window-shopping at my favorite online craft stores. The other thing I love using the Internet for is searching for new, fun fonts from the tens of thousands available for downloading. There are a number of great font sites that include Asian-inspired or Asianlike fonts. (I have listed one of my favorite Web sites in the Resource Guide.) You can also find free (or low-cost) fonts and digital brushes that use authentic Asian characters for use in journaling and titles.

Friends by Andrea Blair

In this project the rubber stamp "You," pronounced "yo," means "friend" in Chinese. While in most cases in the spoken context you will hear the full word *pengyou*, this phrase can also be used. Andrea combined the stamped title on this card to make a lovely greeting.
Supply Credits Cardstock: Bazzill; Patterned paper: My Mind's Eye; Ribbon: Offray; Rub-ons: American Crafts; Tag; Stamps: Technique Tuesday; Felt flowers: American Crafts; Ink: Ranger (distress ink)

Love by Kristy Harris

I stamped the title *Love*, "Ai" in Chinese characters, as a title for this layout of my sister and her fiancé. The character "Love" is the same in the Japanese language as well. In order to make this stamp appear more like a true calligraphy stroke and not just a stamp, I used real sumi-e (Japanese calligraphy ink) and brushed it onto the stamp before stamping it onto the paper. I also used a non-coated cardstock in order to have the ink absorb more into the paper.
Supply Credits Patterned paper: K&Company (green-and-red), Scenic Route (black-and-white). Stamp: All Night Media; Rub-ons: 7gypsies (Love), Lazar StudioWERX

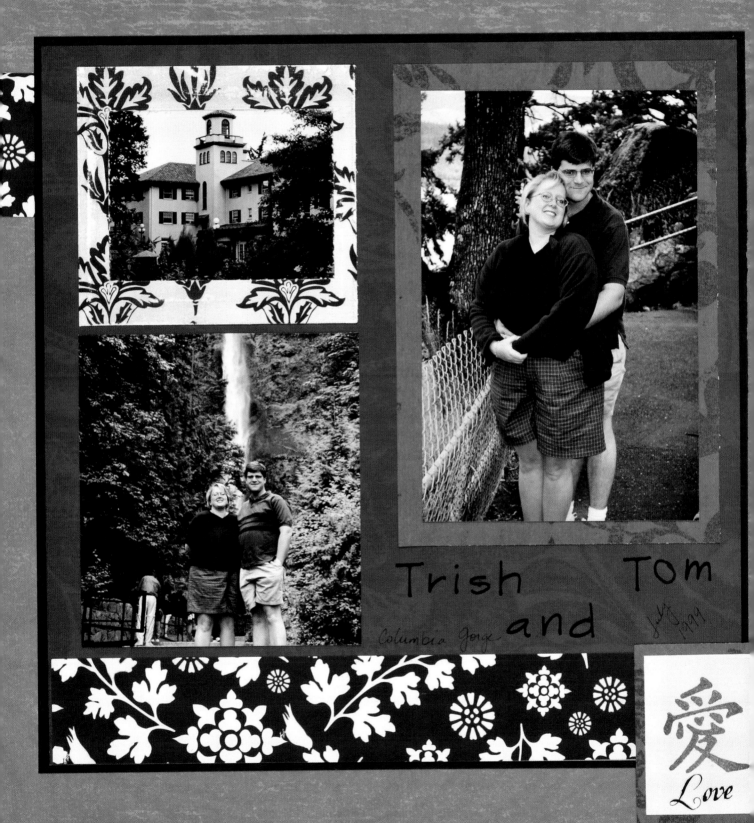

Trish and Tom

Columbia Gorge

July 1999

愛
Love

Street Life
by Selena Hickey
Selena used a faux Indian font called Samarkan for this layout. Using bright colors and vibrant patterns, this layout exemplifies the busy nature of the area of town in Singapore known as Little India. Adding the title treatment in a faux Hindi script ties the whole project together.
Supply Credits
Patterned paper, fibers: BasicGrey; Font: Samarkan (downloaded from the Internet)

Taekwon Do
by Nishi Varshnei
One of the pleasures of the Internet is having immediate access to a worldwide scrapbooking community. Nishi was on an online message board one day asking about the Korean spelling of *Taekwon do*, and much to her surprise a couple of weeks later she received a gift in the mail—a hand cut title for use in her layout. The use of the Korean language adds a degree of authenticity to the layout, and the beautiful handwork in the project is a great bonus.
Supply Credits Cardstock; Patterned paper; Round tag: Avery; Fibers; Hand cut Korean title: Helena Jole

streetlife

little india

Street Colour

Deepavli lights

CHINATOWN

Our first experience of Chinatown was on a public holiday when we took 5 kids, 4 adults & 2 pushchairs. Big, big, BIG mistake. The place was so crowded we kept losing sight of one another and it was all rather frightening. So when I arranged to take my father in March 2006 I was a little apprehensive. However, I needn't have worried. The street market was very quiet and we were able to saunter around very easily even with a pushchair and all the children.

The area is made up of shophouses built in the 1920s, some of which are very dilapidated, others that have been done up to a high standard, but the majority are hidden behind the permanent market stalls, which are entertainingly decorated if rather touristy. It certainly doesn't feel like somewhere the locals go to shop, unlike Little India. However, if you look at the high rise buildings in the back of the photos you will see HDB flats aplenty for the locals, so plenty of locals live in the area.

Walking round Chinatown was a pleasant way to spend an afternoon but not somewhere I would rush back to especially with the kids in tow.

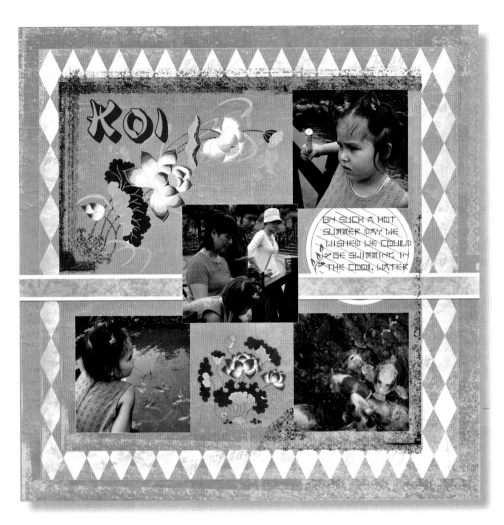

Koi by Julie Kosolofski-Kuo
Julie's Koi layout uses two fonts, one as a title and one for journaling. Keeping the journaling to a minimum, Julie was able to maintain the legibility of the text.
Digital Layout Credits Echoes of Asia Kit, Jessica Sprauge for Creating Keepsakes Download at www.creatingkeepsakes.com; Clipart: Dover; Fonts: Far East (Journaling), Pagoda Caps (title)by Macromedia

Chinatown
by Selena Hickey
Printing the title in a faux Chinese font called Deng Thick on top of the Chinese-text patterned paper gives this title treatment interesting depth. Selena cut the paper strip to the size she wanted, typed her text vertically using Word Art and printed it. Even if you don't have a printer that can print on 12 x 12-inch (30.5 x 30.5-cm) paper, this is one method of getting text that is nearly 12 inches (30.5 cm) in length.
Supply Credits Cardstock: Bazzill; Patterned paper: BasicGrey (yellow), Far and Away (red Chinese text); Font: Deng Thick (downloaded from the Internet); Other: Eyelets

Most of the Internet sites that offer free fonts give you the ability to search by types of fonts—most of the Asian-inspired fonts can be found in categories such as "foreign" or "Asian." Because these fonts are a bit harder to read than traditional fonts created for legibility they tend to be better for use as titles, though they can be used for limited journaling. A few of my favorites fonts for my Chinese and Japanese page titles are Chinese Takeaway and Samuri. I also like using AW Siam English Not Thai, a fun faux Thai font that mimics the look of Thai letters. Another popular faux font is Samarkan, a Hindi-inspired font for use on Indian-themed projects. All of these fonts are freeware, which means they are available for download onto your computer without any additional license fees or charges. One of the goals of scrapbooking is to preserve memories, and to bring the family together. An evening spent looking at scrapbook pages can be a lot of fun! Using Asian text and fonts in your projects adds an interesting

dimension and one-of-a-kind flair that is a sure conversation starter.

The Sky's the Limit
Digital scrapbooking is becoming more and more popular as hundreds of new digital scrapbook pages and kits are being created every day. An Internet search for Asian digital kits will result in dozens of hits, and some of the kits are even free for a limited time. As scrapbookers become more computer proficient, the resources available for finding Asian-inspired products will increase.

So why limit your use of the Internet to downloading digital fonts or chatting? There really are not limits to what can be created digitally. You don't even have to be a digital scrapbooker to take advantage of digital resources. If you have a full-size printer you can print out the "digital" paper and use it like regular patterned paper. The art of "hybrid" scrapbooking—the blend of traditional paper and digital scrapbooking— is becoming

Gift by Heather Taylor

Heather is a stamper who has become a very adept digital scrapbooker. In this layout she created the entire composition by using Photoshop and her own artwork. The addition of the bamboo elements and the Chinese word for *gift* makes a great nontraditional holiday layout. *Digital Layout Credits* All artwork done by the artist

increasingly popular and for good reason. It is easy, inexpensive, fun and a great way to involve younger people in the hobby!

The layouts in this section were made with digital elements that were either downloaded off the Internet or created by the designer. One of the great advantages of digital scrapbooking is that once you purchase or download the kit you can reuse the elements thousands of times, if you wish. And working digitally saves a lot of space in your scrapbook room—that is for sure!

Bong Bong Train by Julie Kosolofski-Kuo

The Chinese language is a great one for using onomatopoeias—you know, those fun words that imitate the sound they are describing—and this layout is about the "Bong Bong" train. The train, named "Bong Bong" because of the sound it makes as it chugs along the tracks, is highlighted in this digital layout due to Julie's use of a large photograph of the train as her background. Using Chinese in the title helps convey the fact that train is located in Taiwan. *Digital Credits* Frame cluster: Let's Scrap (downloaded from letsscrap-theblog.blogspot.com/2007/07/busy-week-over-there-but-still-freebie.html); English font: Bookman Oldstyle; Chinese font: PmingLiU

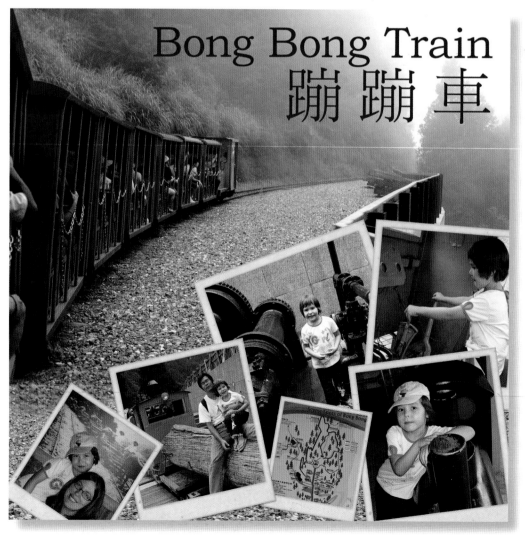

It is such a deli

124

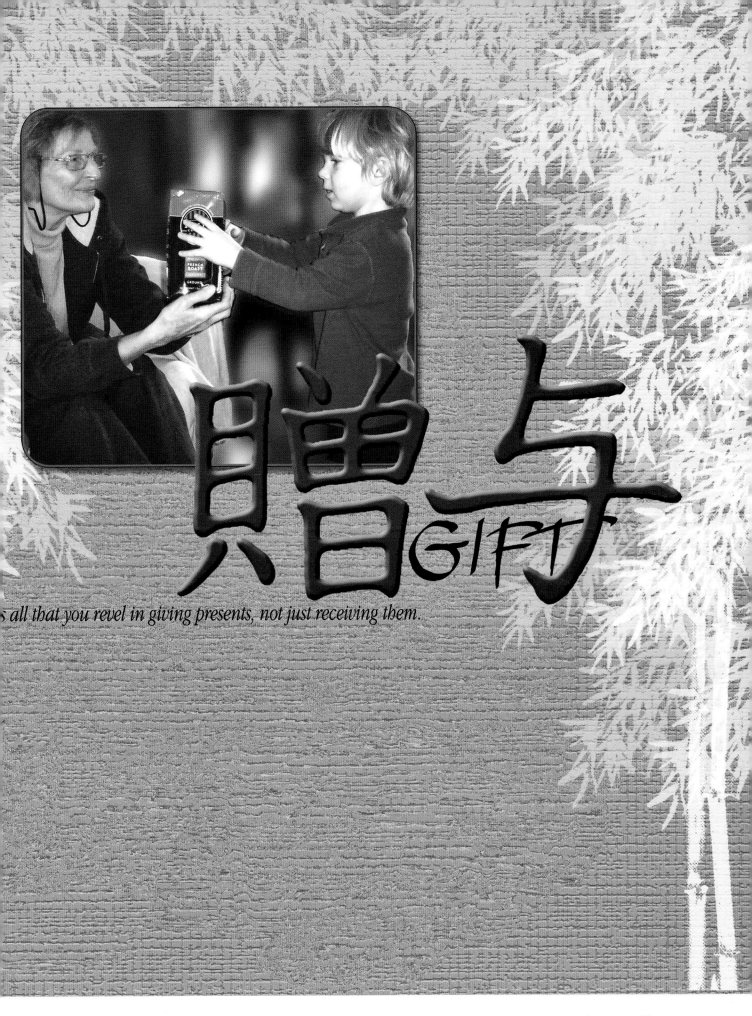

贈与GIFT

s all that you revel in giving presents, not just receiving them.

Balinese Beauty

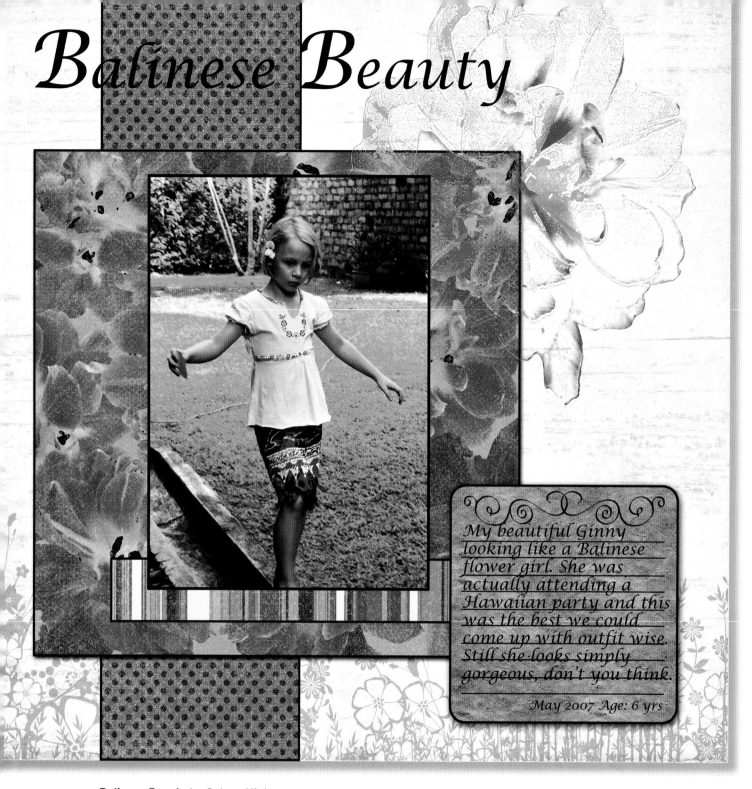

My beautiful Ginny looking like a Balinese flower girl. She was actually attending a Hawaiian party and this was the best we could come up with outfit wise. Still she looks simply gorgeous, don't you think.

May 2007 Age: 6 yrs

Balinese Beauty by Selena Hickey
In this layout Selena has wonderfully expressed the tropical beauty of Bali with a digitally created floral background inspired by Asian flowers. Her use of bright orange and yellow helps set the tropical scene.
Digital Layout Credits Papers, flower brush: oscraps.com/Jan Crowley, "Queen of Quirk"; Tulip flambe journaling tag: oscraps.com/LaWanna Desjardin; Retro Funk Meadow Brush; Design fruit, Japanese foliage: Jason Gaylor; Font: Lucida Calligraphy

Beth by Vidya Ganapati
Vidya also used the Jason Gaylor brushes on this layout, showing how versatile these designs are. In this layout the digital brushes are used similar to rubber stamps or other embellishments in a traditional layout. The digital brushes, inspired by Japanese floral artwork, have made their way into fairly mainstream graphic design circles and can be seen everywhere from digital scrapbook layouts to advertisements on TV and in the press.
Digital Layout Credits: Floral brush (Jason Gaylor/Design Fruit)

beth.
my friend.
my scrapbook buddy.
we laugh.
we scream.
we are crazy.
we scrapbook on the floor.
someday, she's going to be on oprah for doing something cool.
she's also going to b
an amazing nurse.
yup, she's pretty awesome.

Putting It
All Together

Microscope Slide Wall Hanging
by Ann Pennington

This clever and one-of-a-kind project is inspired
by microscope slide mailers, which are available
through most rubber stamp stores.

15 Projects to Flaunt Your Asian Flair

Now the fun begins! In this chapter you have a chance to flex your Asian design muscles. The fifteen step-by-step projects that follow utilize, in differing degrees and combinations, the five basic Asian design themes to which you've just been introduced—composition, colors, motifs, fabrics, papers and text.

In most cases the general crafting supplies listed in the "Basic Toolbox" are all that you'll need to complete the projects in this book. As a fellow scrapbooker, I've assumed that you already have on hand the "Basic Tools," so they aren't repeated in the Materials Needed list for each project. Please double-check your own "toolbox" and read projects before starting them to make sure you have everything you need on hand.

Before we go any further I want to make a quick comment about heritage layouts and preservation of photographs. As a scrapbooker, one of my main concerns is about the long-term preservation of my photographs. To maintain the archival quality of scrapbooks, most scrapbookers use paper and embellishments that are acid and lignin free.

As you already may know, acid and lignin are the enemies of preservation scrapbooking. Lignin, a by-product of the wood pulp paper-making process, causes paper to turn brown and brittle. Acid, which is often found in craft products such as glue, will cause your photos to yellow and fall apart over time. If you are preparing heritage projects, make sure to look for acid/lignin-free products.

While most of the materials used in this book are acid and lignin free, a few aren't. Whenever you are creating a scrapbook you need to determine if your intent is a heritage project containing original photographs to pass down for generations, or if it is to be a project to enjoy now. If you are using nonarchival materials, please, for the sake of your photographs, use duplicate copies and save the originals for later. I love creating artwork that is a bit more temporary in nature, but I wouldn't use the only copy of my son's kindergarten picture for it, and I hope you won't either.

Basic Toolbox

Basic Tools: Paper trimmer, Scissors, Double-sided tape, Bone folder, Anywhere hole punch, Eyelet setter and hammer, Paper piercer, Glue, Ruler, Craft knife, Self-healing cutting mat

Paper: Basic cardstock and patterned paper from manufacturers of your choice

Adhesives: Glue sticks, Double-sided tape, Liquid glue, Heavy-duty glue (such as E6000), Xyron adhesive, Glue dots or glue foam squares, Decopodge such as Mod Podge

Other Items: Fine-grit sandpaper, Paint-brushes and foam brushes, Make-up sponges, Rubbing alcohol, Mister, Acrylic paints, Inks, Rubber stamps

Lotus Card by Brenda Marks

Using photographs of a lotus and featuring Japanese Zen-inspired colors, Brenda has created a wonderful greeting card with an Asian flair. She used rubber stamps to create a pattern featuring Asian text on handmade paper; and she used a monochromatic green color scheme, highlighting the focal point of the card with a dash of color.

Supply Credits Stamps: All Night Media; Ink: Tsukineko/Versamark

MATERIALS NEEDED
8¹/₂ x 5¹/₂-inch (21.5 x 14-cm) olive
 cardstock
2¹/₂ x 3-inch (6.5 x 7.5-cm) pink
 cardstock
Craft knife
Template (see page 186)
Ruler
Rubber stamp
Ink
Handmade/mulberry paper
Scrap paper
2 photographs (1 photo trimmed to
 2¹/₂ x 2¹/₂-inch (6.5 x 6.5-cm) plus
 1 smaller rectangular photo)

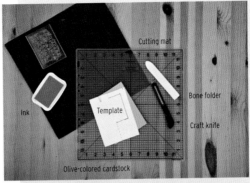

Acrylic stamp with
Chinese text

Cutting mat

Bone folder

Craft knife

Ink

Template

Olive-colored cardstock

Step 1. Trim olive cardstock to measure 8¹/₂ x 5¹/₂ inches (21.5 x 14 cm) and fold it in half. Align the template with the right edge of the cardstock.

Step 2. Open the card (so you can cut through only one layer) and cut on the solid line of the template using a craft knife. Score, by using a bone folder on the dotted line, in order to make folding easier.

Step 3. Fold the right edge of the cut side back onto the rest of the cardstock. Using a bone folder, score the cardstock along the left edge that was folded back.

Step 4. Score the card at the point where the folded-back edge touches in order to fold the card "in half." After folding, score again to make a smooth fold. Trim the card as needed.

Step 5. Place scrap paper in the "window" as well as under the fold in order to protect the cardstock. Stamp the text image using VersaMark watermark ink or an ink color of your choice.

Step 6. Once the ink is dry, mount the square photograph onto the 2¹/₂ x 3-inch (6.5 x 7.5-cm) pink cardstock. Mount it in the window so that the olive cardstock shows.

Step 7. Glue the handmade paper to the base/inside of the card and trim. Mount the smaller rectangular photograph to line up with the window above in the lower right-hand corner of the card base.

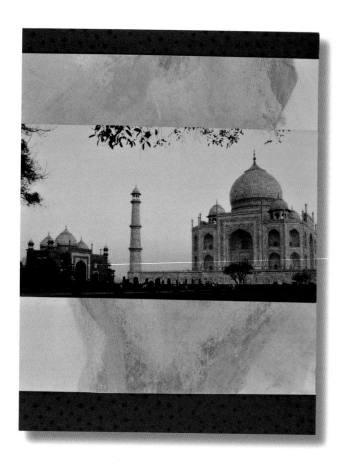

Taj Mahal by Brenda Marks

Creating your own patterned paper using stamping ink is a great way to expand the use of your crafting supplies. To create a greeting card featuring a picture of the iconic Taj Mahal, Brenda has chosen the luxurious jewel-tone colors of India.

Supply Credits Ink: ColorBox (chalk inks: warm violet, azurite, ice jade), VersaMark; Stamp: JudiKins

MATERIALS NEEDED
Coated matte photo paper
1 piece 8$\frac{1}{2}$ x 5$\frac{1}{2}$-inch (21.5 x 14-cm) cardstock, folded in half
Chalk inks
Tissues
Photograph
Stamps
VersaMark ink for pattern on cardstock

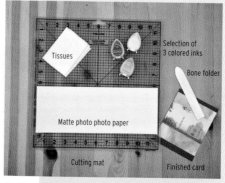

Step 1. Take coated matte cardstock (you can also use coated matte photo paper for your ink-jet printer). Chalk inks will resist one another when applied in layers.
Step 2. Apply color to a portion of the cardstock and let dry. (It's best to start light and progress to dark.)

Step 3. When the first color is dry, apply a second color slightly overlapping the first color, and quickly wipe off the excess ink in the overlapping area with a tissue. The first color will remain unchanged.

Step 4. Let the second color dry and repeat with the third color. You can continue to overlap colors until the cardstock is completely covered.
Step 5. Stamp the dotted background with VersaMark ink on purple cardstock.

Step 6. Assemble the card with photos on the newly created "patterned paper."

Turkey by Kristy Harris
(Technique created by Ann Pennington)

I made this project using the technique Ann Pennington created and used in *Beauty*, and with the natural colors associated with Japan. The seasonal theme of Thanksgiving works well with the Japanese earth-toned colors of yellow, orange, green and umber.
Supply Credits Glossy photo paper; Mulberry paper; Embossing powder: Ranger; Embossing ink: Ranger/Tim Holtz Distress Embossing Ink; Sakura stamp: Kodomo; Ink: Tsukineko/Kaleidacolor

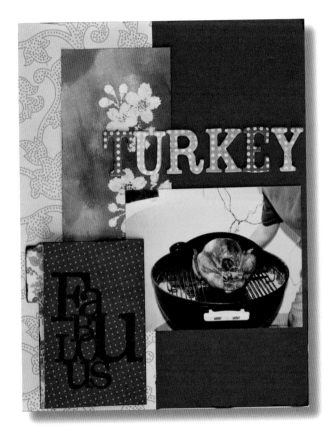

Step 1. Stamp the image onto the mulberry paper using embossing ink or VersaMark ink. Sprinkle embossing powder over the stamped images until covered and shake the excess powder off to reuse.

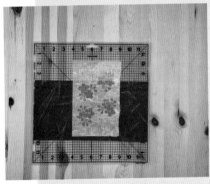

Step 2. Heat the embossing powder with a heat gun until the powder is melted (due to the mulberry paper's thinness, I find it easier to emboss by holding the paper in the air and heating it with a gun from the underside).

Step 3. Place the glossy cardstock or photo paper, glossy side down, on top of the stamped/embossed image. Place the white scrap paper on top and go over the paper with the hot iron (no steam) to transfer the embossed images onto the glossy card. Remove the scrap paper and lift one corner of the glossy card to see if the images have transferred. The glossy card must be removed from the mulberry paper while the embossed area is hot. If it cools, just place the iron on the back of the glossy card and move it along the card while you slowly peel the card off the mulberry paper. The glossy card will now have a negative image, slightly embossed.

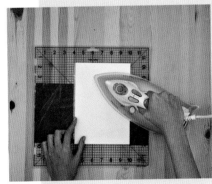

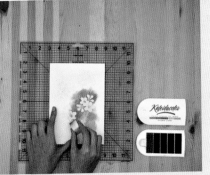

Step 4. Add the inks using a sponge or cut-and-dry foam. When you're happy with the results, wipe over it with a paper towel to remove the ink from the embossed areas. The embossed areas will resist the ink.

Step 5. Assemble the layout as desired using your new paper. The mulberry paper can be used on another project.

Rattan Weave Card
by Brenda Marks

It's easy to add depth to your projects by creating a woven background with paper. Using the same woven design found in many rattan baskets in Southeast Asia, Brenda's project takes a bit of time but is a fun way to add dimensionality in a distinctively Asian style.

Supply Credits Cardstock: Bazzill

MATERIALS NEEDED

8$\frac{1}{4}$ x 11$\frac{1}{2}$-inch (21 x 29.75-cm)(A4)
 cardstock folded in half to make card
Same sized cardstock in a second color
$\frac{1}{8}$-inch (3.2-mm) doublesided tape
Paper trimmer
Embellishments
Stamps and other items desired to finish
 project

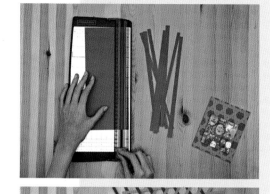

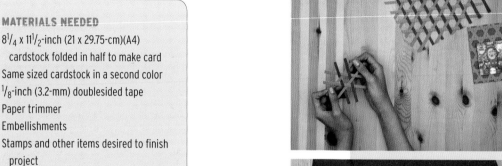

Step 1. Cut 24 pieces of cardstock $\frac{1}{4}$-inch (6.5 mm) wide and approximately 11 inches (28 cm) in length.

Step 2. Starting with 6 strips of paper, create the initial woven design from which the rest of the weave will be based. Start with two strips placed vertically and about 1 inch (2.5 cm) apart from one another (see the purple strips in the second photograph). Place the second two strips (the orange strips) on top of the first two at a 45-degree angle and oriented to the right. Do not weave these; just place them on top. Take a fifth strip (the green one in the photograph) and weave it between the four. Moving from the right to the left, weave the strip at a 45-degree angle to the left, going under the purple strips and over the orange strips. The second green strip will be woven the same way—under the purple and over the orange. This is now the base for the rest of the weave.

Step 3. After you have started to weave a portion, take a $\frac{1}{8}$-inch (3.2-mm)-wide double-sided tape to attach to the back to give the weaving some strength and prevent slipping.

Step 4. After you begin the initial weave, take one strip and weave it in. Rotate the weaving counterclockwise to add another strip. The pattern will remain consistent throughout the weaving with the same strip.

Step 5. Continue to weave by adding additional strips until it reaches your desired size, remembering to tape the back from time to time.

Step 6. Attach the weaving to the front of a card (or onto other paper) and then trim it to size. Embellish as desired.

Happiness
by Brenda Marks

The picture of the Fu Dog in this card was made by using a medium that was specifically designed for image transfers (Sheer Heaven). The Fu Dog means "good luck," in Chinese culture, and this card features creative use of cardstock and even dry goods from your pantry!

Supply Credits Cardstock: Bazzill; Patterned paper: My Mind's Eye/Bohemia; Image transfer paper: Sheer Heaven; Stamps: Hero Arts, Stamp Studio; Ink: Brilliance Moonlight White, Red, and VersaMark; Other: Hot press watercolor paper

MATERIALS NEEDED
Hot press watercolor paper (or other porous art paper)
$8^1/_4$ x $11^1/_2$-inch (21 x 29.75-cm) (A4) red and blue cardstock
Rubber stamps
Image transfer paper (Sheer Heaven)
Inks of your choice (such as VersaMark and Brilliance Ink)
Digital images
Alphabet noodles

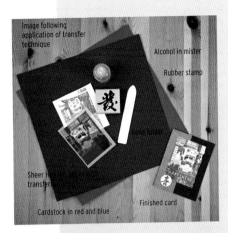

Image following application of transfer technique

Alcohol in mister

Rubber stamp

Bone folder

Sheer Heaven paper with transfer image

Finished card

Cardstock in red and blue

Step 1. To create the image on the image transfer paper, choose your image and use your ink-jet printer to print the desired image onto the rough side of the Sheer Heaven paper. Let dry.

Step 2. Cut the receiving paper (in this case the hot press watercolor paper) to the desired size and transfer the image to watercolor paper. To transfer the image using the Sheer Heaven paper, mist the printed image (the rough side of the paper) with 70 percent isopropyl alcohol and set the dampened image face down on the watercolor paper. Burnish evenly across the image once with the edge of a bone folder and remove the Sheer Heaven paper. Set aside to dry.

Step 3. Stamp the dots on red cardstock with VersaMark ink to create a watermarked effect.

Step 4. Prepare the letters by taking the alphabet noodles and taping them lightly onto double-sided tape. Color the letters with Brilliance ink and heat set by using your embossing gun and heating until the ink is dry. Repeat until you get the color on the noodles that you desire.

Step 5. Stamp a "Happiness" character onto white cardstock and punch it out with a 1-inch (2.5-cm) punch.

Step 6. Assemble the card. Using the red cardstock as a base, fold it in half to make a card. Take a strip of blue cardstock and align it with the left side of the card along the fold and glue down. Attach the photo transfer using your favorite adhesive, glue the title made out of noodles using the craft glue and embellish with your rubber-stamped Chinese text.

Vietnam Album
by Brenda Marks

Using batik fabrics and Japanese print fabrics, Brenda created a handmade memory album as a way to showcase pictures of a trip to Vietnam. The album, which requires no sewing, is a wonderful and unique project that remains a treasured keepsake. *Supply Credits* Fabric; Fabric starch: Golden GAC 400

> **MATERIALS NEEDED**
> One 8½ x 11-inch (21.5 x 28-cm) piece of fabric prestiffened with Golden Gac 400 (or other starch)
> One 8¼ x 5¼-inch (21 x 13.3-cm) piece of coordinating fabric
> One 4 x 22-inch (10.2 x 66-cm) accordianfolded paper strip (each fold should make a page no wider than ⅔ inch (16.8 mm) to fit inside finished book)
> Pictures and other items to embellish book

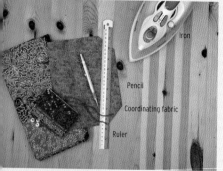

Prestiffened fabric
Finished fabric
Iron
Pencil
Coordinating fabric
Ruler

Step 1. Fold the prestiffened 8½ x 11-inch (21.5 x 28-cm) piece of fabric in half to make an 8½ x 5½-inch (21.5 x 14-cm) rectangle. Mark the center line lightly with a pencil (or press a center line with an iron, if desired).

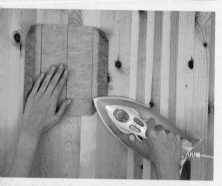

Step 2. Open and fold again by folding the ends to the center line. (You can mark these lines with a pencil if you want or press to get the lines.)

Step 3. Open and fold the edges in to create a ¾-inch (20-mm) "seam." Press and fold the corners over, pressing again.

Step 4. Refold the second fold to the center line and press.

Step 5. Turn over and fold up the bottom half of the fabric approximately 2¼ inches (5.7 cm).

Step 6. Fold down the top approximately 2¼ inches (5.7 cm).

Step 7. Reopen the fabric and insert the coordinating piece of fabric between the center of the folds.

Step 8. Fold again as in steps 5 and 6 and tuck in the corners of one edge to hold the folder together.

Step 9. Add pictures and embellishments to one side of the accordion-folded paper and tuck the edges of the paper into the front and back cover of the folder.

Step 10. Decorate the outside of the album with stickers/labels and charms.

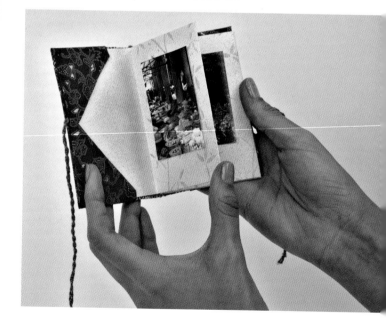

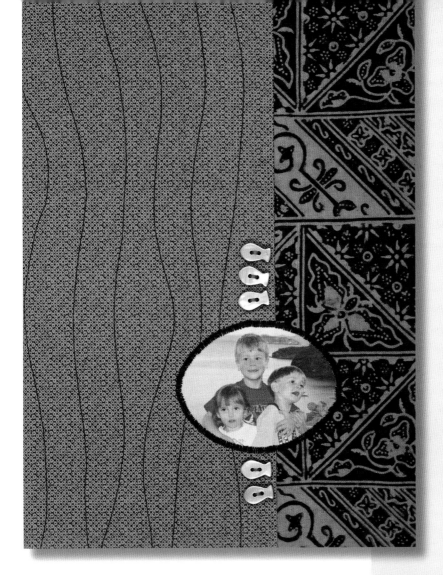

Step 1. Measure the notebook when closed from the far right edge of the front cover to the far edge of the back cover. Add about $1/4$ inch (6.5-mm) for give in the cover. Measure the front cover from the top to the bottom and again add at least $1/4$ inch (6.5-mm) allowance.

Step 2. Plan the cover design: Cut the material, piece it together and set aside. Make sure you add additional fabric on the ends that are at least $1/4$ the total distance of the front edge to the back edge in order to make a pocket to keep the notebook in place. Transfer the photograph onto fabric following the manufacturer's directions.

Step 3. Cut interfacing the size of the measurements of the cover. Use interfacing as the guide for cutting your fabric and include flaps and seam allowances of at least $1/4$ inch (6.5 mm) on the top and bottom.

Step 4. Fuse the interfacing, by using a hot iron or according to the directions provided by the fusing manufacturer, to the back side of the fabric. Sew embellishments and the photograph printed onto the fabric on the front cover. Finish the seams by folding up the top and bottom edges to make a seam and the edges on the sides of the flaps.

Step 5. Sew the flaps together by folding them with the "right sides" (or the sides of the fabric with the boldest colors of the print) together and stitch across the top and bottom, trimming the excess fabric to reduce the bulk. Now the right sides of the fabric will be facing each other and sewn in place. Turn the fabric right side out so that pockets are created. Carefully clip the inside covers near the flaps to allow the top and bottom seams to lay flat. The final seams can be folded over to make a finished edge. Cut fusible tape to fit and fuse the seams to finish the edges. Slip the notebook front and back covers inside the pockets and enjoy your book cover!

Ocean Kids Notebook Cover
by Brenda Marks

Using an Indian block print fabric, Brenda made a great cover for a notebook using pictures of my kids with their cousin. *Supply Credits* Fabric: Indian block-printed fabric, coordinating cotton fabric; Transfer paper: HP, Epson or other brand; Other: Buttons, thread, fusible interfacing

MATERIALS NEEDED

Blockprinted Indian cotton

Blue cotton

White muslin

Fish Buttons Photo Transfer Paper
 for use with fabric

Heavyweight fusible interfacing

Sewing machine and thread

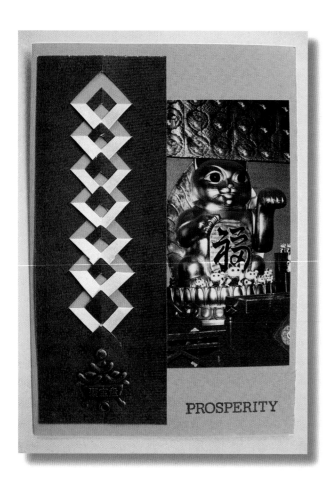

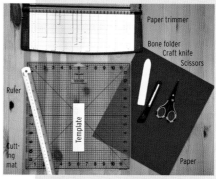

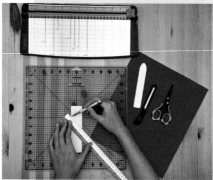

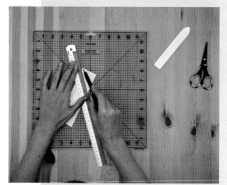

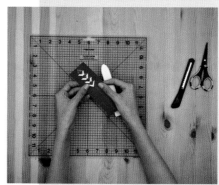

PROSPERITY

Prosperity Card by Kristy Harris

This project uses the lattice fold. A number of templates can be purchased that assist by drawing the cutting lines required to do this fold, but making the template yourself is simple. To make your own template, you will either need to use graph paper or your own grid. This example is for a 2 x 5-inch (5 x 12.5-cm) lattice that will be used as an element for the card. *Note:* The lattice fold itself is much more striking when the paper is colored on one side and white or very light colored on the other.

Supply Credits Blue paper: A Very Useful Paper Company/ Memory Block 2; Stamp: Vicki Enkoff; Charm: Far Flung Craft; Brads: Making Memories; Ink: Ancient Page (Cardinal)

MATERIALS NEEDED

One piece 8$\frac{1}{2}$ x 6-inch (21.5 x 15.2-cm)
 cardstock, folded in half
One colored 2 x 5$\frac{1}{2}$-inch (5 x 14-cm) paper
 strip
Asian charms
Brads
Stamp and ink
Photograph
Graph paper or scratch paper
Pencil and ruler
Craft knife and adhesive

Step 1. Draw two lines $\frac{1}{4}$ inch (6.5 mm) apart from the top of your template to the bottom. Then make $\frac{1}{4}$-inch (6.5-mm) marks down the side of the template and draw parallel lines. You will end up with a grid with $\frac{1}{4}$-inch (6.5-mm) squares.

Step 2. Draw lines diagonally from the top of the first horizontal line to the outside vertical line. Draw a second diagonal line connecting the second vertical line to the inner horizontal line. Continue drawing diagonal lines, alternating between long and short lines.

Step 3. For a finished edge, the last $\frac{1}{2}$-inch (12.7-mm) diagonal line should be skipped and one additional $\frac{1}{4}$-inch (6.5-mm) diagonal line should be drawn (this will allow you to tuck in the last fold).

Step 4. To cut the lattice, fold the strip of colored paper in half. Place the edge of the template on the folded edge of the paper. Cut all of the diagonal lines, being careful to cut all the way through the folded edge. Unfold the border paper and a long line of "V"-shaped cuts will be seen. Starting at the top, fold down the long flap, tucking it behind the shorter flap.

Step 5. Assemble the card by attaching charms with brads to the lattice before gluing the lattice to the card (to hide the back sides of the brads). Attach the lattice to the card. Add the photograph and stamp sentiment in the lower right-hand corner.

Buddha Light Switch Cover
by Brenda Marks

Here is a truly different way to preserve a memory or customize your home décor. Using washi paper and photographs printed onto fabric, you can create a personalized light switch cover that I guarantee will be unique and as individual as you are!

Supply Credits Spray paint: Krylon; Acrylic spray coating (clear): Krylon; Glue: Crafter's Pick/The Ultimate!; Washi paper; Fabric for ink-jet printers; Punch: EK Success

MATERIALS NEEDED

Washi paper

Photographs (printed onto fabric)

Ink pad in coordinating colors

Embellishments, such as punched flowers or Asian charms

Krylon spray paint

Alcohol ink or paint

Acrylic spray coating (clear), such as Krylon

Sandpaper

Thick glue such as The Ultimate! by Crafter's Pick

Craft knife and cutting mat

Step 1. Plan your design around the light switch cover size. Print photos that you want to use onto fabric treated for use in ink-jet printers. Cut out your images, leaving a small border, and ink the edges with ink in order to give the photograph some definition.

Step 2. Lightly sand the light switch plate with sandpaper in order to give it some tooth; wipe off any dust. Precut your washi paper at least $1/2$ inch (12.7 mm) larger on all sides than the light switch plate. Glue the washi paper to the light switch plate leaving a $1/2$-inch (12.7-mm) border on all sides to fold down later. Let dry.

Step 3. Cut the corners off, leaving a small easement close to the corner of the plate, and fold the paper around the plate. Trim the edges to $1/4$ inch (6.5 cm) and glue or tape the edges on the back side of the plate.

Step 4. Place the switch plate right side down on a cutting mat, and using a sharp craft knife, cut an "X" in the center of the light switch holes, fold the tabs back and secure them to the back of the plate with strong glue or tape. Mark screw holes on the front side with a small pencil dot.

Step 5. Flip the plate over and embellish by adding photos and decorations (Brenda used a lotus flower punch by EK Success), being careful not to cover the screw holes. Spray the decorated plate with a protective finish and let dry.

Step 6. Stain the screws to a coordinating color using alcohol inks, Krylon paints or StāzOn inks. Once the plate is dry, flip it over so the front is face down and pierce a small hole through the screw holes with a paper pierce. Flip it over again and push the screws through from front to back to enlarge the holes and mount on your light switch cover!

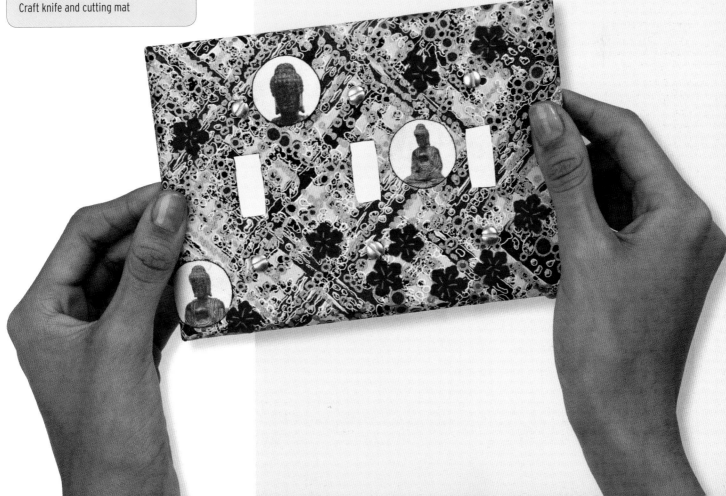

Grandma's Brag Book
by Ann Pennington

This project, by Ann Pennington, takes a simple origami book and turns it into a brag book—a decorated minibook that serves as a photo album—that any grandparent would be proud to show. The folds of this book are fairly simple and involve only basic origami knowledge. The resulting book is small enough to carry with you, but because of the reinforced front and back panels, it is sturdy and won't fall apart. Ann decorated this book by using Asian charms, washi paper and stamps in order to give it an Asian feel.

Supply Credits Rubber stamps: Stamp Attack; Charm, coins, fibers: Far Flung Craft; Yuzen washi paper: Stone House Stamps

MATERIALS NEEDED

3 sheets cardstock cut into 8 inch (20.3-cm) squares

2 pieces 4¹/₄-inch (10.8-cm) square mat board or chipboard (for covers)

2 pieces handmade paper cut into 4¹/₄-inch (10.8-cm) squares

3 pieces red origami paper cut into 3-inch (7.5-cm) squares

3 pieces yuzen washi paper cut into 3-inch (7.5-cm) squares

2 pieces orange origami paper cut into 3-inch (7.5-cm) squares

Rubberstamped text

Embellishments

Black slide mount

Ribbons

Fibers

Gemstones

Punched flowers

Eyelets

Brads for embellishing

Pattern in "Patterns and Templates" (page 186)

TIP When doing this project (and the other origami projects), one of the most important things to learn is the mountain fold and valley fold. A valley fold is formed when you fold the paper toward you and onto itself; a valley fold results in the creased edge forming a valley. A mountain fold is the reverse—a fold in which the creased edge is pointing up, creating a mountain. In the pattern for *Grandma's Brag Book* (page 186), a mountain fold is indicated by a dashed line with dots. A valley fold is indicated by a dashed line.

Paper trimmer

Origami paper

Bone folder

Cardboard

Glue tape

12 x 12-inch (30.5 x 30.5-cm) scrapbook paper

Step 1. Fold one of the 8-inch (20.3-cm) squares in half lengthwise vertically. Open it and fold it in half again in the other direction so the result is 4 x 4-inch (10.2 x 10.2-cm) squares outlined by the folds. Turn the paper over so that the fold creases are up (mountain folds), and fold the paper diagonally once, following the pattern found in the "Patterns and Templates" (page 186).

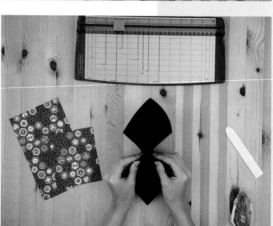

Step 2. Unfold and turn the paper over so the diagonal fold is a mountain fold. Start by holding the edges of the paper and push the diagonal folds gently together to create a flat square.

Step 3. Fold the other two sheets the same way.

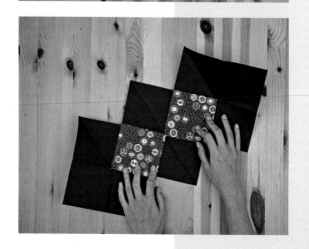

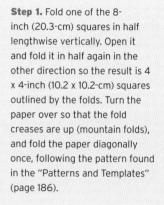

Step 4. Following the pattern, attach the three folded sheets with double-sided tape or glue. Cover the mat board with the paper, tucking the edges of the paper under the back side of the board. Before attaching the mat board to the rest of the book you can sandwich some ribbon and fibers between the board and the paper if you wish to tie the book closed. Attach the covers to sections B1 and B2 of the pattern (after the three pieces are assembled). Add your photographs and embellishments.

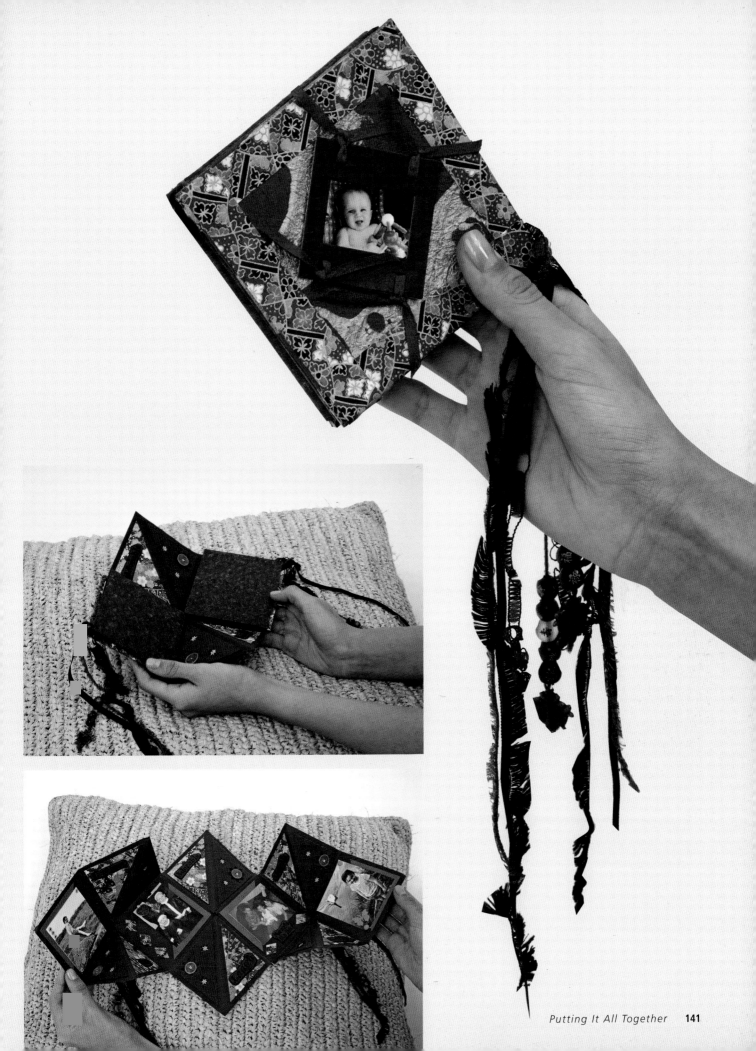

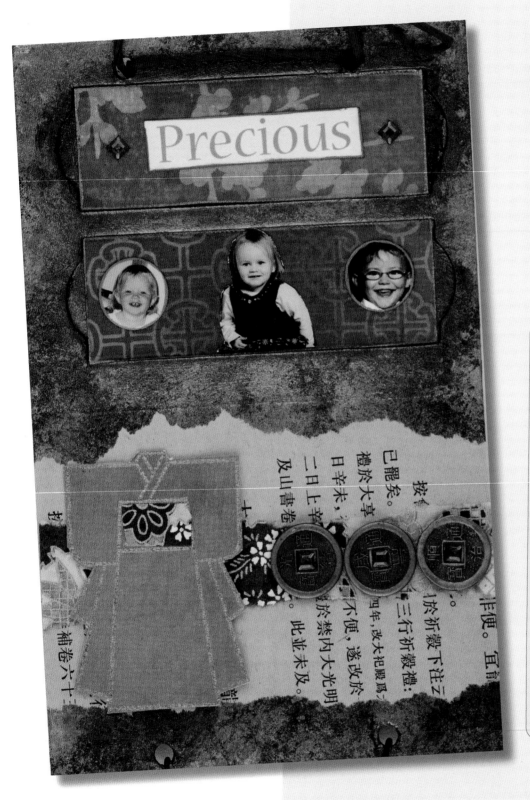

Microscope Slide Wall Hanging
by Ann Pennington

Taking an idea from the rubber-stamping community, Ann used microscope slide mailers (which are available through most rubber stamp stores) and created an innovative wall hanging featuring pictures of her grandchildren. Using Asian papers, charms and stamps, this wall hanging is a great way to use up those less-than-perfect pictures in which your subjects are either too small or a bit out of focus!

Supply Credits Charms, coins: Far Flung Craft; Kimono stamp: Stamp Attack; Washi paper: Stone House Stamps; Patterned paper: DCWV; Paint: Lumiere (Metallic Russet, Purple Halo, Gold)

MATERIALS NEEDED

Cardboard double microscope slide mailers (can be purchased from many multimedia art Web sites as well as medical/scientific supply stores online)
Metallic acrylic paints (gold, silver, copper)
Stamps
Coins/charms
Favorite photographs
6 large paper clips
Computergenerated text
1-inch (2.5-cm) circular paper punch
Pages with Asian text from a book, magazine or newspaper or scrapbook paper with Asian text
Ribbon
Embossing powder and VersaMark pad or embossing pad
Lumiere paints

Lumiere paints
Hole punch
Paper clips
Distress ink
Microscope slide mailer
Sponge
Asian book page
Charms
Hammer
Glue tape
Origami paper

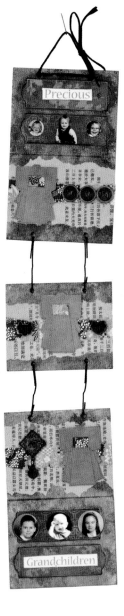

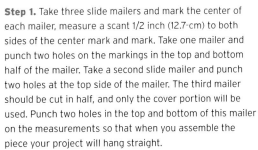

Step 1. Take three slide mailers and mark the center of each mailer, measure a scant 1/2 inch (12.7-cm) to both sides of the center mark and mark. Take one mailer and punch two holes on the markings in the top and bottom half of the mailer. Take a second slide mailer and punch two holes at the top side of the mailer. The third mailer should be cut in half, and only the cover portion will be used. Punch two holes in the top and bottom of this mailer on the measurements so that when you assemble the piece your project will hang straight.

Step 2. Paint the mailers with Lumiere paints according to your own taste and let dry. When dry, sponge gold and silver metallic paint randomly over the top of each mailer; again let dry.

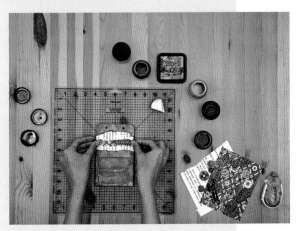

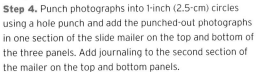

Step 3. Glue a strip of scrap (or washi) paper in each of the microscope sections. In Ann's project she used the Far East paper from DCWV.

Step 4. Punch photographs into 1-inch (2.5-cm) circles using a hole punch and add the punched-out photographs in one section of the slide mailer on the top and bottom of the three panels. Add journaling to the second section of the mailer on the top and bottom panels.

Step 5. Place Asian text or other patterned paper to the center of each solid panel and attach a strip of washi paper over the top of the patterned paper. Stamp kimono onto the scrapbook paper using VersaMark or embossing ink and emboss with gold embossing powder; cut out and create an obi with a small strip of washi paper. Use it as an embellishment on the center panel. Add charms and coins to embellish each section.

Step 6. Open the paper clips to use as hooks between each panel and place them through the holes. Assemble the panels. To hang use ribbon, fibers or thread and string through the top holes of the first panel.

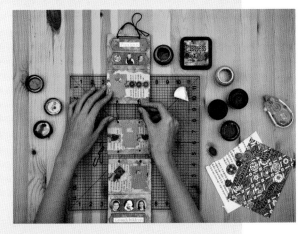

Photo Cube
by Ann Pennington

Using an origami pattern, Ann created a clever and novel photo cube to display pictures of her grandchildren. Creating six individual "frames" by using the origami folds, these individual squares are connected into a photo cube that could also be used as a hanging ornament. What a perfect idea for a holiday gift!
Supply Credits Cardstock; Washi paper: Stone house Stamps; Press-on corners: LynnR Papercrafts; Others: Ribbon, embellishment

MATERIALS NEEDED
Six 6 x 6-inch (15.2 x 15.2-cm) pieces of cardstock or plain colored origami paper
Nine 2inch (5 cm) squares of samecolored cardstock/paper
Washi paper or other decorative paper
Six $3^1/_2$ x $3^1/_2$-inch (9 x 9-cm) photographs
Ribbon and embellishments
Pattern in "Patterns and Templates," page 187

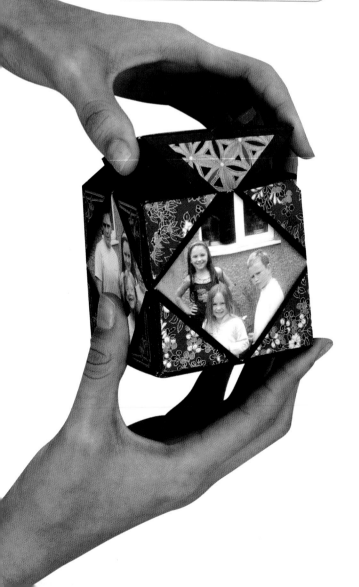

Step 1. Take a single piece of 6 x 6-inch (15.2 x 15.2-cm) paper and place it pattern side down. Fold the paper in half vertically, unfold and fold it in half horizontally and unfold. Then fold the paper into quadrants and unfold. The finished paper should have four folded lines vertically and four folded lines horizontally. (See pattern, page 187.)

Step 2. Turn the paper over so the pattern or right side of the paper is facing up. Fold all four corners into the center following the diagram and unfold. (See pattern, page 187.)

Step 3. Turn the paper over so that the pattern is facing down and fold down the corners following the diagram. The corner should only touch the inner corner of the small "folded square." (See pattern, page 187.)

Step 4. Taking the paper and lifting points A, B, C and D (see pattern, page 187) fold or "squash" them into the center to create a square. The folded corners (gray in the diagram) will squash down and create corners into which you can slip your photos.

Step 5. Repeat these four steps with all 6 pieces of 6 x 6-inch (15.2 x 15.2-cm) paper. Place a drop of glue in the center under the points of the corners to hold them in place.

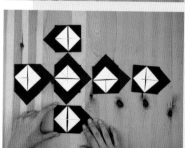

Step 6. Insert the 2-inch (5-cm) squares into the sides of a photo frame at an angle. Attach a second frame to the first. Use double-sided tape or glue to secure. Repeat to create a chain of four frames. Place each frame right side up on the table. Add an additional 2-inch (5-cm) square on the top of the second frame from the left and attach a frame on top. Repeat to add a frame to the bottom. You should now have a cross-shaped frame.

Step 7. Embellish with washi paper and small embellishments. Add ribbon to the top square by tucking it under the flap. Add photographs and assemble the box by gluing the triangle pieces into the squares.

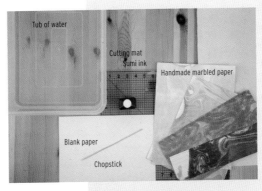

Tub of water
Cutting mat
Sumi ink
Handmade marbled paper
Blank paper
Chopstick

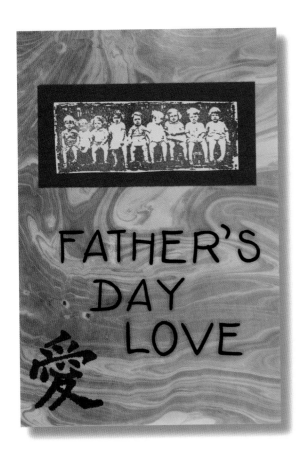

Father's Day by Kristy Harris

This project features the Chinese character for "Love" and a beautiful paper-marbling technique achieved with sumi ink. After seeing an article about marbling with sumi ink in the craft magazine, I realized that the technique would be a great way to create unique papers for heritage scrapbook pages. Because sumi ink is made from vegetable soot, it is acid free! You can find sumi ink in most art supply stores or online through resources such as Dick Blick.

Supply Credits Cardstock: white; Letter stickers: Deluxe Designs; Stamps: Hero Arts ("Love" in Chinese) Stampington Clearly Impressed (children); Ink: StāzOn (black); Other: Sumi ink

MATERIALS NEEDED

Sumi ink

Water

Basin

Chopstick

White, offwhite or lightcolored paper in the thickness of your choice

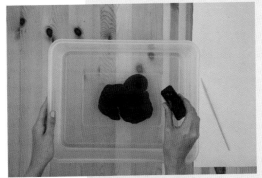

Step 1. Fill a tub with approximately 1 inch (2.5 cm)of water. The tub must be bigger than the paper you want to marble.

Step 2. Add one or two drops of sumi ink to the water. Most of the ink will sink to the bottom, but a small portion will stay on top. A little ink goes a long way.

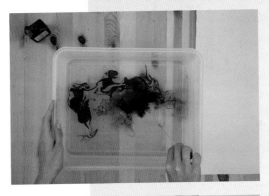

Step 3. Stir the ink with a chopstick or fork to create a marble effect on top of the water.

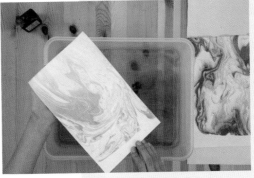

Step 4. Take paper (light-colored papers are key here) and ROLL the paper over the surface of the water. Do not submerge the paper. You can usually ink two or three sheets of paper before you need to change the water. The first sheet will be darker than the second and third sheets.

Step 5. Dry the sheets on paper towels and iron them if needed after they are dry to flatten. Use on projects in place of patterned paper.

Wedding Guest Book
by Lynita Chin

This piano hinge book is a fun project that is fairly easy to make. It makes a great book for use as a mini-scrapbook or, in this case, a guest book for a wedding.

Supply Credits Cardstock: Cream, red; Patterned paper: grassroots; Fibers, charms; Far Flung Craft; Chopsticks; Paint: Lumiere (gold); Stamps: Leave Memories

MATERIALS NEEDED

Two 8½ x 11-inch (21.5 x 28-cm) (or A4) sheets of red cardstock

3 sheets of white or cream lightweight cardstock

Rubber stamps

Craft knife

Ruler

6 chopsticks (3 sets)

Charms

Fibers to embellish

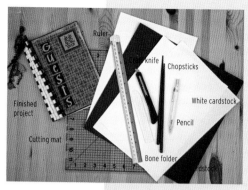

Step 1. Fold the red cardstock in half to measure 5½ x 8½-inches (14 x 21-cm). Fold the white papers in half and set aside. Embellish the red cardstock cover as desired using patterned paper, stamps and charms.

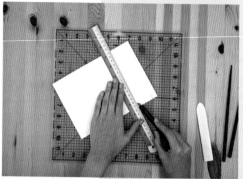

Step 2. Create a template for the spine by taking a piece of scrap paper measuring 5½ x 8½-inches (14 x 21-cm). Measure ½-inch (12.7-mm) from the edge and draw a line from top to bottom. Starting from the top along the edge, draw a line ¼-inch (6.4 mm) and repeat until you reach the bottom of the page. You will have one vertical line ½-inch (12.7-mm) from the edge and twenty-one sections each spaced ¼-inch (6.4-mm) apart.

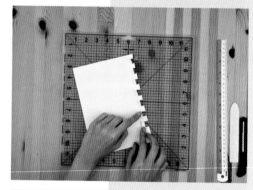

Step 3. Stack all of your papers together including the red cardstock and place the template with the lines on the fold. Cut the horizontal lines up to but not over the vertical line to create sections. Separate the papers and, starting at the top, fold up every other section slightly, separating the sections. You can glue the red cardstock together at this time, leaving the sections unglued. You will have a front and back cover with cut-out sections along the fold.

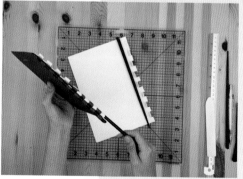

Step 4. Restack the papers with the two pieces of red cardstock at the top and bottom of the pile and the white paper in the middle. Thread a chopstick through every other section; the first chopstick will only have red sections showing, the second chopstick will have red and white sections showing. Continue until you have created the book. Add fibers and charms as desired to further embellish.

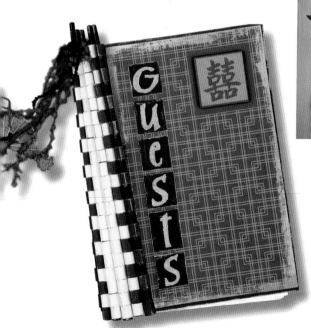

Shou Card
by Kristy Harris

Lacquerware is one of the most famous souvenirs from Asia and is often seen in Japan, China and Southeast Asian countries such as Vietnam. In this project I used a simple faux-lacquer technique with just UTEE– rubber stamps with an Asian character. *Supply Credits* Cardstock: Bazill (black), Worldwin (red); Embossing powder; UTEE: Ranger/Suze Weinberg, Gold; Ink: StāzOn (black), Ranger (embossing ink); Stamp: Hero Arts, Vicki Enkoff

> **MATERIALS NEEDED**
> Cardstock in red and black
> UTEE in clear and gold
> Embossing ink
> Rubber stamps
> Heat gun

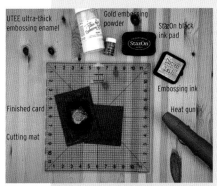

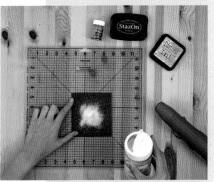

Step 1. Take a small piece of red cardstock and apply the embossing ink to a large section in the center of the cardstock. Apply UTEE and melt it with a heat gun. While the UTEE is melting you can add an additional layer of UTEE (you may need to add more embossing ink, but make sure it is clear ink as colored ink will show on top of the first coat of UTEE). Melt the second coat. The result will be a large section of covered cardstock.

Step 2. Reheat the UTEE with the heat gun, being careful to prevent scorching, and when it is melted pour gold embossing powder (or gold UTEE) in the center of the cardstock. Emboss.
Step 3. Ink a rubber stamp (it must be rubber; acrylic stamps will not work for this technique) with StāzOn; ink, set aside. You will have about 30 seconds to work.
Step 4. Reheat the embossing powder, and while the powder is still melting place the stamp in the center of the gold embossing powder and let it cool for about 30 seconds. The embossing powder will set up, and you can remove the stamp. You will be left with an impression of the stamp.

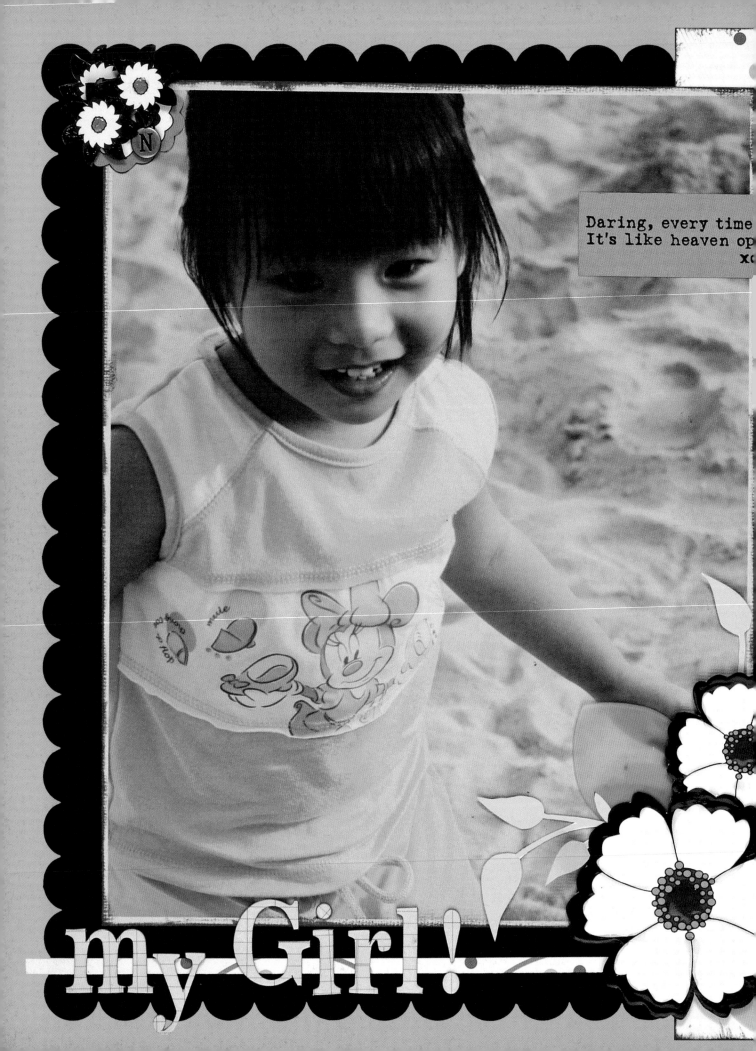

Daring, every time
It's like heaven op
x

my Girl!

our face,
her gates.
..... mummy

A Gift from the Sky

My Girl by Jennie Yeo
The graphic design of the patterned paper used by Jennie in this layout, while not overtly Asian in style, reminds me of the Japanese sakura branch. I have seen similar use of this design in modern art, and I love the clean inspiration this paper gives me. Jennie is a detail-oriented scrapbooker, spending her time making her pages dimensional and unique. She hand cut the floral accents in this layout and added additional visual focus by using crackle and matte accents.
Supply Credits Cardstock: Bazzill; Patterned paper: American Crafts; Chipboard letters: Heidi Swapp; Ink: ColorBox (Chestnut Roan); Crackle accents, matte accents: Inkssentials; Other: pop dots

A Gallery with an Asian Twist

"A gift from the sky" is a Chinese phrase that means a little something extra, a bonus if you will. Now that you have learned the basics of Asian-style scrapbooking, tried your hand at a few projects. Here is that bonus—a gallery of additional projects to inspire you as you develop your own sense of Asian flair.

As the contributors and I set out to create projects that fit into the design concepts of the book, I was pleased to find the number of ways that we developed the themes of color, motifs, fabric, paper and writing. Each project shows different aspects of Asian style, often blending colors with motifs or motifs and Asian text. Often the layouts represent a combination of all of the elements of Asian style and feature creative uses of papers, embellishments and photos.

I hope that the following layouts and projects serve as that little extra something—the inspiration, mojo, kick or nudge in the right direction—to jump-start your creative juices. And anyway, leafing through the gallery is a great excuse to sit down with a cup of Japanese green tea and a plate of curry or some fresh mango slices as you soak up some Asian style. Enjoy!

Wonderful Life
by Lynita Chin
Lynita has used batik fabric as an embellishment, which is a fun way of adding a Southeast Asian flair to your layouts without breaking the bank. Most fabric stores carry Asian-inspired fabrics, often sold in small pieces or by the quarter yard or meter, which are great sources of inspiration for nontraditional scrapbook projects.
Supply Credits Cardstock: Bazzill (red linen); Patterned paper: BasicGrey; Fabric, charms, fibers: Far Flung Craft; Flowers, brads, eyelets: Making Memories

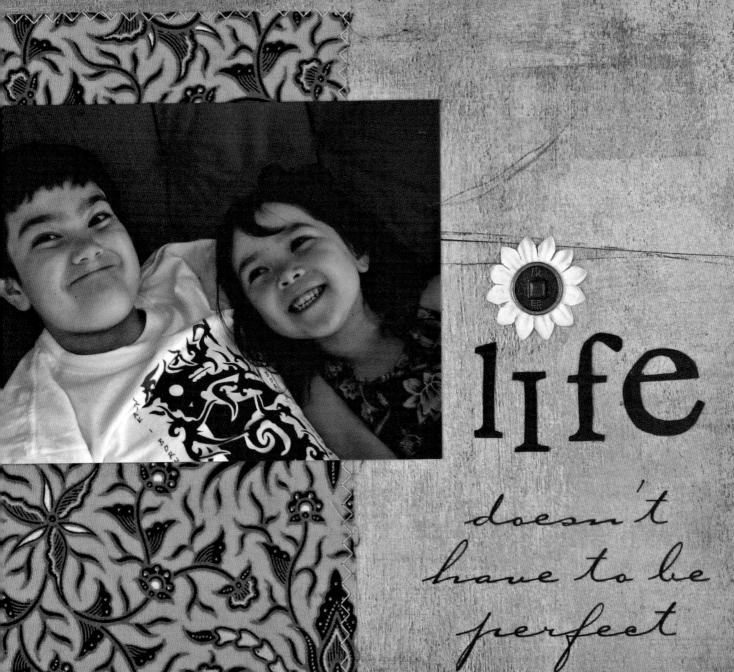

life

doesn't
have to be
perfect
to be

wonderful

NOV '20

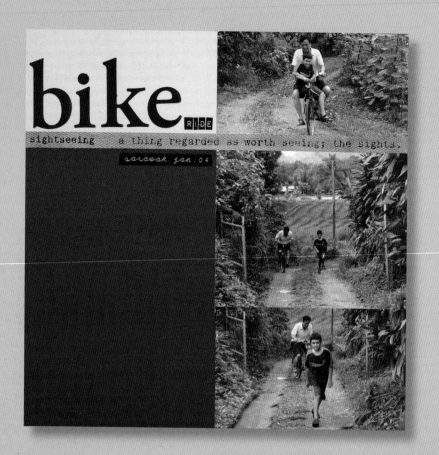

bike ride

sightseeing a thing regarded as worth seeing; the sights.

sarawak jan.06

KL by Kristy Harris
The courthouse at the Padang
in Kuala Lumpur is built in
the Moorish style, a form of
Islamic architecture. I used
cut-out shapes found in an
Islamic-inspired patterned
paper to replicate the angles
of this beautiful heritage
building in the layout.
Supply Credits Cardstock:
WorldWin; Patterned paper:
imaginisce (green geometric);
7gypsies (green floral);
Handmade paper: DMD;
Rub-on frame: Luxe Designs;
Journaling tag: Fancy Pants
Designs; Photo corners: Far
Flung Craft

Bike Ride by Lynita Chin
Blues and brown when mixed
with pictures of an outdoor
scene follow the Zen aesthetic:
using earth tones balanced by
a small accent of color.
Supply Credits Cardstock:
Bazzill (linen); Alphabet
stickers: American Crafts;
Dymo tape; Border stickers:
Pebbles Inc./Real Life

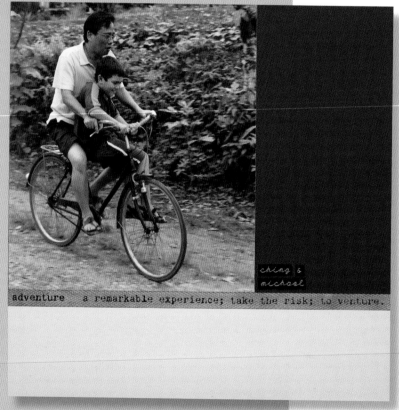

ching &
michael

adventure a remarkable experience; take the risk; to venture.

152

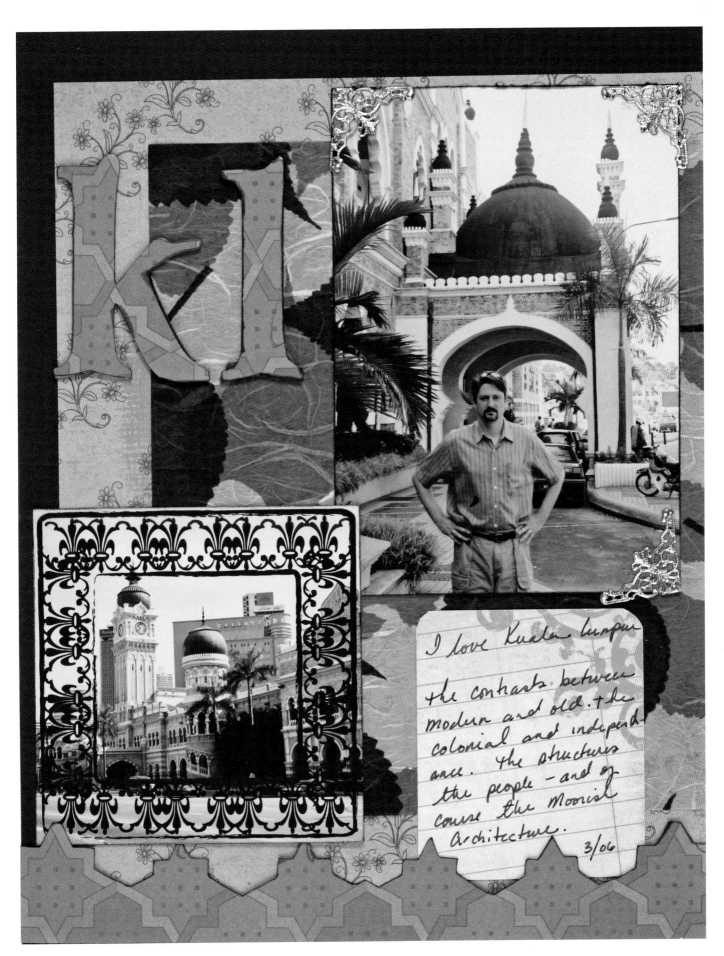

I love Kuala Lumpur the contrasts between modern and old. the colonial and independance. the structures the people - and of course the Moorish Architecture.

3/06

An Unexpected Exuberance
by Andrea Blair

The orange flower placed at the side of this simple and classic layout sets the tone for this page. This layout is warm, and the orange ink on the edges of the cardstock is a cohesive element finishing the layout.
Supply Credits Cardstock: Bazzill; Patterned paper: Chatterbox; Flower: Dollar Store; Ink: Ranger; Other: Ribbon, pin, felt

Nature Boy by Lynita Chin

The black-and-white photographs on the red paper to the far right of the layout draw your eyes toward them following the natural progression of the eye.
Supply Credits Cardstock: Bazzill; Patterned paper: DCWV/Far East Collection; Alphabet stickers: American Crafts; Ribbon: American Crafts; Square brads: Making Memories; Journaling block: Heidi Swapp; Other: Black Dymo tape, stamps, inks

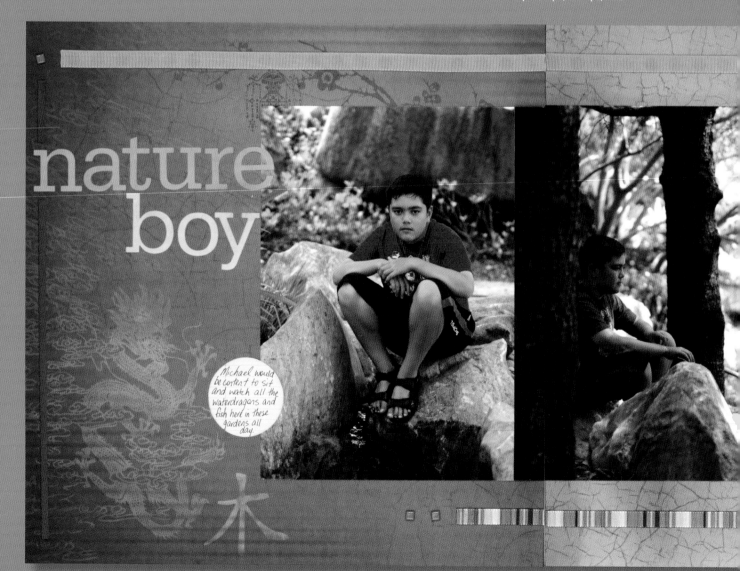

Sun Kissed
by Lynita Chin

The colors in the layout were chosen based on their similarity to traditional Japanese colors of *kaki* (persimmon), *moegi* (light green) and *asagi* (a light indigo blue).

Supply Credits Patterned paper: Crate Paper, Cosmo Cricket, Scenic Route; Chipboard alphabet: Heidi Swapp; Acrylic heart: Heidi Grace; Ghost flower: Heidi Swapp; Gems: My Mind's Eye/ Bohemia; Other: Hand-dyed tags, stamps, inks, cardstock

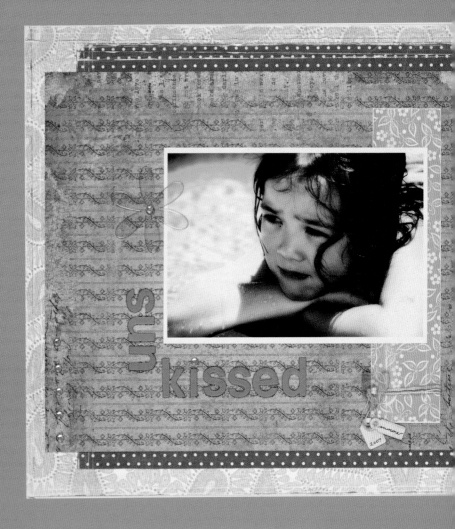

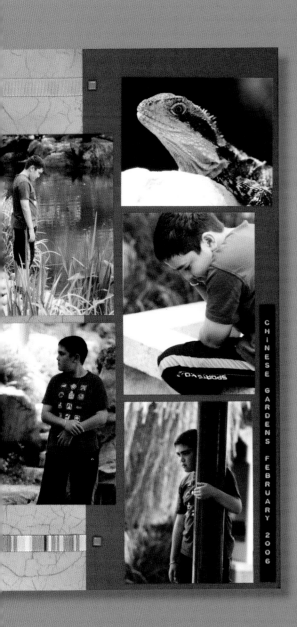

CHINESE GARDENS FEBRUARY 2006

Tub Love by Andrea Blair

Felt flower embellishments add highlights of color to this otherwise monochromatic layout.

Supply Credits Cardstock: Bazzill; Stamp: Fancy Pants Designs; Ink: StāzOn; Love embellishment: Heidi Swapp; Letters, felt flowers: American Crafts; Other: Felt, DMC floss

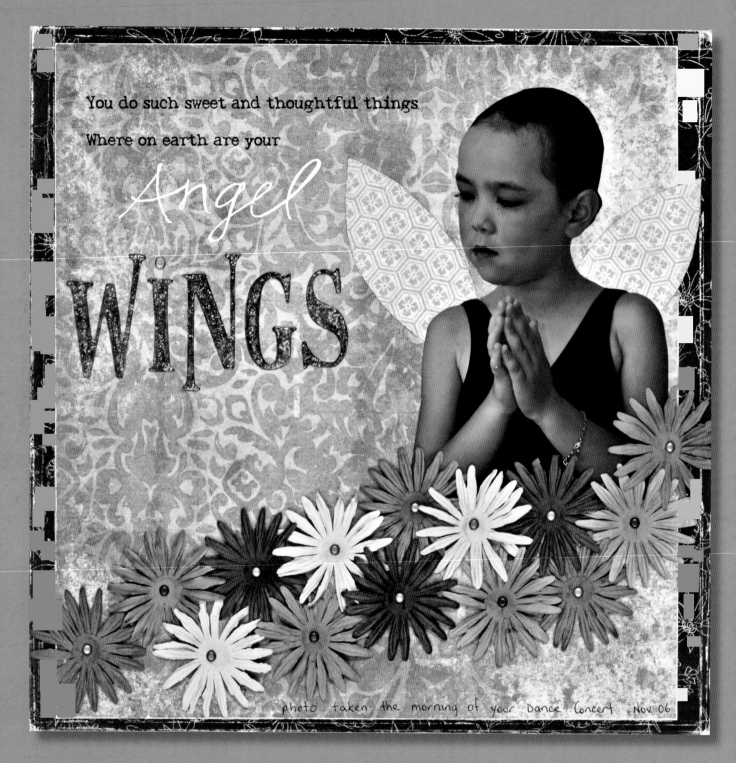

You do such sweet and thoughtful things.

Where on earth are your

Angel

WINGS

photo taken the morning of your Dance Concert. Nov 06

Angel Wings by Lynita Chin

This tender layout is inspired by a traditional Chinese New Year's poster (see page 158). Lynita followed the color scheme from the original poster, including the light blue background and pink flowers. Lynita's layout shows how inspiration for scrapping can be found anywhere.

Supply Credits Cardstock; Patterned paper: Crate Paper, My Mind's Eye/Bohemia; Washi paper; Japanese yuzen washi paper; Rub-ons: Making Memories; Ghost alphabet: Heidi Swapp; Gem: My Mind's Eye/Bohemia; Brads: Making Memories; Flowers: Prima; Other: Stamps, inks

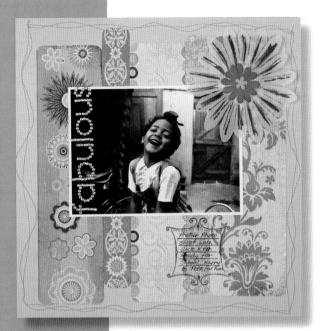

Fabulous by Wendy Steward

A heritage photograph doesn't need to be partnered with dowdy, old-fashioned paper. Using tropical colors gives this older photograph a more contemporary feel.

Supply Credits Cardstock: Bazzill; Patterned paper: BasicGrey, My Mind's Eye/Bohemia; Flower: Heidi Swapp and others; Yellow flower brad: Making Memories; Journaling block stamp: Lil Davis Designs; Ink: Versa Cube (pink)

Emily's Smile by Lynita Chin

Using a color scheme inspired by tropical Asia, Lynita used a sepia-colored photograph of her niece. By using a black-and-white photograph you don't have to worry about the colors of the picture interfering with the paper colors.

Supply Credits Patterned paper: My Mind's Eye (Every Day Tango); Monograms: Colorbok; Ghost alphabet: Heidi Swapp; Alphabet stickers: Doodlebug Designs; Rub-ons: BasicGrey; Tag: Making Memories; Journaling block: Heidi Swapp; Other: Ribbon, buttons, flower, gems

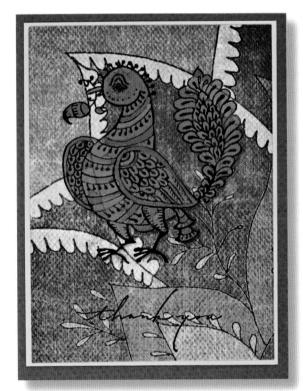

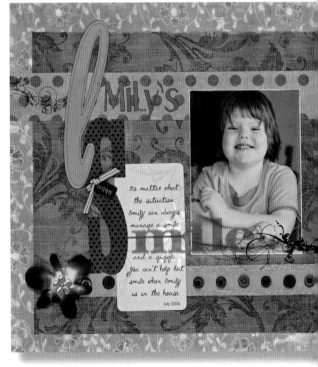

Thank You by Heather Taylor

Patterned paper in bright jewel tones with an Indian-inspired pattern blend perfectly with this Indian bird stamp.

Supply Credits Cardstock; Patterned paper: Fancy Pants Designs; Stamps: Art Neko (bird), Wordsworth (Thank You); Ink: Versacraft (black); Embossing powder: Ranger; Acrylic paints: Making Memories, Plaid/Vernis

Temple Dragons
by Julie Kosolofski-Kou

Using an analogous color scheme, Julie has loosely interpreted the traditional Chinese New Year's poster below. Her layout features flowers in Chinese spring colors based with greens and peacock blue.

Supply Credits Cardstock; Fabric: Far Flung Craft; Paper flowers: Prima; Letter stickers: Scrap Shotz ("Sassy"); Brads: Making Memories; Other: Peel-off photo corners

Christmas Lunch by Lynita Chin

Traditional Christmas colors, when seen together with Asian-inspired paper, could easily be used for a Chinese-inspired project if partnered with Asian embellishments. This layout, however, takes a more traditional Christmas theme.

Supply Credits Patterned paper: BasicGrey; Alphabet stickers: American Crafts; Plastic alphabet letters: Heidi Swapp; Chipboard coaster: Blue Cardigan Designs; Journaling stamp: Autumn Leaves; Ink: StāzOn; Other: Brads, stitched twill ribbon

爱 祖 国（对开）统一书号：8081·12823 周瑞庄 陆 廷作

Source It!

Look to Chinese art, both antique as well as modern, to gain inspiration for your projects. While writing the book, I challenged some of my friends to take inspiration from an old Chinese New Year's poster that I bought in China back in the late '90s. (See *Temple Dragons*, above, and *Angel Wings*, page 156.) The poster features children sitting in a field of flowers (to represent spring) in blues, yellows, pinks and reds, and also prominently featured the Chinese flag. This poster, and ones like it, were a popular method of advertising and propaganda for the Chinese Communist Party. While I found this poster in China, it is easy to find similar works in museums or online.

christmas
lunch

Christmas lunch
with Grandma,
Gus, Nari, Chris
(Nari's daughter)
and us. Lunch was
cold meats, salads
and christmas
pudding.

2006

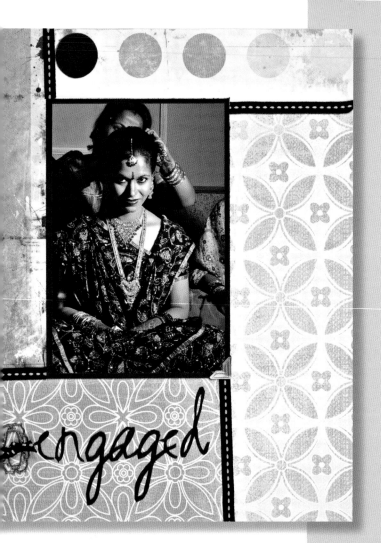

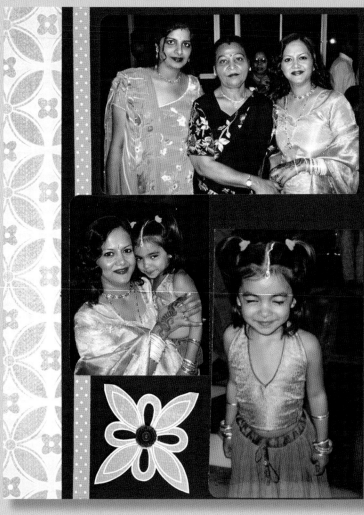

Engaged by Nishi Varshnei

An engagement party in India with brightly colored decorations and attire coordinate well with the jewel tones of the Sassafras Lass papers. The patterns on the paper also lend themselves to the Indian-inspired feel of the layout. *Supply Credits* Cardstock: Bazzill; Patterned paper: Sassafras Lass; Other: Ribbon, brads

Uparayanam
by Vidya Ganapati

Another blend of traditional Indian-inspired colors include the spice tones. Cinnamon (reddish-brown), turmeric (yellow) and coriander (tan) are all spice colors that evoke visions of traditional Indian culture. *Supply Credits* Patterned paper: Die Cuts With A View; Fibers: Far Flung Craft

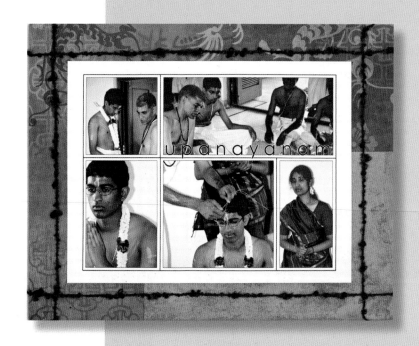

We Are Two
by Sharon Chan

Tropical flowers with lime and coral work well in this celebration layout, making it bright and energetic.
Supply Credits Cardstock: Bazzill; Patterned paper: Luxe Designs; Letters: Heidi Swapp

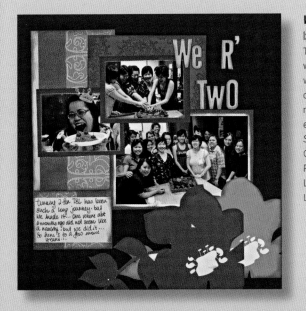

Sisters
by Ann Pennington

By using alcohol inks and blending solution Ann created a textured background in spice colors for her stamp of the two girls. The spice tones are commonly used with Indian and Middle Eastern style projects.
Supply Credits Cardstock; Alcohol inks: Ranger (Butterscotch, Terracotta, Ginger, Rust); Blending solution: Ranger; Stamp: Paper Artsy; Ink: StāzOn (black)

Burma 24
by Odile Germaneau

The use of the bright tropical colors takes your imagination to a warm, semitropical location, and the colors correspond to the bright colors of the clothing worn by the monk in this picture.
Supply Credits Cardstock; Patterned paper: Daisy D's, Fancy Pants Designs; Brads: Making Memories; Charms; Flowers: Prima

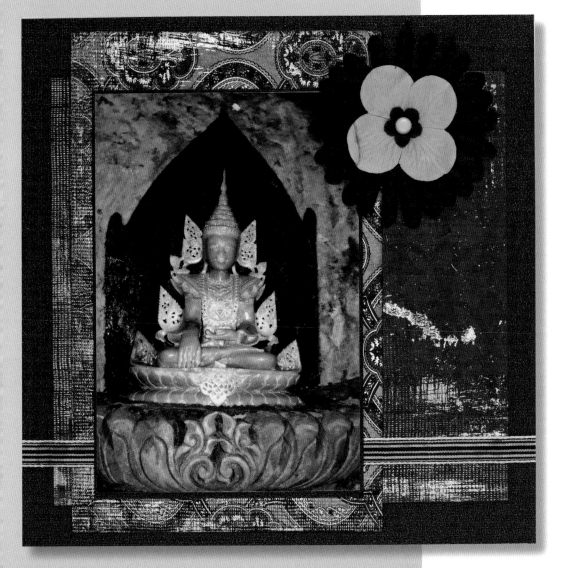

Chinese New Year Card
by Ann Pennington

Ann made a multilayered project by creating an alcohol ink background and layering it with stamps of paisleys. Finishing the card by adding an image transfer using packing tape, this project is an example of how, with careful imagination, you can mix elements from parts of Asia that would otherwise seem incongruous.

Supply Credits Cardstock; Alcohol ink: Ranger; Paisley rubber stamps; Ink: StãzOn; Pen: Krylon (gold); Asian charms, coin: Far Flung Craft; Other: Dymo embossing labeler, Kumihimo braid, Asian vintage image, embroidery thread, packing tape

Life **by Andrea Blair**

Andrea used handmade paper along with her hand-drawn Mehndi design to create this one-of-a-kind card.

Supply Credits Pen: Uni-ball Signo: Other: Cardstock, handmade paper, ribbon; Mehndi design (hand drawn by artist)

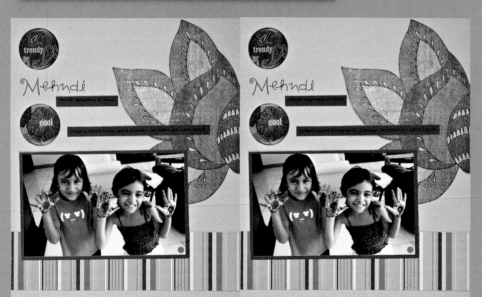

Mehndi **by Nishi Varshnei**

Using a bold Indian-inspired flower, Nishi divided the layout onto two pages, unifying the layout by placing the motif in the center of the two pages and cutting it down the middle.

Supply Credits Cardstock: Bazzill; Patterned paper: My Mind's Eye (striped), Fancy Pants Designs (Indian motif); Epoxy stickers: Cloud 9 Design; Other: Brads, photo corners

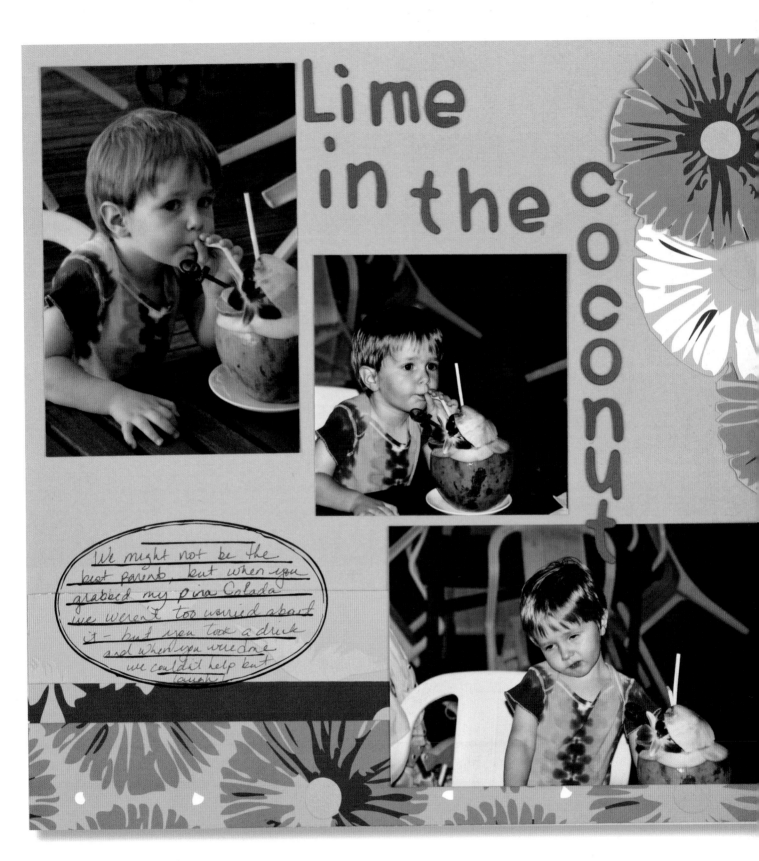

Lime in the Coconut by Kristy Harris

Ocean blue, fuchsia and lime green flowers place this layout squarely in the tropics, as if the coconut drink didn't give you a clue!

Supply Credits Cardstock: Bazzill; Patterned paper: Tinkering Ink; Chipboard letters: Prima; Rub-ons: Hambly Studios

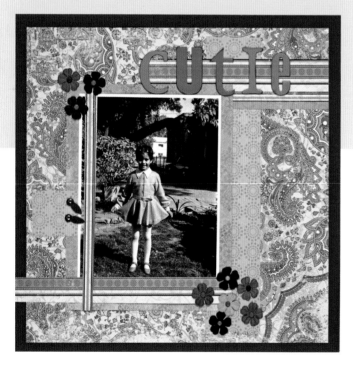

Sunkissed by Kristy Harris

The Sassafras Lass patterned paper drew heavily on Japanese pop and anime culture, using Japanese-inspired flowers in traditional mon designs. In order to create a matching title, I dyed the ghost letters with Ranger alcohol inks.

Supply Credits Cardstock: Bazzill; Patterned paper, journaling block: Sassafras Lass; Flowers, jewel: mjsdesigns; Alphabet letters; Heidi Swapp (ghost letters); Alcohol inks: Ranger

Chinese-Inspired Card by Heather Taylor

Red, yellow and blue, when combined with Asian stamps, result in a very Asian-inspired project.

Supply Credits Cardstock: Red, yellow, glossy blue; Patterned paper: Inspirables, EK Success; Stamp: Non Sequitur; Embossing powder: Pastel Yellow Jewels

Graduation
by Kristy Harris

The floral motif in this paper is a traditional Indo-Persian design. The rich jewel-toned colors blend well with the theme of a graduation layout.

Supply Credits Cardstock: Bazzill; Patterned paper: Far Flung Craft; Chipboard shapes: Maya Road; Chipboard title: Scenic Route; Acrylic paint: Plaid

Cutie by Wendy Steward

Paisley prints and Indian motifs in lilac make an excellent backdrop for pictures of a young girl in India.

Supply Credits Cardstock: Bazzill (purple); Patterned paper: Making Memories; Flowers: Prima; Chipboard letters: Heidi Swapp; Schizophrenic range lilac; Others: Brads, photo anchors.

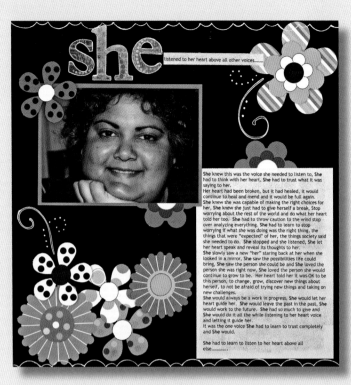

She by Wendy Steward

Wendy created an all-about-me page celebrating her strengths. The flowers from the Urban Lily papers are similar to the Japanese mon motifs used by other companies and follow the trend of gathering inspiration from the East. By using black paper and cut-out floral elements, this layout uses Japanese-inspired elements yet remains clean and modern.
Supply Credits Cardstock: Bazzill; Flowers: Urban Lily; Die cuts; Pen; Letters: Sandylion/Kelly Panacci; Doodling template: Chatterbox (Doodle Genie)

Paisley Book by Aida Haron

Using a paisley shape to create a mini-album, Aida continued the Asian theme by using Asian-inspired patterned paper. By using paper that was Oriental in design but not Indian inspired resulted in an album that was classic in style, Asian in design.
Supply Credits Cardstock: Bazzill; Patterned paper: Chatterbox, Scenic Route; Ribbon: May Arts; Brads: imaginisce; Paint: Making Memories; Stamps; Hero Arts, Making Memories

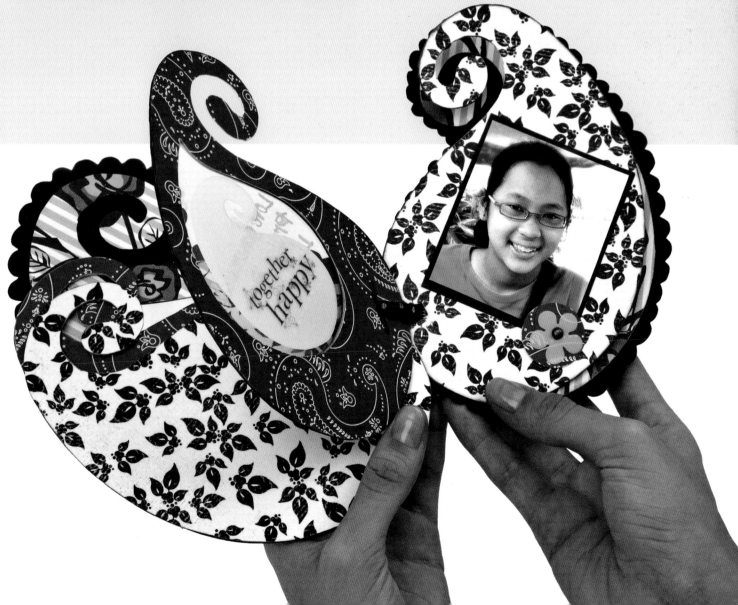

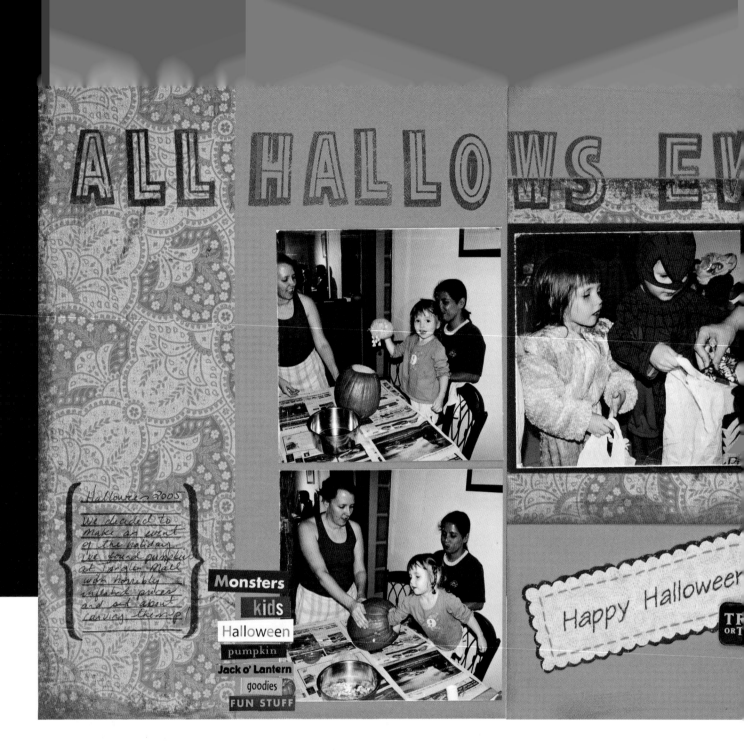

Alung Sitthou 3
by Odile Germaneau

The floral paper used by Odile in this layout is a traditional Indian floral design; and when the paper is matched with photographs of a temple in Burma, the simple design of this layout is balanced between the Asian-inspired paper and the photographs.
Supply Credits Cardstock: Bazzill; Patterned paper: Crate Paper

jet'áime

Stockings by **Kristy Harris**

Paisley paper with Indo-Persian floral motifs make perfect Christmas patterns when created in blues, greens and reds. BasicGrey consistently provides papers that take inspiration from all parts of Asia.
Supply Credits Patterned paper: BasicGrey; Letters: American Crafts; Journaling card: Fancy Pants Designs; Rub-ons: BasicGrey(paisley); Label: Fontwerks; Die cut flowers: Die Cuts With A View; Epoxy sticker; Ribbon: Making Memories

All Hallows Eve by **Kristy Harris**

This layout using traditional Halloween colors with a twist of purple features papers that have been inspired by Indo-Persian floral motifs. The floral motifs of the Mughal era often represented the glory of heaven.
Supply Credits Cardstock: Bazzill; Patterned paper: Bo Bunny; Stamps: Fontwerks (title), Autumn Leaves (journaling block): Stickers: Making Memories (wordfetti); Die cut: My Mind's Eye (Happy Halloween); Ink

Jataime
by **Jennie Yeo**

Using the Chester line of papers by My Mind's Eye, Jennie hand cut these Asian-inspired flowers and layered them on the cardstock in order to create a frame for her daughter's picture. This layout is fairly simple to re-create; you only need time and a steady hand to individually cut each flower from Chester paper and layer them one by one over the left side of your photo.
Supply Credits Cardstock: Bazzill; Patterned paper: MAMBI/Chester; Stamp: Heidi Swapp; Rub-ons: BasicGrey

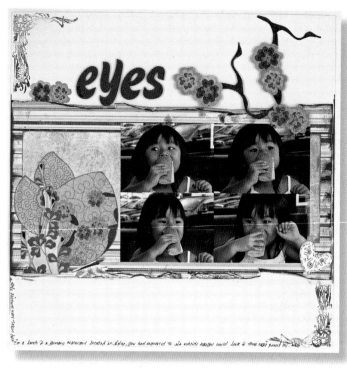

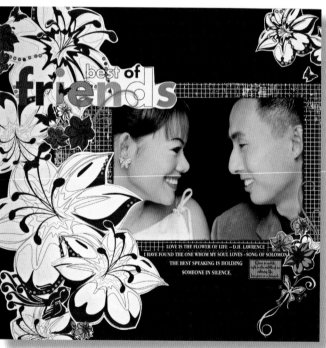

Those Eyes
by Jennie Yeo
Jennie uses classic Chinoiserie elements, such as birds, floral and branch elements, to embellish this layout about her daughter's expression. The additional detail work on this project includes adding dimentional glaze to the paper-cut pieces to highlight the colors of the flowers and branch.
Supply Credits Cardstock: Bazzill; Patterned paper: BasicGrey; Alphabet stickers: American Crafts/Thickers: Rub-ons; Crackle accent, glossy accent: Ranger; Other: Ink

Japan by Aida Haron
Simple geometric paper, when combined with natural jute string and notebook paper, give this layout a Zen-type feel, clean and uncluttered. Notice that the girls are wearing floral kimonos that balance the geometric pattern in the paper. The balance between geometric and natural does not have to be done with the paper alone as seen in this project.
Supply Credits Cardstock: Bazzill; Patterned paper: Scenic Route; Rub-ons: Making Memories (Japan); Stickers: 7gypsies

But Is It Art? by Selena Hickey
An otherwise nondistinct geometric paper, when paired with colors reminiscent of Asia and a photograph of a rattan ball, give this layout a certain Asian feel.
Supply Credits Cardstock: Bazzill; Patterned paper: Center City Designs (Manhattan Parks); Eyelets: Making Memories; Ink: Plaid; Other: Page pebbles

Best Friend
by Jennie Yeo
Big, bold Asian lilies frame this picture of a young couple in love. Tiger lilies symbolize wealth, prosperity and love.
Supply Credits Cardstock: Bazzill; Overlay: Hambly Studios; Rub-ons: BasicGrey, 7gypsies; Patterned paper: Urban Lily

JAPAN

NOT TO MENTION

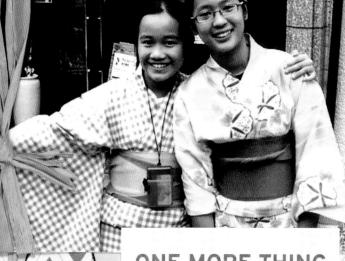

ONE MORE THING

SNAP
SHOTS

St. Margaret's Sec. School
Japan Exchange Programme
May 2007 ~ Yukie
and Stasha

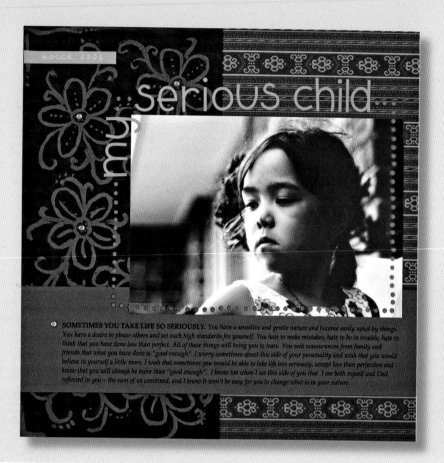

My Serious Child by Lynita Chin

To create the faux batik Lynita took melted wax and painted a design over plain cardstock. She covered the entire paper with brown liquid Ink (you can use re-inkers for this) and let it dry. To remove the wax she covered it with a piece of scrap paper and ironed it off. The color of the paper under the wax has resisted the ink, leaving a faux batik look.

Supply Credits Cardstock: Bazzill (linen); pink; Patterned paper: grassroots; Alphabet stickers: Doodlebug Design, Inc. My Mind's Eye (orange gem); Dymo tape; Ink: Adirondack (Ginger); Other: Wax

Favorite Photos–Mini-album by Lynita Chin

Fabric makes excellent covers for mini-albums. For this project, which features photographs from around Asia, Lynita made the covers by gluing and sewing batik fabric onto chipboards.

Supply Credits Patterned paper: grassroots, BasicGrey, K&Company, Chatterbox, Rusty Pickle, Over The Moon Press; Chinese book text; Bookplate; Chinese charms: Far Flung Craft; Batik material: Far Flung Craft; Wooden alphabet letters, brads, chipboard alphabet, mini rub-ons, word tags: Making Memories; Tags; Ghost flower: Heidi Swapp; Alphabet stickers: Chatterbox; Ink: Archival ink (sepia); Stamps: Hero Arts (Chinese newspaper word print), Stamp Craft (Asian stamp), alphabet stamps; Other: Metal rings

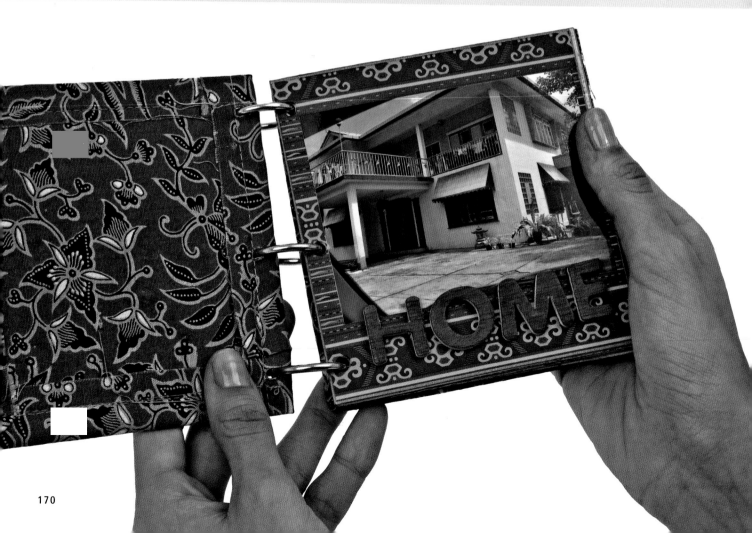

Lunch in Singapore
by Kristy Harris

In this layout a batik fabric in brown colors highlights the ethnic feel of the theme. Using fabric as though it were patterned paper, I used double-sided tape to adhere the fabric to the cardstock. I then added journaling and other embellishments to the top of the fabric.

Supply Credits Cardstock: Bazzill and unknown; Fabric: Far Flung Craft

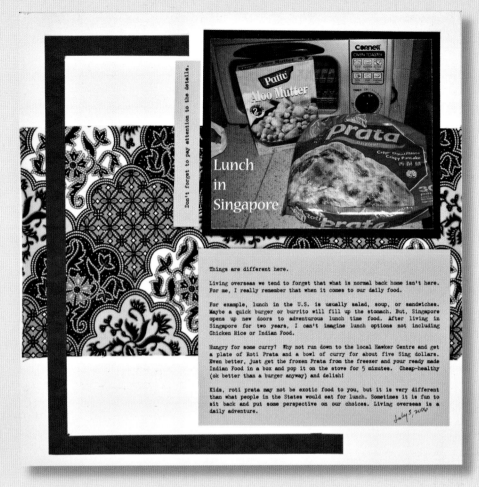

Don't forget to pay attention to the details.

Lunch in Singapore

Things are different here.

Living overseas we tend to forget that what is normal back home isn't here. For me, I really remember that when it comes to our daily food.

For example, lunch in the U.S. is usually salad, soup, or sandwiches. Maybe a quick burger or burrito will fill up the stomach. But, Singapore opens up new doors to adventurous lunch time food. After living in Singapore for two years, I can't imagine lunch options not including Chicken Rice or Indian Food.

Hungry for some curry? Why not run down to the local Hawker Centre and get a plate of Roti Prata and a bowl of curry for about five Sing dollars. Even better, just get the frozen Prata from the freezer and your ready made Indian Food in a box and pop it on the stove for 5 minutes. Cheap-healthy (ok better than a burger anyway) and delish!

Kids, roti prata may not be exotic food to you, but it is very different than what people in the States would eat for lunch. Sometimes it is fun to sit back and put some perspective on our choices. Living overseas is a daily adventure.

July 5, 2006

I Am Me by Vidya Ganapati

Using a paisley pattern, Vidya actually accents the colors in the patterned paper by using coordinating colored fibers and embellishments. The paisley print here includes other basic Indian leaf and flower motifs discussed in Chapter 2.

Supply Credits Cardstock; Patterned paper: My Mind's Eye/Bj172 ohemia; Fibers: Far Flung Craft; Flower: Far Flung Craft; Ink: Gold

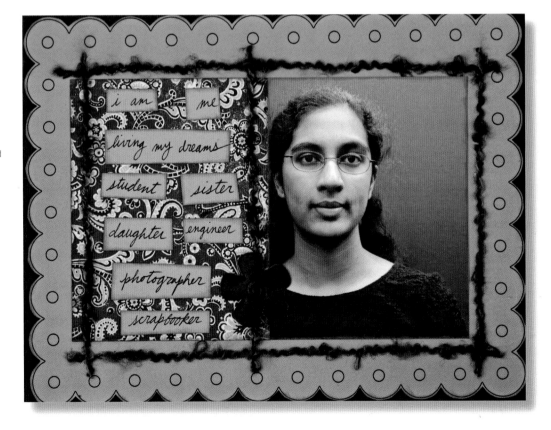

i am me

living my dreams

student sister

daughter engineer

photographer

scrapbooker

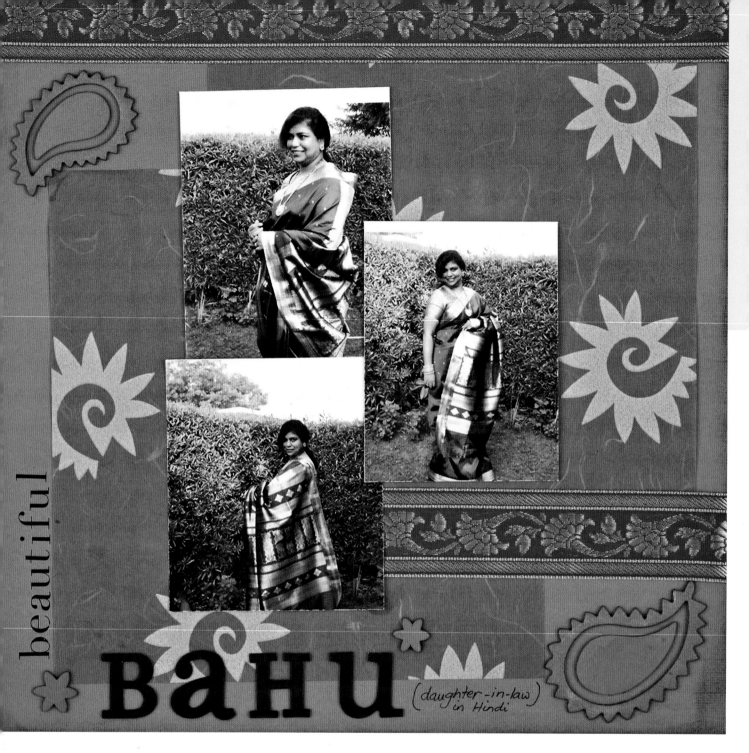

beautiful

BAHU
(daughter-in-law) in Hindi

Bahu by Wendy Steward
Gold and turquoise ribbon with paisley embellishments combined with handmade Indian papers give this layout a distinct Indian feel; of course the pictures add to the flair, but substituting different pictures would still result in an ethnically themed project.
Supply Credits Cardstock: Bazzill; Handmade paper: Target/DMD; Paisley chipboard: Maya Road; Ink: Versa Cube (gold, teal, brown); Rubons: All My Memories; Chipboard letters: Heidi Swapp

So This is LOVE

So This Is Love by Andrea Blair
In a sweet layout, Andrea uses red batik fabric as an embellishment to make a fabric heart. The addition of a partial fabric flower along with coordinating stitching throughout connects the layout.
Supply Credits Cardstock: White; Bazzill (bling); Fabric: Far Flung Craft; Flower; Other: Red and black ink, notebook paper, DMC floss

Travel by **Andrea Blair**
The coordinating patterned papers developed by Chatterbox show how paisley designs can be balanced by a strong, striped pattern. Originally only found on fabric, the paisley motif has now found its way in to paper products.
Supply Credits Cardstock: Bazzill; Patterned paper: Chatterbox; Journaling tag: 7gypsies; Brads: Making Memories; Silhouette words: Heidi Swapp; Other: Chipboard bookplate, DMC floss

Every Boy by **Andrea Blair**
Today the paisley pattern is no longer relegated to fabric. Andrea has used a patterned paper with small paisley prints in boyish colors to create a touching layout. The paisley patterns highlighted in small squares of patterned paper on the right side of the page balance the title treatment on the left.
Supply Credits Cardstock: Bazzill (brown), white; Patterned paper: Chatterbox; Ink: StāzOn (black); Other: Ribbon, chipboard letters, shapes

Geisha Card by **Heather Taylor**
Handmade papers are great to use in creative ways. By hand dying the paper and adding a bit of distressing, the handmade paper has a completely different look.
Supply Credits Stamps: Art Neko; Asian text patterned paper; Cardstock; Handmade paper

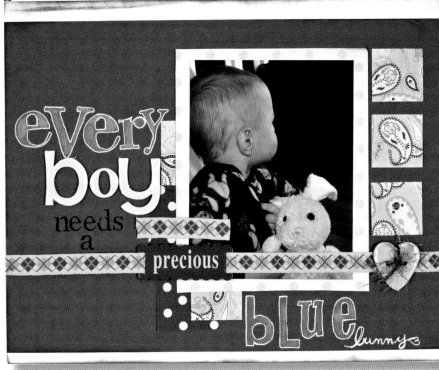

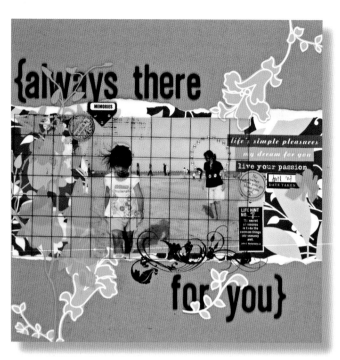

Always There for You by Jennie Yeo

In this layout the use of the sedate tan cardstock balances the bright lime color and the bold, tropically inspired floral papers. The layout is further enhanced by the use of one strip of bright red paper, which brings the eye to the featured figure in the photograph: the mother in the background. *Supply Credits* Cardstock: Bazzill; Patterned paper: American Crafts; Alphabet stickers: American Crafts/Thickers; Overlay: Hambly Studios; Bling: Heidi Swapp; Stickers: 7gypsies; Rub-ons: BasicGrey

Kebaya by Michelle Anne Elias

Fabric flowers and ribbons link the layout to the intricate fabric work on the clothing in the photograph. *Supply Credits* Cardstock: Die Cuts With A View; Patterned paper: My Mind's Eye; Wax seal: 7gypsies; Metal pins: 7gypsies; Metal crown charm: ARTChix Studio; Stamp: Sassafras Lass; Clear stamps; Vintage stamps; Tags: Fancy Shmancy; Alphabets: Pressed Petals; Inks: ColorBox (chalks), Tsukineko/Brilliance; Flowers, bling: Prima; Fibers: Spotlight/Moda Vera Jazz; Velvet ribbon: Spotlight/Ludmila Braid; Glittered accent: K&Company (Twinkle Type); Brads: We R Memory Keepers

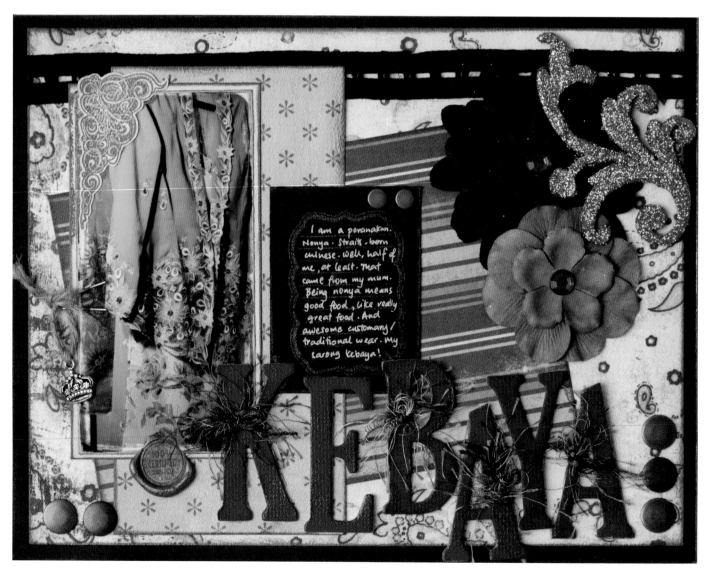

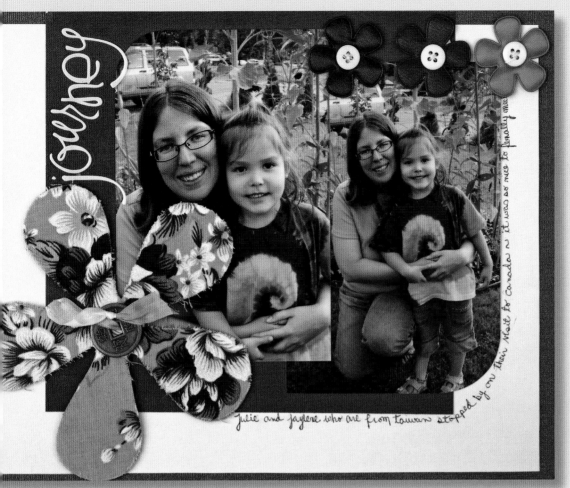

Journey by Andrea Blair

Using a bold Chinese pattern, Andrea uses fabric to cover a chipboard shape. Fabric-covered chipboard is just one more example of the many ways scrapbookers can use fabric in their layouts!

Supply Credits Cardstock: Bazzill (red bling), white; Patterned paper: My Mind's Eye/Magnolia (Starburst "Beauty" Floral/Red); Fabric, charm, flowers: Far Flung Craft; Chipboard flower: Fancy Pants Designs; Other: Silk ribbon, thread

Ten Days by Andrea Blair

This layout proves that the use of floral accents need not be limited to layouts of little girls. Andrea layered floral mon accents cut from patterned paper and felt to create a cluster of interest in the right-hand corner of the layout.

Supply Credits Cardstock: Bazzill (blue bling), white; Patterned paper: Autumn Leaves: Rub-ons: Making Memories (Days); Letter stickers: American Crafts; Felt flowers: Artist's own design; Other: DMC floss

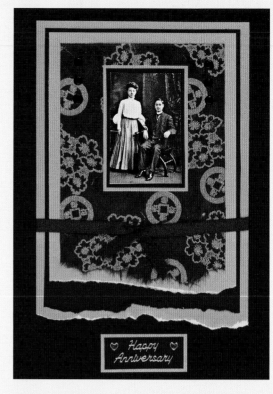

Happy Anniversary by Ann Pennington

Washi paper makes great-looking greeting cards and can be used for celebratory occasions. As you recall, the color red is used in Chinese culture to celebrate special events; and the combination of the color and washi paper makes a wonderful anniversary card.

Supply Credits Cardstock: Red, black, gold; Washi paper; Other: Ribbon, eyelets

Inchies by Ann Pennington

"Inchies" are fun 1-inch (2.5-cm)-square collages that use up your scrap papers and ephemera. Simple to make and easy to assemble, combine inchies in odd numbers to create an overall artwork and mat as desired.

Supply Credits Stamps: Stamp Attack; Charms, coins: Far Flung Craft; Vintage images: Paper Delights; Other: Cardstock, magazine images, ephemera, Asian text paper

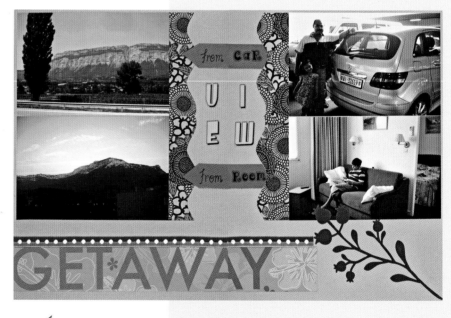

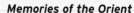

Memories of the Orient by Ann Pennington

This minibook is just the right size for small mementos of your trip or wallet-size photos. The project was created by using the library pocket die cut and placing it on an accordion-folded strip of paper for binding. Embellish with Asian joss paper, rubber stamps and Asian charms.

Supply Credits Asian emphera; Charms: Far Flung Craft; Library pocket die cut: Sizzix

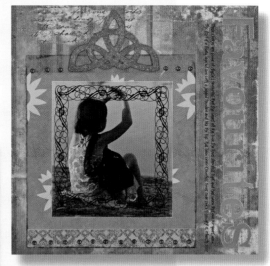

Favorites by Lynita Chin

In this layout Lynita uses handmade Indian paper to create a photo mat for the photograph of her daughter. The paper, with batik-inspired motifs, is slightly translucent, which allows the background paper to peak through, creating an interesting visual effect.

Supply Credits Patterned paper: Cosmo Cricket; Handmade papers; Target/DMD; Chipboard scroll: Maya Road; Acrylic paint: Jo Sonja; Glitter glaze: Lil Davis Designs; Rub-ons frame: Luxe Designs; Gems: My Mind's Eye; Alphabet stickers: American Crafts

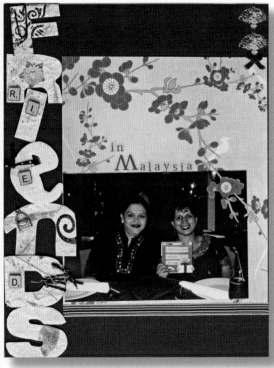

Friends by Nishi Varshnei

Using handmade paper on the title, Nishi backed the paper either with chipboard letters or heavy-duty cardstock in order to give the paper more weight.

Supply Credits Cardstock: Bazzill; Patterned paper: DCWV; Thai paper; Fan, purse charms; Far Flung Craft; Scrabble letters: EK Success; Others: Fibers, paper clip, silk flowers

Enjoy Life by Lynita Chin

Lynita glued the handmade paper printed with Asian text to a canvas in order to create an Asian-inspired wall hanging featuring pictures of her daughter's day at the beach. Once the paper was dry on the canvas (you can attach it with a medium such as Mod Podge) she embellished it with other patterned papers, stickers and charms.

Supply Credits Handmade paper; Chipboard stickers, die cut: DCWV/Far East Collection; Cloth sticker: EK Success; Word tag, brads; Making Memories; Inks: StāzOn (brown); Stamps: Kaiser Stamps (Life's Journey): Other: Acrylic paint, canvas

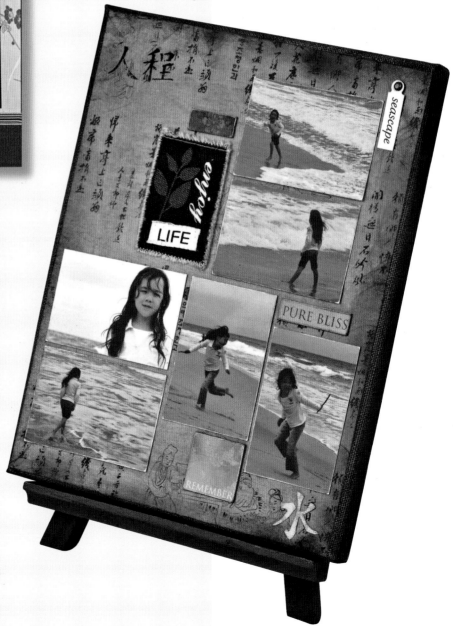

Screen Card by Ann Pennington

Using a photograph of her father while he was serving in the military and stationed in Asia, Ann created this screen card. The fold of the card allows it to be folded flat for mailing and storage, but it can be opened to act as a frame for your favorite images. Ann decorated the card by using yuzen paper, Asian stamps and Asian charms.
Supply Credits Screen template: wsdesignsonline; Cherry blossom, bird, verse stamps: Katy'sCorner; Cheongsam stamp: About Art Accents; Oriental charms: Far Flung Craft; Corner peel-off stickers: www.lynnr-papercrafts.co.uk

Memories
by Ann Pennigton

Ann used both scrapbooking paper as well as Asian text gathered from other sources such as books and newspapers to create this item of home décor. The use of scrapbook supplies as a way to decorate a home with pictures of family and friends is finding more favor.
Supply Credits Patterned paper: Die Cuts With A View/Far East Paper Stack; Chinese coins, charms: Far Flung Craft; Paint: Lumiere (Metallic Russet), Golden Artist Colors, Inc.(fluid acrylic: gold, copper, silver); Other: Wooden photo frame, rubber stamp, Asian ephemera

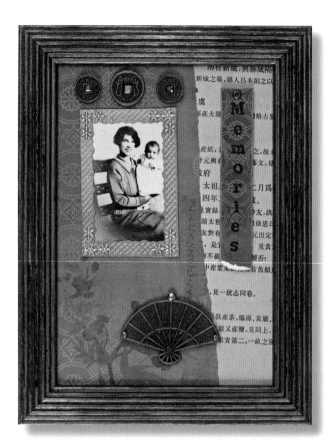

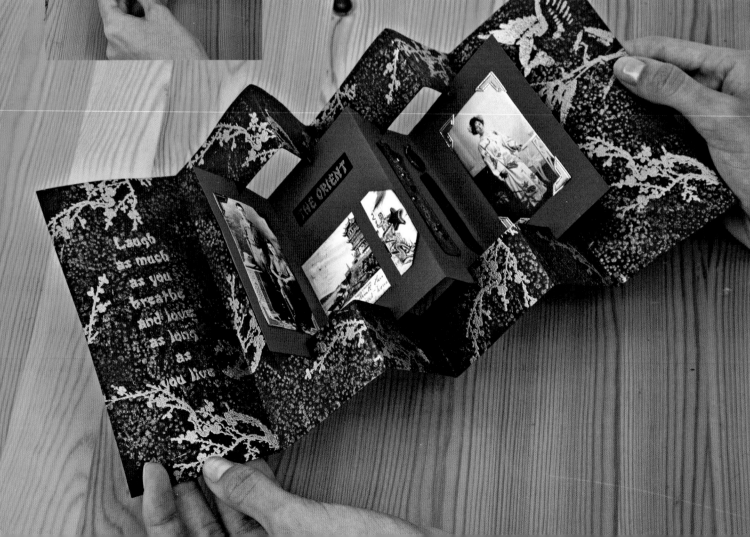

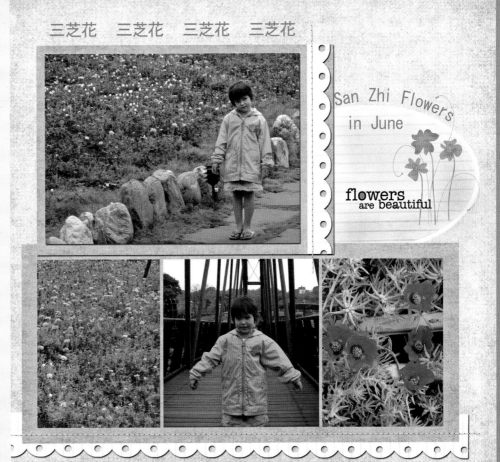

三芝花　三芝花　三芝花　三芝花

San Zhi Flowers in June

flowers are beautiful

Sanzhi Flowers
by Julie Kosolofski-Kuo
Julie uses the Chinese characters to create a title as well as act as a decorative element.
Digital Layout Credits Rhonna Farrer: Word Art; All other elements by ksharonk designs

Facination by Nishi Varshnei
Nishi again uses the Chinese text patterned paper in a layout featuring a traditional Chinese holiday event. Did you notice the cute Chinese charm in the corner of the layout? This is a great way to embellish this project.
Supply Credits Cardstock: Bazzill; Patterned paper: Over The Moon Press (Chinese text); Other: Charm; Other: ribbon

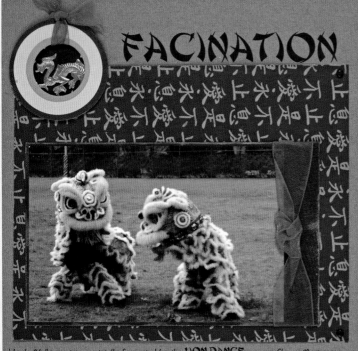

FACINATION

Hersh Vidhi you two are totally fascinated by the LION DANCE , a very Chinese New year tradition. This year we went to see a lot of these . SO at every given chance both of you will do your own Lion Dance in the home. Hersh – you would take a towel & pretend to be the lion & Dance around with music played by Vidhi. Then it will be Vidhi's turn to be the lion & Hersh will play the loud music. I can see it really influenced you two. And the loud music didn't seem to bother you two either.
I have to agree it is very fascinating dance & the way they move is just amazing. Chinese people call the Dance teams to perform at their homes & business places to bring good luck. They also distribute oranges. A very unique tradition!

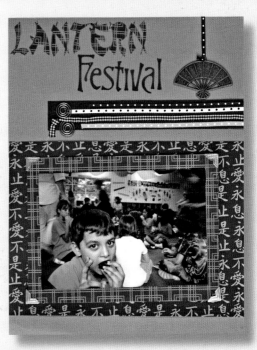

LANTERN Festival

Lantern Festival by Nishi Varshnei
Nishi was able to highlight the photographs of the Chinese lion dancers by matting them with a patterned paper that features Chinese text. Her inclusion of other Asian motifs and her choice of a faux Asian-style font for the title further help to set the layout's theme of the Chinese Lantern Festival.
Supply Credits Cardstock: Bazzill; Patterned paper: Over The Moon Press (Chinese text), grassroots (red); Charm: Far Flung Craft; Other: Photo corners, ribbon

Relax by Andrea Blair

The following two layouts use the same paper from Heidi Grace. Note how the paper, when used with different photos, gives off a different vibe. In Andrea's layout the paper and text seem to be an extension of the title, causing you to relax. This layout, very Zen in style, features not only the Asian text but animal motifs (the butterfly) and a very Zen/Japanese-inspired color scheme.

Supply Credits Cardstock; Patterned paper: Heidi Grace; Rub-ons: Urban Lily; Letters: American Crafts; Pen: Uni-ball Signo

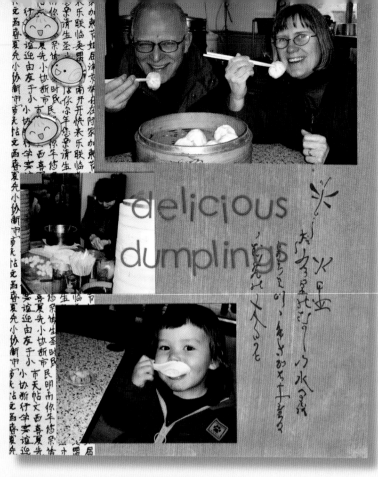

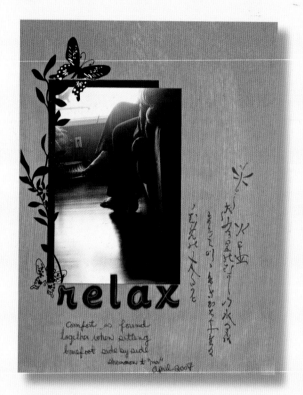

Dumplings by Julie Kosolofski-Kuo

In this layout, Julie has used the same paper that Andrea used in *Relax*. Yet the result is entirely different. Here the green paper is paired with an off-white patterned paper along with some fun kitschy stickers, creating a more energetic project.

Supply Credits Patterned paper: Heidi Grace; Stickers: SEI (alphabet), Epoxy

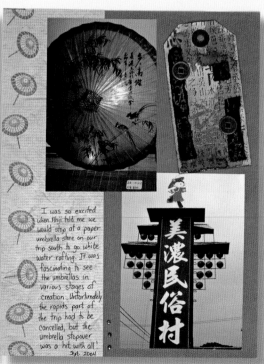

Paper Umbrella Museum by Julie Kosolofski-Kuo

Julie's border, created with umbrella stamps, is combined with Asian text paper, which lends a sense of cohesiveness to this two-page layout.

Supply Credits Cardstock; Patterned paper: me & my BIG ideas; Stamp: Hero Arts; Tag: 7gypsies

Favorite Photos—Mini-Album
by Lynita Chin

In this layout Lynita takes pages from Chinese almanacs and uses them as background paper. Remember that the paper may not be acid free and should be treated with a product such as Archival Mist.

Supply Credits Patterned paper: grassroots, BasicGrey, K&Company, Chatterbox, Rusty Pickle, Over The Moon Press; Chinese book text; Bookplate; Chinese charms: Far Flung Craft; Batik material: Far Flung Craft; Wooden alphabet letters, brads, chipboard alphabet, mini rub-ons, word tags: Making Memories; Tags; Ghost flower: Heidi Swapp; Alphabet stickers: Chatterbox; Ink: Archival Ink (sepia); Stamps: Hero Arts (Chinese newspaper word print , Stamp Craft (Asian stamp), alphabet stamps; Other: Metal

Precious Treasure Worth Cherishing
by Lynita Chin

The title of this layout is a traditional Chinese saying that Lynita found while reading a book called *A Thousand Pieces of Gold* by Adeline Yen Mah. You never know where your inspiration will come from!

Supply Credits Cardstock: Bazzill (linen); Patterned paper: BasicGrey, Rusty Pickle, Anna Griffin; Key: K&Company; Bookplate: K&Company; Word charm; Paint: Jo Sonja; Other: Old buttons

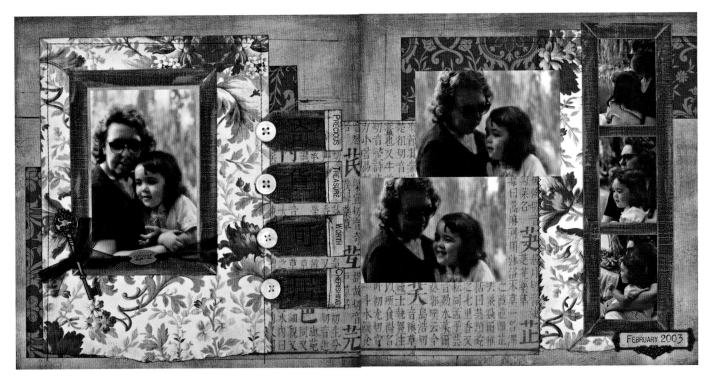

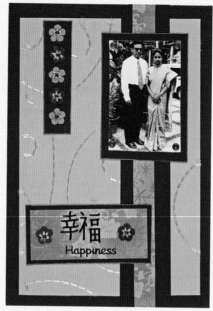

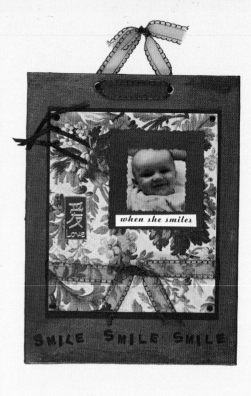

Recipe List by Kristy Harris

Using patterned paper that had long since gone out of style, I marbled over the top with the sumi ink marbling technique (page 145) to create a fun notebook in which to write my favorite recipes.

Supply Credits Notebook: Moleskine Cahier; Stickers; 7gypsies (tabs, words), Fancy Pants Designs (letters); Book binding tape: 7gypsies

Happiness by Ann Pennington

This layout shows that with a little imagination you can blend elements of different Asian cultures in one project. Here Ann has combined Indian colors and a photograph of a woman in a sari with Chinese characters for "Happiness."

Supply Credits Patterned paper: Die Cuts With A View; Pen: Krylon (gold); Other: Cardstock, handmade paper, eyelets, Chinese sticker

Wall Hanging by Ann Pennigton

Ann created the wall hanging by altering a simple canvas and embellishing it with paints, papers and the Chinese word for "Love."

Supply Credits Art canvas; Ribbon; Patterned paper; Paint; Sticker

Hong Kong Disney Autograph Book
by Kristy Harris

Wanting to create a one-of-a kind autograph book for our recent trip to Hong Kong Disney, I combined traditional Chinese text papers with a sticker of Mickey Mouse.

Supply Credits Patterned paper: EK Success; Letter stickers: American Crafts; Mickey sticker: EK Success

Wei Wei by Jennie Yeo

Jennie's daughter has a habit of answering the phone in true Chinese style, saying "Wei Wei" rather than "Hello." A clever idea of retaining portions of her mother tongue, Jennie does the title in both Chinese and English.
Supply Credits Cardstock: Bazzill; Patterned paper: BasicGrey, American Crafts; Transparency: Hambly Studios; Chipboard letters, shapes; Other: Buttons

Family New Year
by Lynita Chin

This simple and clean layout features patterned papers in more than one color but uniform in design. This layout will stand the test of time and look as classic in twenty years as it does today.
Supply Credits Cardstock : Bazzill (linen); Patterned paper: Handmade Chinese text paper; Tags, brads: Making Memories; Alphabet rub-ons: 7gypsies; Other: Wooden carved bead

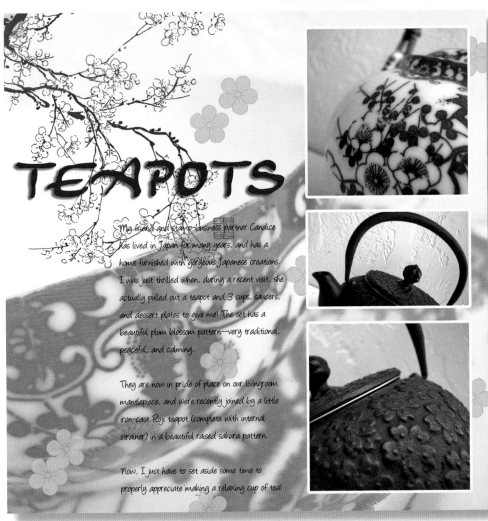

Teapots by Heather Taylor

This example of digital artistry is from Heather's own design. The title is done in a faux calligraphy (using a typeface called Juergen) and blends well with the Oriental teapot featured in the layout. Heather created the digital elements and the layout in Photoshop.
Supply Credits Digital layout: all elements by the artist

[RESOURCE GUIDE]

Disclaimer: Effort was made to find the name of manufacturers for every product used on every page in this book. If not all were available, we have included the available information and suggest that you may be able to find other items at any scrapbook or craft store.

Papers

The papers shown in the two photographs to the right are examples of papers produced by scrapbooking manufacturing companies that are largely inspired by Asian design. The Sassafrass Lass papers are very Japanese inspired, the College Press and Amy Butler papers are inspired by Chinese design and the Autumn Leaves paper features Indian paisley.

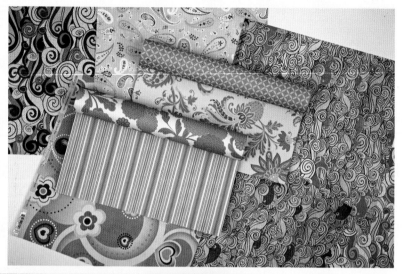

Scrapbooking papers by Sassafras Lass, College Press and Autumn Leaves

Asian-inspired Patterned Paper

The following manufacturers make Asian-inspired scrapbook paper that is acid free and lignin free. Most of these are available at your local scrapbook stores and craft and hobby stores. For more information please see the individual company Web pages:

EK Success	www.eksuccess.com
Sasafrass Lass	www.sassafraslass.com
Far Flung Craft	www.farflungcraft.com
Scenic Route	www.scenicroutepaper.com
Kodomo	www.kodomoinc.com
Dove of the East	www.doveoftheeast.com

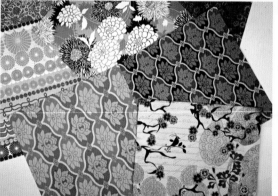

Scrapbooking papers by Sassafras Lass, Amy Butler for K&Company, and BasicGrey

Asian Handmade Papers

Handmade papers can usually be found at most major craft stores and specialty paper stores. The following online vendors also sell handmade papers:

Stone House Stamps	www.stonehousestamps.com
Oriental Trading Company	www.orientaltrading.com
Hanko Designs	www.hankodesigns.com
Paper Source	www.paper-source.com

Handmade papers from Taiwan

Asian Fabrics

Asian fabrics can often be found at your local quilt store as well as online at the following vendors:

eQuilter	www.equilter.com
Quilt Ethnic	www.quiltethnic.com/fabrics.html
Far Flung Craft	www.farflungcraft.com

Asian-inspired Rubber Stamps

Art Neko	www.artneko.com
Sassafrass Lass	www.sassafraslass.com
About Art Accents	www.aboutartaccents.com
Stampendous	www.stampendous.com
Hero Arts	www.heroarts.com
Stamp Attack	www.stampattack.co.uk
Kodomo	www.kodomoinc.com/stamps/index.cfm
Non Sequitur	www.nonsequiturstamps.com
Stone House Stamps	www.stonehousestamps.com
Katys Corner	www.katyscorner.org.uk

Asian Mixed-media Supplies

Far Flung Craft	www. farflungcraft.com
Stampington & Company	www.Stampington.com
Lynn R. Papercrafts	www.lynnr-papercrafts.co.uk
Bmuse	www.b-muse.com

Asian-inspired Digital Scrapbooking and Fonts

Oscraps.com	www.scrapbookingtop50.com

Some Asian-inspired rubber stamps

Detail of a piano hinge book by Lynita Chin

Source It!

For more inspiration and information about Asian culture and design, check out the following Web sites:

Oriental Stamp Arts	www.orientalstampart1.com
Stampington & Company (Publishers of Sommerset Magazines)	www.stampington.com
Chinese Characters	http://chineseculture.about.com/library
China Sprout	www.chinasprout.com
Made With Love (Singapore's largest scrapbook store)	www.madewithlove.com.sg
The Scrappers Loft (Asia's largest online forum for scrapbookers)	www.thescrappersloft.com

[PATTERNS AND TEMPLATES]

The following are the templates and patterns used and referenced in the book:

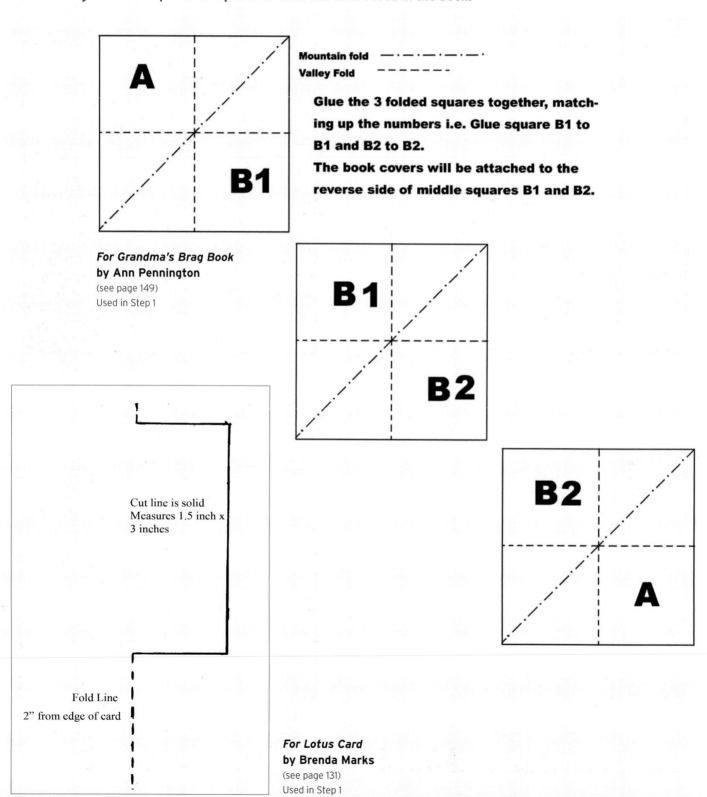

A

B1

Mountain fold — · — · — · — · —
Valley Fold — — — — — — —

Glue the 3 folded squares together, matching up the numbers i.e. Glue square B1 to B1 and B2 to B2.

The book covers will be attached to the reverse side of middle squares B1 and B2.

For Grandma's Brag Book
by Ann Pennington
(see page 149)
Used in Step 1

B1

B2

B2

A

Cut line is solid
Measures 1.5 inch x
3 inches

Fold Line
2" from edge of card

For Lotus Card
by Brenda Marks
(see page 131)
Used in Step 1

For Photo Cube by Ann Pennington
(see page 144)
Used in Step 1

Used in Step 2

Used in Step 3

Used in Step 4

A

D

B

C

[METRIC CONVERSION CHART]

Imperial		Metric
12 x 12 in		30.5 x 30.5 cm
8.5 x 11 in		21.5 x 28 cm
5 x 7 in		12.7 x 17.8 cm
4 x 5 in		10.2 x 12.7 cm
1 in		25.4 mm
3/4 in	(.75 in)	19.1 mm
5/8 in	(.625 in)	15.9 mm
1/2 in	(.5 in)	12.7 mm
1/4 in	(.25 in)	6.4 mm
1/8 in	(.125 in)	3.2 mm
1/16 in	(.0325 in)	1.6 mm

To convert between centimeters and inches, multiply the number of centimeters by .3937.

To convert between millimeters and inches, multiply the number of millimeters by .03937.

To convert between inches and centimeters, multiply the number of inches by 2.54.

To convert between inches and millimeters, multiply the number of inches by 25.4.

8.5 x 11 (21.5 x 28 cm) paper does not have an equivalent size in metric sizes. A4 paper is slightly longer (8.27 x 11.69 inches/21 x 30 cm) but most scrapbook stores worldwide sell 12 x 12-inch (30.5 x 30.5-cm) paper.

[ASIAN ANIMAL MOTIFS AND THEIR MEANING]

(Differentiating among different countries or regions of Asia as appropriate)

Lunar Calendar Zodiac Animals	Meaning
Rat	Beginnings; and when applied to people born in the year of the rat, creative, vital and energetic
Ox	Harvest, agriculture; and when applied to people, tenacity, hard work and perseverance
Tiger	Strength, masculinity, royalty
Rabbit	Fertility, life, gentility and kindness
Dragon	Power, courage, wisdom (throughout Asia)
Snake	Guardians of treasure and lucky with money; and when applied to people born in the year of the snake, secretive, cunning and sly, but good with money
Horse	Strength by way of health and stamina
Goat/Sheep	Arts and femininity; the people born in the year of the goat tend to be teachers, artists, craftsmen
Monkey	Cleverness/curiosity, fun and frolic
Rooster	Aggressiveness and alertness; rooster people are bright and analytical
Dog	Security, home, loyalty and devotion
Pig	Night dwellers, symbolizing completion and good fortune
Other Animal Symbols	
Bat	Good luck
Butterfly	Happiness, joy and summer
Crane	Long life and fidelity (Japan, China and Korea)
Duck	Couples, marriage, union (Japan and China)
Elephant	National symbol of Thailand; happiness/good luck around the rest of Asia
Fish (often a carp)	Wealth and prosperity (Japan and China); multiple children/family (Korea)
Phoenix	Symbol of rebirth, imperial authority
Tortoise	Longevity (throughout Asia)

[ASIAN COLORS AND THEIR MEANING]

Color	Meaning	Country
Red	Celebration, luck, marriage and prosperity Femininism, sexuality and marriage Heroism, national pride	China India Japan
Yellow	Gold–imperial power Saffron yellow–sacred Luck and auspicious Courage	China India India Japan
Blue	Immortality/longevity, earth The god Krishna and peace	China India
Green	Longevity, earth Earth, nature, life	China Japan
White	Death, mourning Unhappiness	Japan, China, Korea India
Black	Evil spirits	Regionwide

[ASIAN PLANTS AND THEIR MEANING]

Motif	Meaning	Countries/Region
Bamboo	Strength	China
Chrysanthemum	Long life Eternity	Japan China
Gourd	Longevity	China
Lotus	Birth and rebirth, fertility, creation and purity A religious symbol associated with Buddhism	Throughout Asia
Peony	Wealth and abundance Love	China
Pine Tree	Long life and hardiness; ability to survive the bleakest of conditions	China, Japan, Korea
Sakura (cherry blossom)	Ephemeral nature/spring	Japan
Plum blossom	Perseverance in the face of adversity Revolutionary struggle	Japan, Taiwan and China Mainland China
Mandarin oranges	Good luck and prosperity	China

[INDEX]

To Jeff, Declan and Kiera—for travels around Asia and beyond and for being the reason that I want to scrapbook

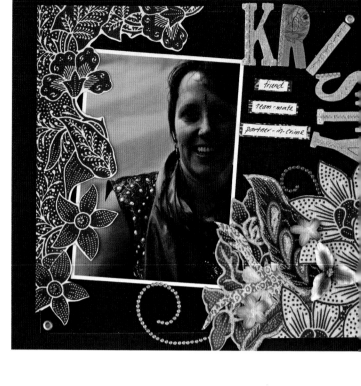

Note: Every effort has been made to ensure that all information in this book is accurate. However, due to differing conditions, tools and individual skills, the publisher cannot be responsible for any injuries, losses and/or damages that may result from the use of information in this book. If readers are unfamiliar with or not proficient in a skill necessary to attempt a project, we urge that they refer to an instructional book specifically addressing the required technique.

Published by Tuttle Publishing, an imprint of Periplus Editions (HK) Ltd., with editorial offices at 364 Innovation Drive, North Clarendon, Vermont 05759 U.S.A.

Library of Congress Cataloging-in-Publication Data
Harris, Kristy.
 Scrapbook Asian style! : create one-of-a-kind projects with Asian-inspired materials, colors and motifs / Kristy Harris.
 p. cm.
 Includes index.
 ISBN 978-0-8048-3933-4 (pbk.)
1. Photograph albums. 2. Scrapbooks. 3. Asia—In art. I. Title.
 TR501.H374 2008
 745.593—dc22
 2008013496

ISBN: 978-0-8048-3933-4

Distributed by
North America, Latin America & Europe
Tuttle Publishing
364 Innovation Drive
North Clarendon, VT 05759-9436 U.S.A.
Tel: 1 (802) 773-8930
Fax: 1 (802) 773-6993
info@tuttlepublishing.com
www.tuttlepublishing.com

Asia Pacific
Berkeley Books Pte. Ltd.
61 Tai Seng Avenue
#02-12, Singapore 534167
Tel: (65) 6280-1330 Fax: (65) 6280-6290
Email: inquiries@periplus.com.sg
www.periplus.com

First edition
10 09 08 10 9 8 7 6 5 4 3 2 1

Printed in Singapore

TUTTLE PUBLISHING® is a registered trademark of Tuttle Publishing, a division of Periplus Editions (HK) Ltd.

[ACKNOWLEDGMENTS]

This book could not have been completed, or be nearly as beautiful, without the help and support of the many contributors. I thank you for sharing your work with me and scrapbookers around the world.

 Thanks to the girls in Singapore, all of those scrapping friends who encouraged me along the way and who eagerly anticipate the publication of a book proving that Asian scrapbooking is going strong. Faye, thanks for late-night e-mails and being able to take the reins when I needed time to devote to the book; and Nancy, thanks for all you do for me and the family.

 And finally a special shout out to my husband; the journey of this book began when you said, "Yes, follow your dream. Let's move to Asia."

[LIST OF CONTRIBUTORS]

Aida Herron
Alanna Yeo
Andrea Blair
Ann Pennington
Avina Lim
Brenda Marks
Claudia Lim
Edleen Maryam
Heather Taylor
Jennie Yeo
Julie Kosolofski-Kuo

Lynita Chin
Mei Ling Low
Michelle Anne Elias
Nishi Varshnei
Odile Germaneau
Sasha Farina
Selena Hickey
Sharon Chan
Vidya Ganapati
Wendy Steward